W9-DBH-221

# Devotion & Splendor

## MEDIEVAL ART AT THE ART INSTITUTE OF CHICAGO

## THE ART INSTITUTE OF CHICAGO
*in association with the University of Washington Press*

ISSN 0069–3235

ISBN 0-86559-214-4 *(The Art Institute of Chicago)*

ISBN 0-295-98458-9 *(University of Washington Press)*

2004 © The Art Institute of Chicago. All rights reserved. No part of the contents of this publication may be reproduced, stored in a retrieval system, or transmitted in any form or by any means, electronic, mechanical, photocopying, recording, or otherwise, without the written permission of The Art Institute of Chicago.

Executive Director of Publications: Susan F. Rossen; Editor of *Museum Studies*: Gregory Nosan; Designer: Jeffrey D. Wonderland; Production: Sarah E. Guernsey; Subscription and Circulation Manager: Bryan D. Miller.

Unless otherwise noted, all works in the Art Institute's collection were photographed by the Department of Imaging, Christopher Gallagher, Acting Executive Director, and images are © The Art Institute of Chicago. Many images in this publication are subject to copyright and may not be reproduced without the approval of the rights holder. Every effort has been made to contact copyright holders for all reproductions.

This publication was typeset in Stempel Garamond; color separations were made by Professional Graphics, Inc., Rockford, Illinois. Printed by Meridian Printing, East Greenwich, Rhode Island.

Front cover: *Saint George Killing the Dragon* (cat. 54, detail)
Opposite: *Initial* M *with Saint Matthew as Scribe, Initial* L *with the Tree of Jesse* (cat. 22, detail)
Back cover: *The Veltheim Cross* (cat. 30), *Velvet Panel with Ox Heads and Eagles* (cat. 42, detail)

*Devotion and Splendor: Medieval Art at the Art Institute of Chicago* was published in conjunction with the exhibition *Devotion and Splendor: Medieval Art at the Art Institute*, presented at the Art Institute of Chicago from September 25, 2004 to January 2, 2005.

Distributed by University of Washington Press, P.O. Box 50096, Seattle, Washington, 98145-5096, and www.washington.edu/uwpress.

This publication is volume 30, number 2 of *Museum Studies*, which is published semiannually by the Art Institute of Chicago Publications Department, 111 South Michigan Avenue, Chicago, Illinois 60603-6110.

For information on subscriptions and back issues, consult www.artic.edu/aic/books/msbooks, or contact (312) 443-3786 or pubsmus@artic.edu. Wholesale orders for *Devotion and Splendor* should be directed to University of Washington Press at (800) 441-4115.

Ongoing support for *Museum Studies* has been provided by a grant for scholarly catalogues and publications from The Andrew W. Mellon Foundation.

R0403164001

# CONTENTS

## CATALOGUE

# ACKNOWLEDGMENTS

When the Art Institute's relatively small yet impressive collection of medieval art was first assembled, it was displayed together, with paintings, sculptures, tapestries, and other decorative arts viewed side by side. Likewise, the only catalogue of the museum's holdings, published over fifty years ago, treats them as an ensemble, regardless of medium. Starting in the 1950s, however, these works were divided among curatorial departments throughout the Art Institute and since then only a small number has been on view at any given time. Together, this issue of *Museum Studies* and its companion exhibition have provided an occasion to reassess and reunite these precious objects, which range in date from the sixth to the fifteenth century and include works from Western Europe, the Byzantine Empire, and the Islamic world.

Many thanks are due to my colleagues in the Department of European Decorative Arts and Sculpture, and Ancient Art, and to equally congenial and skilled staff in other museum departments, who offered assistance and advice of the highest order. These individuals include Jessica Batty, Pamela Ellsworth, Larry J. Feinberg, Mary Greuel, William Gross, P. J. Grous, Barbara Hall, Emily Heye, Barbara Hinde, Suzanne Folds McCullagh, Karen Manchester, Jane Neet, Caroline Nutley, Brandon Ruud, Bart Ryckbosch, Suzanne Schnepp, Martha Tedeschi, Christa C. Mayer Thurman, Martha Wolff, and Ghenete Zelleke. Chicago historian Celia Hilliard graciously shared her knowledge of the Antiquarian Society, allowing me to better understand that group's importance in the formation of the medieval collection. Sarah Guernsey and Jeff Wonderland expertly guided the production of the catalogue, while Greg Nosan was, from the start, an enormously insightful and energetic editor. His patience and good humor made this a particularly enjoyable project.

At the same time, a number of individuals from other institutions offered encouragement and expert opinions of their own, while others made available research files on objects in their care. Among these are Tracey Albainy, Barbara Drake Boehm, Marian Campbell, Chris Dunham, Stephen Fliegel, Rob Hallman, Todd Herman, Sandra Hindman, Charles Little, Christopher T. Newth, William Noel, Fernando Peña, Paul Saenger, Avinoam Shalem, Mary Alice Talbot, and Paul Williamson. Laura K. Bruck, in particular, deserves special mention for her work with the Art Institute's collection of illuminated manuscripts, leaves, and cuttings.

Both on the page and in the gallery, *Devotion and Splendor* would have been impossible without the foresight of Bruce Boucher, Eloise W. Martin Curator of European Decorative Arts and Sculpture, and Ancient Art, who understood the potential benefits of examining the medieval collection afresh. Nor could the project have been undertaken without the generosity of the Andrew W. Mellon Foundation, which has provided me the opportunity to work with a collection that I had long admired—but only partially knew—as a graduate student in Chicago. It is my hope that this catalogue and exhibition will be useful to general and more specialized audiences alike, and that they will be inspired to actively encounter this important collection in their own ways.

*Christina M. Nielsen*
*Andrew W. Mellon Curatorial Fellow*
*Department of European Decorative Arts and Sculpture, and Ancient Art*

# INTRODUCTION

The modern interest in the Gothic stems from the eighteenth century, when antiquarians like Horace Walpole began to value the period in its own right and not simply as a seemingly endless prelude to the Renaissance. The sham-medieval interiors of Walpole's estate, Strawberry Hill, soon led to more ambitious mid-nineteenth-century undertakings, including Alexandre Lenoir's Musée des Monuments Français and Alexandre du Sommerand's Musée de Cluny in Paris. The latter was especially important in establishing a vogue for all things Gothic, with visitors describing their experience as stepping into the past or entering one of Walter Scott's historical novels. The nascent study and collecting of objects from this period found eloquent champions in John Ruskin and Eugène Emmanuel Viollet-le-Duc, not to mention their American apostles Charles Eliot Norton and George Gray Barnard.

The American quest for the medieval reached its peak during the early decades of the last century, and, as the following essay testifies, Chicagoans collected art of the Middle Ages almost as avidly as they acquired Impressionist paintings. Indeed, many of the illustrious donors whose names are found on the labels of the Art Institute's Monets and Renoirs also endowed the museum with a dazzling array of medieval caskets, reliquaries, and textiles. Chicagoans in the early twentieth century would have seen an extensive display of medieval artifacts in the galleries around McKinlock Court and experienced the interior of the Lucy Maud Buckingham Memorial Gothic Room, something that would not have seemed out of place at William Randolph Hearst's California castle, San Simeon. At the same time, those who designed many of our early skyscrapers turned to the Gothic as a natural idiom for verticality, while area institutions such as Northwestern University and the University of Chicago embraced the style for its scholarly associations.

By the 1950s, changes in taste and collecting patterns required that more gallery space be devoted to modern and non-Western art, which meant that many of the objects celebrated here were removed from view. The Art Institute's medieval holdings have remained in a state of suspended animation for more than twenty years, but the time is ripe for a new look at these mostly hidden treasures from the departments of European Decorative Arts and Sculpture, and Ancient Art; European Painting; Prints and Drawings; and Textiles. Anyone leafing through these pages will admire the acumen of the Chicago patrons and curators who assembled the marvelous range of drawings, illuminated manuscripts, sculptures, and textiles on parade. Many have not been seen or studied in decades, but this issue of *Museum Studies* has allowed us to reevaluate them. An accompanying exhibition, entitled *Devotion and Splendor: Medieval Art at the Art Institute*, will be on view from September 25, 2004, to January 2, 2005, in Galleries 141 and 142. Together, these dual endeavors mark a first step in plans for a new multimedia display of our medieval and Renaissance artifacts, which we hope to develop in concert with the departments named above.

We have been fortunate in having Dr. Christina M. Nielsen as an Andrew W. Mellon Curatorial Fellow in our department, for it is her vision and expertise that have led to the creation of *Devotion and Splendor* as both a publication and an exhibition. We are grateful to the Andrew W. Mellon Foundation for providing such a wonderful opportunity for her, and for us. In addition, I would like to acknowledge the superb contributions of colleagues throughout the museum, without whose help this rediscovery of our medieval holdings could never have taken place. We believe the splendid results justify the time and effort of all involved.

*Bruce Boucher*

*Eloise W. Martin Curator of European Decorative Arts and Sculpture, and Ancient Art*

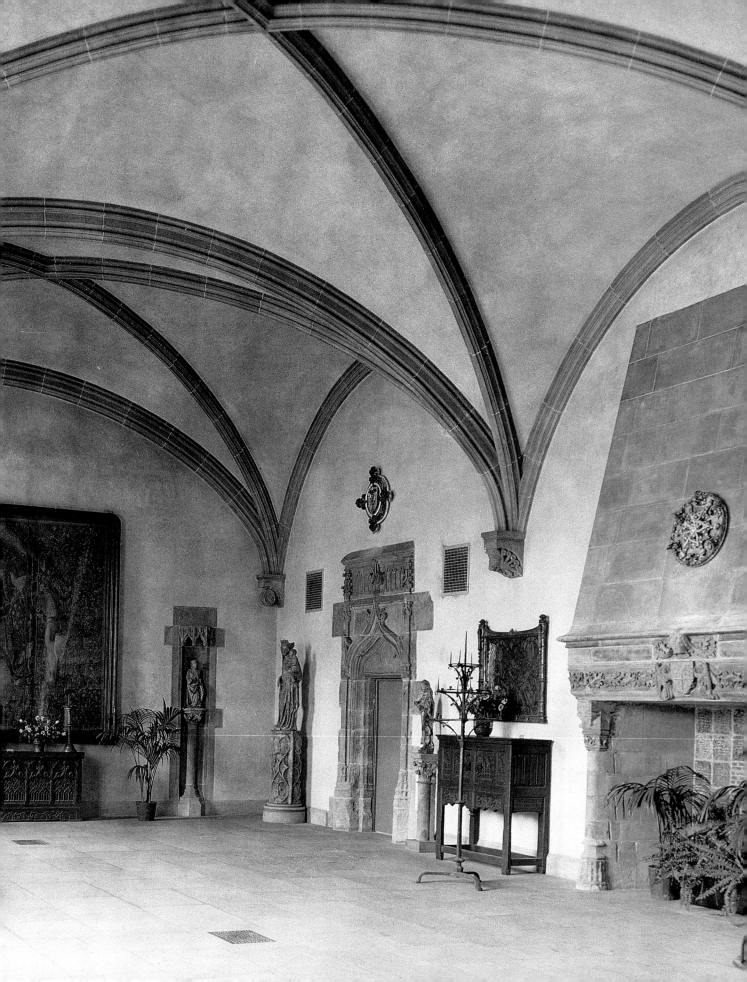

# "TO STEP INTO ANOTHER WORLD":

# BUILDING A MEDIEVAL COLLECTION AT THE

# ART INSTITUTE OF CHICAGO

CHRISTINA M. NIELSEN, *Department of European Decorative Arts and Sculpture, and Ancient Art*

The collection of medieval art at the Art Institute of Chicago contains exceptional works in a variety of media. The history of these objects begins with a group of spirited midwestern amateurs who possessed equal amounts of intellectual curiosity, generosity, and acquisitive vigor. In many ways, it reads like a tale of Chicago itself, with members of the city's prominent families—Buckinghams, Deerings, McCormicks, and Ryersons—as main characters.[1] While this unique story is of great local importance, it was also inevitably informed by greater national and international trends. Indeed, when viewed as an ensemble, the museum's medieval works are in many respects as informative about the twentieth century—its personal tastes, social influences, and art-market trends—as they are about the Middle Ages.

By the late nineteenth century, European connoisseurs had been avidly collecting and studying medieval art for several hundred years, but Americans were relative latecomers to the field.[2] Only in the 1890s did they begin to compete seriously, and only in the few decades that followed did the market begin to shift from Paris and London to New York thanks to the buying power of individuals such as Isabella Stewart Gardner, J. Pierpont Morgan, and Henry Walters. Several important developments fueled the new American appetite for things medieval. One of these was the 1909 passage of the Payne Bill, which repealed the 20 percent tax levied on artworks brought into the United States from abroad. As a result, Morgan, the Wall Street financier, transferred his incomparable collection of medieval sculpture and decorative arts from London to the Metropolitan Museum of Art in New York. In 1910 the Metropolitan opened a new wing dedicated to the decorative arts, and there installed its quickly expanding medieval collection in a suite of period rooms. One year earlier the Walters Art Gallery in Baltimore had begun hosting annual benefit openings of its galleries, which also boasted a Gothic room.[3] With the emergence of these venues, American audiences, who previously knew medieval art only through plaster casts, were able to view authentic objects.

Another important figure at this moment was the charismatic George Gray Barnard, an American artist who became an expert in Romanesque and Gothic sculpture.[4] While he had hoped to sell his substantial collection to an individual or institution, he ultimately adopted an entrepreneurial approach, creating the first museum in America devoted to medieval art. The

FIGURE 1. The Lucy Maud Buckingham Memorial Gothic Room, c. 1914 (detail).

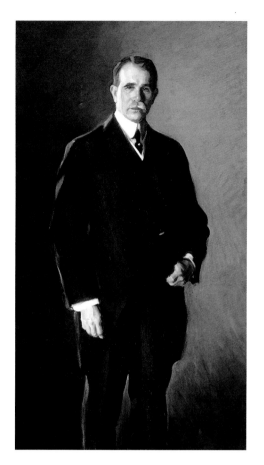

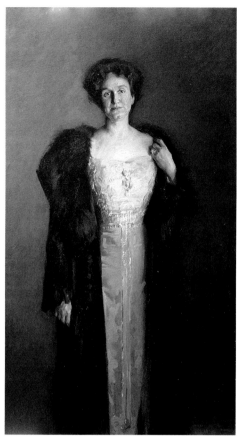

FIGURE 2. Louis Betts (American, 1873–1961). *Martin A. Ryerson*, 1913. Oil on canvas; 166.4 x 95.3 cm (65 1/2 x 37 1/2 in.). Mr. and Mrs. Martin A. Ryerson Collection, 1933.1183.

FIGURE 3. Louis Betts. *Mrs. Martin A. Ryerson*, 1912. Oil on canvas; 169.6 x 93.4 cm (66 3/4 x 36 3/4 in.). Mr. and Mrs. Martin A. Ryerson Collection, 1935.433.

Cloisters, located in upper Manhattan, opened in 1914 and was greeted by a public enchanted by period rooms, which consisted of creative pastiches of churches, courtyards, and decorative objects, all illuminated by candlelight. "Monks" served as tour guides and a soundtrack of medieval chants added to the theatrical effect. Purchased for the Metropolitan Museum in 1925, Barnard's Cloisters sparked enormous interest in medieval art on the part of collectors, curators, and audiences alike.

By this point it had become obligatory for any great collection to include a selection of medieval pieces. Germain Seligman, the son of Jacques Seligman, one of the most important Parisian dealers of these objects, remembered that collectors were "captivated" by the art of the Middle Ages and Renaissance and that such works "brought prices which are now reserved for Cézannes and Picassos."[5] This demand was inspired in part by the Gothic Revival of the nineteenth century, which had awakened interest in medieval art and led more and more Americans

to appreciate its visual characteristics. In Chicago in particular this was reflected in the new campus of the University of Chicago and even in skyscrapers such as the Tribune Tower on North Michigan Avenue.[6] The vogue for medieval objects was also affected by contemporary artistic movements such as Expressionism, which prompted an aesthetic reappraisal of "primitive" art, and by extension medieval art, with its expressive, emotive qualities.

Just as fashionable collectors on the East Coast had turned their gaze toward the medieval, so too did wealthy Chicagoans. Two of the city's greatest cultural patrons, the hotel magnate Potter Palmer and his wife, Bertha Honoré Palmer, amassed impressive holdings that ranged from important French Impressionist paintings to Asian art. Mrs. Palmer was reportedly advised in her purchases by no less than "J. P. Morgan's tutor," Wilhelm von Bode of Berlin, an eminent scholar of Renaissance art who was intimately familiar with a number of the finest private collections in Europe.[7] Among her acquisitions were sev-

eral works from the Middle Ages, including Jacques de Baerze's corpus of Christ (cat. 37), one of the most prized pieces of early sculpture in the Art Institute. As a family, the Palmers were also responsible for donating a casket from the Embriachi workshop in Venice (cat. 44) and a series of fifteenth-century Italian prints resembling playing cards (see cat. 46).

While the Palmers most likely acquired these objects as a matter of style, another Chicago couple, Martin A. and Carrie Hutchinson Ryerson (see figs. 2–3), showed a deeper interest in a wide variety of medieval artifacts. These included ceramics, illuminated manuscripts, paintings, sculptures, and textiles, which they purchased both for their home (see fig. 4) and for the Art Institute. Their impeccable taste also ran to Greek pottery, Japanese woodcuts, and European "primitive" paintings, and there was hardly an area of the museum that did not benefit from their extraordinary generosity. The heir to a Michigan lumber fortune, Martin Ryerson was educated

in Paris and Geneva and received his law degree from Harvard before returning to the Midwest.[8] He retired from business in the 1890s, devoting himself to philanthropic efforts on behalf of the Columbian Museum (now the Field Museum), the University of Chicago, and the Art Institute, which he supported actively for more than thirty years.

Ryerson took an intensely personal approach to acquiring works for the museum. In one letter, for example, he entertained Art Institute director Robert Harshe with his impressions of Perugia and Siena—"It is surprising how much we can find by the roadside in this wonderful country"—and also announced that he had made purchases that would "be dropping in at the Art Institute from time to time." One of these was a fifteenth-century stone statue of the Virgin of the Annunciation, secured from the dealer Clemente in Florence.[9]

Buying largely from leading dealers in Europe and the United States, Ryerson obtained some of his finest

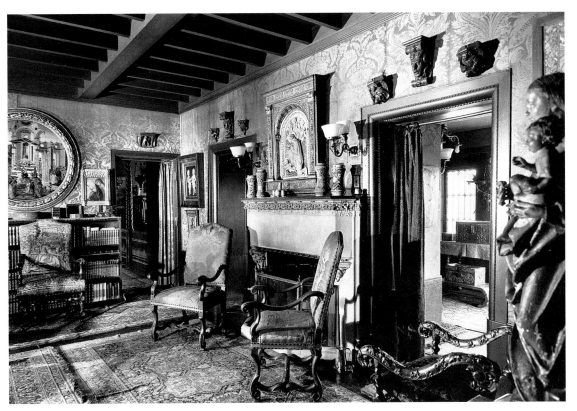

FIGURE 4. Interior of the Martin A. Ryerson residence on Chicago's Drexel Avenue, 1924/37.

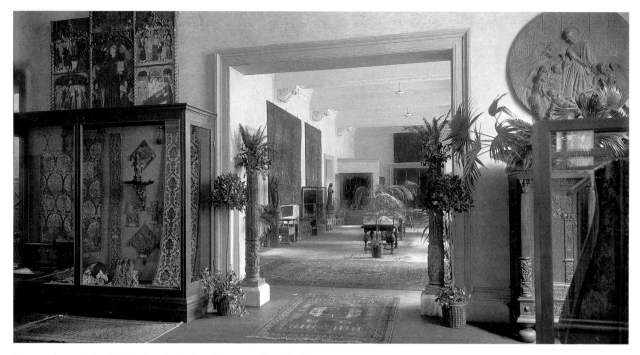

FIGURE 5. The galleries of the Antiquarian Society of the Art Institute of Chicago, c. 1910.

pieces of decorative art from the collection of Frédéric Spitzer, one of the most important nineteenth-century connoisseurs of medieval and Renaissance works.[10] Among these were fifteen examples of Italian maiolica, three tapestries, and eighteen pieces of "enamel, goldsmith work, ivory, etc.," including the Hispano-Moresque lusterware plate (cat. 9) and spectacular ivory triptych (cat. 35) featured in this catalogue.[11]

Carrie Ryerson's efforts on the Art Institute's behalf were no less substantial, especially during her tenure as president of the Antiquarian Society from 1908 to 1919. In the first few decades of the museum's existence, the Antiquarians were a force to be reckoned with.[12] In fact, since there was no official curator of decorative arts until 1914, these women served for years as de facto experts, acquiring objects and maintaining the galleries entrusted to their care.[13] In a photograph of those rooms taken around 1910 (fig. 5), we can see just how much fashionable domestic interiors influenced the early display of medieval art in the museum. Indeed, like the Ryersons' drawing room, the Antiquarian galleries displayed a wide variety of objects in an opulent environment complete with Persian carpets and potted plants.[14]

Mrs. Ryerson encouraged the Antiquarians to buy Gothic and Renaissance artworks of quality and engineered ingenious benefit galas, including a grand Renaissance pageant, to help pay for them.[15] With her close friend Frances Kinsley Hutchinson, who was likewise familiar with the international art market, Ryerson was in the perfect position to direct the group's tastes and acquisitions toward the medieval. She was successful, and in 1909, for example, was able to announce the purchase of a Spanish wooden altarpiece of the Nativity and a late-fourteenth-century stone Virgin and Child that was "pronounced by the expert employed by the French Government to be almost if not quite equal to [one] in the Louvre." The following year, she also reported on "some madonnas and various antiques to be had in Paris at reasonable prices" and expressed the hope that funds could be raised to obtain some of them. Her wishes may well have been met, since the Art Institute's *Bulletin* soon remarked on the "many specimens of medieval and Renaissance sculpture" secured by the Antiquarian Society. Ryerson's message was reinforced by none other than George Gray Barnard himself, who in 1910 gave a "delightful and informative" talk on Gothic art in the Antiquarian galleries. Congratulating

FIGURE 6. Mary Mitchell Blair's collection of medieval and Renaissance art, on exhibit at the Art Institute of Chicago in 1914.

members on their recent acquisitions, he exhorted them to capture what Gothic works they could "at once, as every day examples grew scarcer and much higher in price and would soon be impossible to obtain at any price."[16]

During the two decades that followed, the society sponsored a number of temporary exhibitions featuring medieval objects. The first of these featured the impressive collection of Mary Mitchell Blair, a fellow Antiquarian who divided her time between homes in Chicago and Paris.[17] The beneficial tax implications of the Payne Bill, coupled with possibility of war in Europe, may have prompted her return to the United States for good in 1913. Blair shipped most of her collection directly to the Art Institute, where it was displayed with much fanfare in 1914 (see fig. 6). The *Chicago Daily Tribune* likened the exhibition to a small Musée de Cluny, while the *Record Herald* exclaimed that it almost made feudal castles and baronial halls "take real substance before one's fancy." When the exhibition closed in 1915, the *Herald* lamented the fact that war had evidently "tightened the purse strings of those who might buy [the collection]" for the museum.[18]

Following this success came a series of other medieval loan exhibitions, presumably organized in the hope that patrons might buy the works on display either for themselves or the museum.[19] In stark contrast to today's practices, the Art Institute even kept a salesman on staff, who earned a commission on each work sold. One of the most important of these quasi-commercial ventures actually formed the basis for the museum's collection of illuminated manuscripts, leaves, and cuttings. In 1915 Wilfrid F. Voynich, a rare book dealer with offices in London and New York, hosted an exhibition that attracted the interest of artists, scholars, and the general public.[20] Art Institute benefactors such as Mrs. J. J. Borland made several important purchases on the museum's behalf (see cat. 49), while other acquisitions came through endowed funds. The museum's *Bulletin* reported the arrival of six more Voynich pieces the following year, when they were on view in the Antiquarian galleries.[21] Others followed, and by 1935 constituted a "small but valuable" collection of complete manuscripts and over eighty single leaves.[22]

Throughout the 1920s, it was the inimitable Kate S. Buckingham, heiress to a family fortune made in banking, grain elevators, and streetcars, who influenced the Art Institute's medieval collection most profoundly. Strong-willed and fiercely independent, she was only

loosely affiliated with the Antiquarians and was proud of never having belonged to any "club, church, or man."[23] Although Buckingham (see fig. 7) had dabbled in collecting Asian art, her true passion was creating memorials to her family.[24] In the 1910s she gave the Art Institute her brother Clarence's extraordinary collection of European prints and Japanese woodblocks, establishing an endowment in his name. In 1921 she donated a Jacobean period room, the first of its kind in the museum, in her parents' memory. Lauded for re-creating "the spirit of the past," it was hoped that this space might also stimulate "good taste in the community."[25]

Obviously encouraged by this praise, Buckingham turned her attentions to creating another, Gothic period room, this time in honor of her sister Lucy Maud, who died in 1920. She spent an astonishing $300,000 to outfit this new attraction, buying works from the finest dealers in New York and Paris. While she may have modeled the

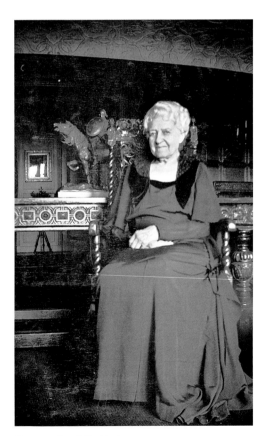

FIGURE 7. Kate S. Buckingham, c. 1930.

project in part on Barnard's Cloisters or Isabella Stewart Gardner's museum in Boston, her surest inspiration was her friend Florence Blumenthal, who had, along with her husband, amassed an impressive art collection that included a sixteenth-century marble patio from Spain, which the couple reinstalled in their Park Avenue home.[26]

Opened in 1924, the Lucy Maud Buckingham Memorial Gothic Room (see figs. 1, 8) contained architectural fragments, furniture, stone and wood sculpture, and tapestries, mainly from fifteenth- and sixteenth-century France. Louis Cornillon, a dealer who referred to himself as an "artist, architect, decorator," helped with the design, contriving the arched vault that he felt rendered the space "truly Gothic."[27] The museum's *Bulletin* echoed this view, proclaiming that to enter this Gothic room was "to step into another world. The high vaulted ceiling and the ogival windows through which light sifts softly contribute to an air of serenity and spaciousness."[28]

Like the Ryersons before her, Buckingham was personally involved in the acquisitions she made for the Art Institute. Much to the frustration of registrars, she would even bring objects into the galleries herself and place them in cases. Sometimes she paid dealers directly, while at others the museum learned only after a shipment had arrived that payments were to be made out of funds she had provided. She was even in the habit of listing her return address as "Miss Kate S. Buckingham, c/o The Art Institute of Chicago, Michigan Avenue, Chicago, Illinois."[29]

More troublesome by far was the fact that, while Buckingham did acquire a few great medieval pieces such as a Spanish corpus of Christ (cat. 27), her enthusiasm as a collector was rarely matched by her expertise. Florence Blumenthal's untimely death, Seligman suggested, left her at the mercy of dealers, which unfortunately resulted in a number of very costly missteps. One of these was the 1922 purchase of a complete—and completely inauthentic—drawing room from Urishay Castle, Herefordshire, obtained through Chicago's Marshall Field & Co. department store for $22,000. In a letter of 1933 to a museum registrar, Buckingham acknowledged that "it is quite a novelty to find anything I have given to the Art Institute that is not questionable"—despite the fact that she tried to

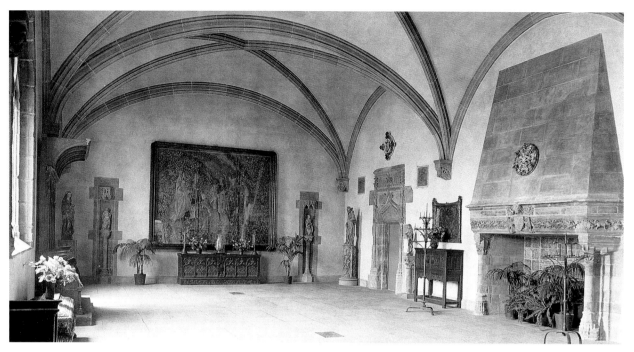

FIGURE 8. The Lucy Maud Buckingham Memorial Gothic Room, c. 1924

have her purchases examined by the best "experts" (a word she placed in quotation marks) she could find.[30] In the end, however, she did leave behind a lasting legacy that helped fund another brilliant phase of medieval collecting in the 1940s.

During the 1920s, while Kate Buckingham was engrossed in her Gothic room venture, Marion Deering McCormick also became keenly interested in continuing the Antiquarian tradition of acquiring choice medieval objects. She served on the society's board (as her mother had also done) beginning in 1921, acting as president from 1927 to 1931. McCormick's strong commitment to the Art Institute and her appreciation of medieval art were apparently inherited from her father, Charles Deering, who championed great Spanish art from the medieval to the modern. In 1928 he donated the Ayala Altarpiece (cat. 36), while two other works formerly in his collection—a retable and altar frontal from the Cathedral of Burgo de Osma (cat. 48) and Bernat Martorell's *Saint George Killing the Dragon* (cat. 54)—were bequeathed to the museum by Mrs. McCormick and her sister, Barbara Deering Danielson, in 1927 and 1933, respectively. Together with her husband, Chauncey, Marion McCormick wielded

great influence in shaping the museum's continued growth and was instrumental in securing a number of special exhibitions, including several related to medieval art.[31]

Most influential, however, was her work in bringing the blockbuster Guelph Treasure exhibition to Chicago in 1931. This amazingly intact medieval treasure included eighty-two ecclesiastical objects that ranged in date from the eleventh to the late fifteenth century. Their extraordinary artistic and historical importance was matched by their impeccable provenance. The collection had been housed in the Cathedral of Saint Blaise in Brunswick, Germany, until the Reformation, when it was safeguarded by the ducal house in various locations.[32] Following World War I, the family sold the treasure, for an estimated sum of five million dollars, to a consortium headed by Julius F. Goldschmidt, an influential Berlin dealer.

This group decided to sell the treasure piece by piece, and William M. Milliken of the Cleveland Museum of Art stepped forward as one of the first buyers. Traveling to Berlin with $200,000, he returned triumphantly with six of the earliest and most important pieces, immediately increasing the prestige of his institution and exciting American museums, collectors, and the press. The pur-

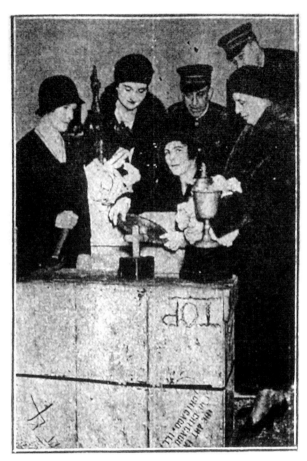

FIGURE 9. Protected by armed guards, Antiquarian Society members Mrs. Joseph Medill Patterson, Mrs. Bruce Borland, Mrs. Waller Borden, and Mrs. Parmalee McFadden unpack the Guelph Treasure, on display at the Art Institute from March 31 to April 20, 1931. Published in the *Chicago Evening Post*, March 28, 1931. Courtesy Chicago Historical Society.

chase also encouraged Goldschmidt and his partners, who placed the treasure on display at the Goldschmidt and Reinhardt Galleries in New York in late 1930.[33] From there the exhibition traveled to Cleveland, where it broke all attendance records: over 2,500 people attended the invitation-only opening and another 8,000 to 10,000 thronged the museum the following day. It later went on to the Detroit Institute of Arts, the Pennsylvania Museum of Art in Philadelphia, the Art Institute of Chicago, and the M. H. de Young Memorial Museum in San Francisco. By the end of the tour half the objects had been sold; those that remained were returned to Germany, where they entered the collection of the Kunstgewerbemuseum, Berlin, in 1935.[34]

On view in Chicago in March and April 1931, the Guelph Treasure received lavish praise in the local press and drew record crowds to the Art Institute. In anticipation the museum took extraordinary precautions, instituting a substantial patrol system that included plainclothes security guards and watchdogs. The Antiquarians basked in the glory of their special role as hostesses on this important occasion and were featured in various newspaper reports (see fig. 9). One photo from the society section of the *Chicago Tribune* (fig. 10) shows Marion McCormick proudly displaying one object she bought from the treasure: a pyx, or casket used to hold the consecrated Host. The Ayala Altarpiece, formerly her father's, provides a fitting backdrop to the scene. Mrs. McCormick also bought three other pieces and persuaded the Antiquarians to purchase a silver processional cross.[35] Kate Buckingham also secured three items from the exhibition, which were bequeathed to the museum following her death in 1938. These were to be the last great acquisitions of medieval art the Antiquarians made. In 1939 Art Institute director Daniel Catton Rich suggested that the society help address gaps in the museum's collection, particularly in Romanesque, Gothic, and Italian Renaissance art. The group opted for the last, as the "costliness of the other two was too prohibitive"—a decision that makes the subsequent "rehabilitation" of the medieval collection seem all the more remarkable.[36]

In 1939 Rich named as curator of decorative arts Meyric Rogers, who hired Oswald Goetz as his associate curator of medieval and Renaissance art the following year. Both of these appointments were directly in keeping with the director's philosophy, which was to assemble a more professional museum staff.[37] Prior to his arrival in Chicago, Goetz had been a curator at the Städel-Museum in Frankfurt; he was one of a number of intellectual émigrés who were forced out of Germany by the National Socialists in the late 1930s.

One of Goetz's most pressing projects was the reassessment of the Buckingham Gothic Room. Three years after Kate Buckingham's death in 1937, Rich submitted a highly confidential report to the museum's trustees in which he reported on the "extensive and important collections" she had provided to the departments of Decorative

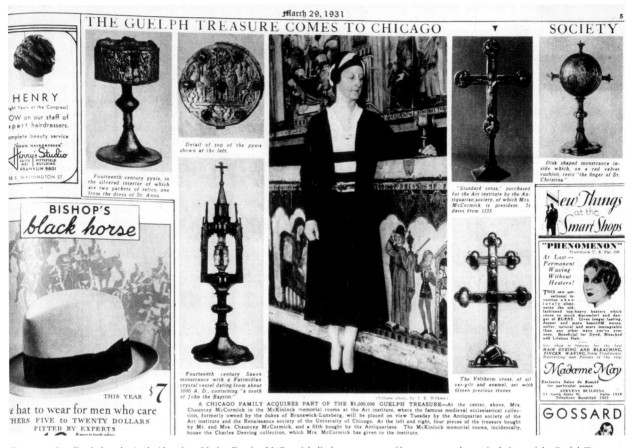

FIGURE 10. Standing before the Ayala Altarpiece, Marion Deering McCormick displays a pyx, one of her own, recently acquired pieces of the Guelph Treasure. Published in the *Chicago Tribune*, March 29, 1931. Courtesy Chicago Historical Society.

Arts, Oriental Art, and Prints and Drawings. In the document he offered suggestions for "replacements and revisions" in order to strengthen these collections and show them off to best advantage.[38] Damning in his assessments, the director proved what Buckingham herself had come to accept, that "many objects in the Jacobean and Gothic room are spurious." In the end, he suggested a dramatic transformation of both these galleries to bring them up to museum standards.

Meanwhile, the inauguration of a new Buckingham endowment for acquisitions allowed Goetz to take full advantage of a special window of opportunity that existed in the 1940s. During this turbulent period, extraordinary pieces were spirited out of Europe and became available for purchase in the United States. A number of these objects, many of them medieval enamels, were in the possession of an heir to the German-Jewish industri-

alist Harry Fuld. Both Goetz and his friend Georg Swarzenski, a former colleague at the Städel-Museum who had relocated to the Museum of Fine Arts, Boston, made purchases from the "Mayer-Fuld" collection during the 1940s. Goetz, for example, was able to acquire several reliquary fragments, including a superb plaque of a bishop (cat. 12), an intact Limoges *châsse* (cat. 20), and a Spanish reliquary casket of saints Adrian and Natalia (cat. 11).[39]

Later in the same decade, Goetz was also able to buy several of the Art Institute's most noteworthy medieval pieces from the collection of Dr. Jacob Hirsch, a fellow European émigré then living in New York. One of these is a Romanesque illuminated manuscript leaf from Weingarten Abbey in southern Germany (cat. 15). Two others have rather romantic—and unverifiable—provenance histories. The head of an apostle from Notre-Dame

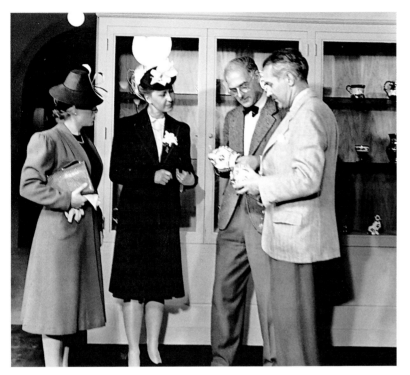

FIGURE II. Curators Oswald Goetz and Meyric Rogers with unidentified museum patrons, c. 1945.

theless. Arriving in 1957, for instance, was a leaf from an illuminated manuscript by the Maître François (cat. 52); that same year, the museum played host to *Treasures from the Pierpont Morgan Library*, an exhibition celebrating that renowned institution's fiftieth anniversary.[43] During the rest of Rich's tenure, the Art Institute received the important gift of the Charles H. and Mary F. S. Worcester Collection, which the director had helped to form. Particularly rich in Italian and German painting, the grouping included two fine International Gothic–style panels (cats. 50–51).[44] In the 1950s, Mrs. Chauncey Borland donated a number of impressive textiles, among them the fragment of Doña Leonora's mantle (cat. 8) and an Italian silk panel (cat. 21). Christa C. Mayer Thurman, curator of textiles since 1967, has acquired other excellent examples such as a Florentine orphrey band (cat. 29), an *Opus anglicanum* fragment (cat. 34), and a Bohemian or South German orphrey band (cat. 53).

Cathedral (cat. 18) was supposedly excavated in 1852 during Baron Haussmann's reconstruction of Paris, and the German Man of Sorrows woodcut (cat. 55) apparently rescued from London's rubble following the Blitz.[40] Another prized possession, a reliquary bust of Saint Margaret (cat. 56), was discovered by Goetz at Gimbel Brothers department store in New York.[41]

By 1945 Goetz and Rogers had completed their work on the medieval collection, "revising" the galleries and publishing a catalogue to showcase new acquisitions.[42] Of the sixty-six objects included in that book only eighteen predated Goetz's tenure at the museum. In their preface, the curators boasted that they had assembled "one of the best and most complete small surveys of medieval art in the United States"—and indeed they had. For his part, Rich praised the "forward-looking" Buckingham for collecting in this "uncommon field" and for providing "generous bequest funds" that allowed Goetz to improve upon her work with such spectacular results.

Although great medieval works became increasingly hard to find in the decades that followed, a number of noteworthy items entered the Art Institute's collection none-

In 1982 the Harding Collection was permanently transferred to the Art Institute, where it was placed under the care of the Department of Decorative Arts and Sculpture, and Ancient Art. The man who assembled it, George F. Harding, was a local politician who built a grand, castlelike home on the city's South Side to house his eclectic assortment of medieval, medieval revival, and American art. Among these possessions were carved alabasters, armor, and stained glass from the Middle Ages.[45] In the 1990s, a generous gift of Renaissance jewelry from the collection of James and Marilynn B. Alsdorf included a French pendant with the head of Saint John the Baptist (cat. 47).[46]

This issue of *Museum Studies* and the exhibition that accompanies it afford an exciting opportunity to revisit the Art Institute's medieval holdings—now divided among different curatorial departments—and to view their strengths across a variety of media. They also allow

us to explore the work of the visionaries, both amateur and professional, who were able to build such an impressive collection of works even as they faced stiff competition from many other museums and collectors. Our future plans include a multimedia, interdepartmental reinstallation that will ensure that their legacy continues and that new generations of scholars, students, and the public will be informed and inspired by these rich, rare objects.

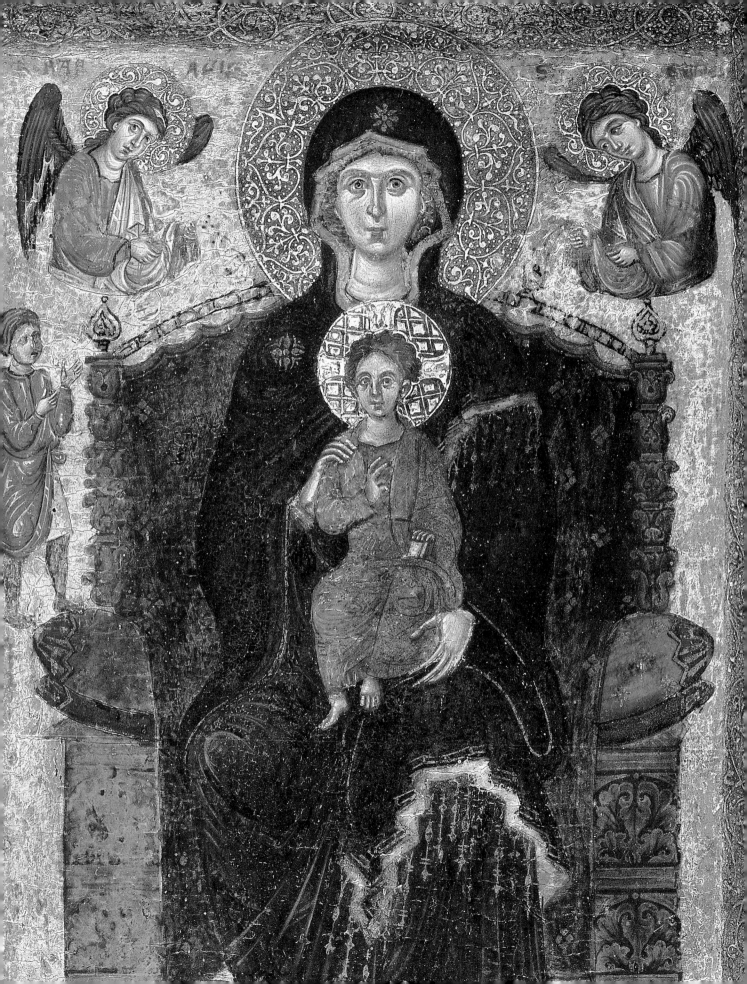

# Western Europe, Byzantium, and the Islamic World

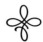

Medieval society was a highly mobile one in many respects, with large numbers of people traversing continents in search of fortune, glory, and salvation. From migrating hordes and plunderers to individual pilgrims, from mendicant preachers to merchants such as Marco Polo, travelers carried with them ideas, objects, and artistic styles. In contrast to this issue's other sections, which follow a chronological arrangement, this group of works celebrates the artistic and intellectual exchanges that took place between diverse cultures throughout the Middle Ages.

At times, Christians in Western Europe, guided by the pope in Rome, and Christians in the Byzantine Empire, who were headed by the patriarch of Constantinople, profited from peaceful alliances with one another. At other moments, however, the groups' interactions were fraught with tension. For example, the two factions fundamentally disagreed about the proper role of images in religious worship. In 787 the Church Council of Nicaea (now Iznik, Turkey) decreed that images were worthy of veneration; meanwhile, in the West, theologians at the court of Charlemagne denounced these declarations. Profound ideological differences such as these eventually led to an official schism between the Western and Byzantine churches in 1054. 150 years later, enmity between the two sides had grown so profound that European Crusaders heading to the Holy Land plundered Constantinople, forcing the Byzantine emperor into exile and looting the city's artistic masterpieces to fill the treasuries of their own churches.

From the early seventh century onward, the rise of Islam—which eventually spread from the Arabian Peninsula through the Middle East, across North Africa, and into southern Spain—presented Christians in both Western Europe and Byzantium with yet a different set of political and spiritual challenges. It also had a great impact on European art. Although the Qur'an contains no direct prohibition against the use of images, various parties within Islam held strong iconoclastic views and eschewed the representation of figures within holy sites; for this reason, calligraphic script and other decorative motifs dominated Islamic art. Christian clients appreciated the talents of Muslim artisans throughout the Middle Ages, particularly in places such as Sicily, Spain, and the Holy Land, where the two cultures came into contact most closely.

Opposite: Cat. 1 (detail).

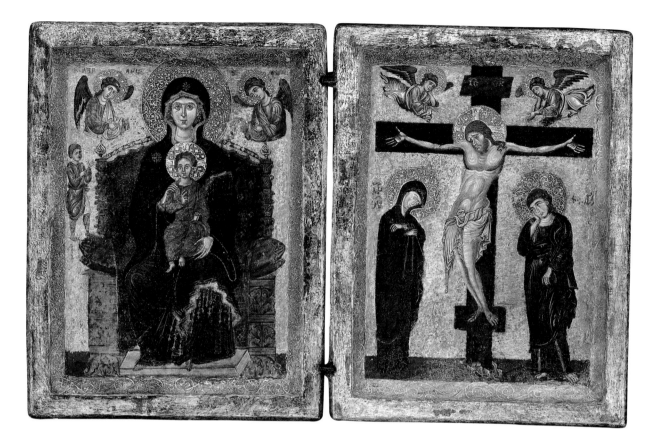

## 1. *Virgin and Child Enthroned with the Archangels Raphael and Gabriel, Christ on the Cross between the Virgin and Saint John the Evangelist*

1275/85
Latin Kingdom (1244–91), probably Acre
Tempera and gold leaf on panel; left wing: 38 x 29.5 cm
(14⁵/₁₆ x 11⁵/₈ in.); right wing: 38 x 29.5 cm (14¹⁵/₁₆ x 11⁵/₈ in.)
Inscriptions: left wing: at upper left, *S. RAPAEL*, at upper right,
*S. GABRIEL*, vertical, at center left, *FL*; right wing: on the
cross, *IC CR* (Jesus Christ), at center left, $\overline{MP}$ $\overline{OY}$ (Mother of
God), at center right, *Ṣ* (possibly Saint John the Theologian)
Mr. and Mrs. Martin A. Ryerson Collection, 1933.1035

THIS DIPTYCH, A MODEST, PORTABLE painting probably
intended for private devotion, was likely created in a so-
called Crusader atelier in the port city of Acre, located at
the northern edge of Haifa Bay.¹ Following the decisive
Muslim capture of Jerusalem in 1244, the town became

the capital and cultural center of the Latin Kingdom (the
Christian territory in the Holy Land), a status it held
until its own fall to the Muslims in 1291. In its style and
technique this work is very similar to illuminated manu-
scripts produced in Acre, notably the Arsenal Bible
(1250/54; Bibliothèque de l'Arsenal, Paris) and the Perugia
Missal (1250/75; Museo Capitolare di San Lorenzo,
Perugia).² For example, the gilt-plaster relief decoration
of the halos and frames, called *pastiglia*, is found on icons
usually attributed to Acre painters held in the Monastery
of Saint Catherine in the Sinai.³ Likewise, the diptych's
distinctly Italianate details, such as the Virgin's red
snood, or head cloth, and the face of the crucified Christ,
suggest that it was executed either by an Italian-trained
artist active in Acre or by a painter working in Italy who
had his instruction in Acre.⁴ In either case, it captures the
artistic cross-fertilization of the Latin Kingdom, where
painters of Western and Eastern origins practiced their
craft in close proximity.

The work has a religious iconography that is no less hybrid. The left wing features an imposing, victorious Virgin *Nikopeia* who is venerated by a small donor figure, also in the Byzantine style. The elegant, swayed Christ on the right wing, meanwhile, resembles the type of suffering *Christus patiens* that appears in the work of Giunta Pisano, the master who dominated the Pisan school in the second quarter of the thirteenth century and seems to have exerted considerable influence on Acre's artistic community.[5] Like their visual language, the panels' written inscriptions involve an intermixing of the Greek and the Latin.

Theologically, by juxtaposing a scene of the Virgin and Child with one of the Crucifixion, the donor and artist meant to stress the Virgin's foreknowledge of the Crucifixion and the connection between the body of Christ and the Eucharist.

L.J.F.

## 2. *Siculo-Arabic Casket*

1200/25
Sicily
Ivory, brass, tempera, and gold leaf; 15.9 x 10.3 cm (6 ¼ x 4 ¹⁄₁₆ in.)
Samuel P. Avery Endowment, 1926.389

THIS TYPE OF BOX IS one of a group of ornately painted ivory caskets that survive in relatively large numbers in church treasuries, where they serve as reliquaries. Judging from their Arabic inscriptions, which contain wishes for happiness, blessings, or glory, it seems most likely that many of them were originally intended for secular use as wedding gifts and jewelry boxes. On this example, traces of an inscription reading "May glory endure" remain on the front rim and cover.[1]

Sicily is a likely place of origin for such works, and the largest number of them can be found in the treasury at Palermo.[2] The island, situated at the crossroads of Mediterranean trade, was controlled during the Middle Ages by a succession of rulers—pagan, Byzantine Christ-

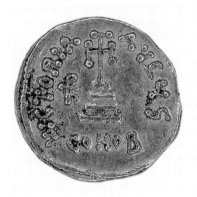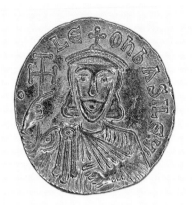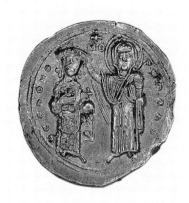

ian, Muslim, and Roman Christian. The Normans first entered Sicily as mercenaries in the early eleventh century, ultimately invading Palermo and deposing the Muslim emirs, who had governed as vassals of the Fatimid caliphs in Cairo for more than 150 years. A large Islamic population remained on the island, and this confluence of cultures naturally led to the exchange of artistic styles. Surely the grandest example of this aesthetic mixing can be found at the Capella Palatina in Palermo (1140), which boasts Byzantine-style mosaics, a Western basilica plan, and an ornate Islamic *muqarnas*, or stalactite ceiling. In fact, the painted decoration on that carved wooden ceiling, with its arabesques, rosettes, and benedictory inscriptions, is very similar to that on caskets such as this one.

The style of the casket betrays a heavy Islamic influence. Here, the painted ornament includes a gazelle, peacocks, and medallions that encircle arabesque designs; small birds, cheetahs, rosettes, and another peacock are visible in the field. To achieve these, craftsmen sketched outlines in black pigment and then filled them in with colors including ultramarine blue, malachite green, and vermilion red. Gold, in both liquid and leaf form, played the most important role in this refined manner of decoration. Unfortunately, age and wear have muted the brilliance of these designs to the point where only the original contours are still visible.

C.M.N.

## 3. *Solidus of Heraclius*

636/37?
Constantinople
Gold; diam. 2 cm (3/4 in.)
Obverse: Heraclius flanked by his two sons, Heraclius Constantine and Heraclonas, all front, holding globes
Reverse: Greek cross on three steps; below, **CONOB** (Gold of the standard of Constantinople); around, **VICTORIA AV** (Victory to Augustus)
Gift of Mrs. Emily Crane Chadbourne, 1940.14

## 4. *Solidus of Leo V, the Armenian*

813/20
Constantinople
Gold; diam. 2 cm (3/4 in.)
Obverse: Bust of Leo V, front, holding cross; above, **LE ONbASILEЧS** (King Leo)
Reverse: Bust, front, holding globe; around, **CONSƮ ANƮˊDESP′** (Despot Constantine)
Gift of Mrs. Emily Crane Chadbourne, 1940.22

## 5. *Nomisma of Romanus III Argyrus*

1028/34
Constantinople
Gold; diam. 2 ½ cm (1 in.)
Obverse: Christ in Majesty; around, **+IhSXPSREX REGNANTIhM** (Jesus Christ, King of Kings)
Reverse: Romanus standing, front, with globe, Virgin nimbate crowns emperor with right hand, at right, front; around, **ΘKЄbOHΘ′ RШMΛNꞶ** (Mother of God, aid Romanus); between figures, **M̄Θ̄** (Mother of God)
Gift of Mrs. Emily Crane Chadbourne, 1940.25

COINS WERE AN IDEAL WAY for Byzantine emperors to circulate their images throughout the empire and even beyond, since they were used to pay for imported merchandise and to remunerate foreign mercenaries. As these examples demonstrate, they could also be employed as powerful vehicles for propaganda, promoting dynastic succession and emphasizing the close relationship between earthly and heavenly monarchs.

A gold solidus (cat. 3) from the reign of Heraclius (610–41) fulfilled both of these political objectives. On the obverse of the coin, the ruler appears flanked by his two sons, Heraclius Constantine and Heraclonas, also called Constantine.[1] The reverse, pictured here, links the emperor and his sons to Christ, whose presence is symbolized by four steps surmounted by a cross. This image, also used on a glass pilgrimage jug of the same date (cat. 6), represents a large cross that was erected in the fourth century on the site of Christ's crucifixion in Jerusalem.

This motif of a cross and steps first appeared on the coins of Tiberius II (r. 578–82) and its increasing popularity reflected the progressive Christianizing of imperial iconography, in which symbols such as the cross came to replace pagan elements like winged Victories. This coin's reference to Jerusalem only begins to suggest the city's prized status: it was conquered by the Persians in 614 but recaptured by Heraclius in 620. This coin, minted in 636/37, would therefore have held great significance for Heraclius's reclamation of Jerusalem; ironically, one year later the city would be lost again to Arabs spreading the new religion of Islam.

Another solidus (cat. 4) features Leo V (r. 813–20) on the obverse, pictured here. The reverse depicts his son Constantine, who bears the title of "despot," indicating that he was to succeed his father as emperor.[2] Although Leo holds a small cross, Christian imagery is downplayed on this coin; this is unsurprising given the emperor's stance as a staunch Iconoclast. From the mid-eighth to mid-ninth century, the Byzantine Empire was divided by a fierce controversy surrounding the appropriate role of imagery in religious worship. Iconoclasts (from the Greek, *eikon*, or image, and *klao*, to break) argued for the suppression of sacred art that could be misunderstood by a credulous populace.

The gold nomisma (cat. 5) from the short reign of Romanus III (1028–34), however, shares none of its companion's iconoclastic characteristics.[3] While the obverse shows Christ in Majesty with the inscription "King of Kings," the reverse, shown here, displays the coronation of Romanus III by the Virgin Mary herself. This highly symbolic image, in which the emperor is crowned by a heavenly figure, is similar to those found on well-known Byzantine monuments, including an ivory plaque with Christ crowning Romanus I and the empress Eudokia (944/49; Cabinet des médailles, Bibliothèque nationale, Paris).[4]

C.M.N.

## 6. *Pilgrimage Jug with Christian Symbols*

578/636
Jerusalem
Mold-blown glass with applied handle and tooled rim;
h. 15 cm (5 ⅞ in.)
Gift of Theodore W. and Frances S. Robinson, 1947.958

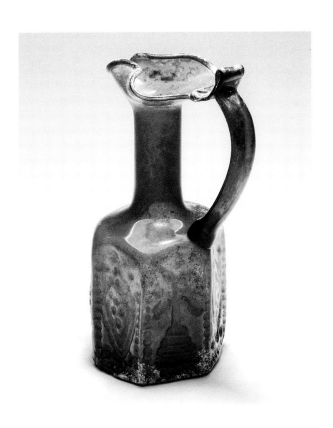

THIS HEXAGONAL JUG BELONGS TO a wide range of late antique objects made for the pilgrimage trade, including amulets, jewelry, and terracotta lamps.[1] Glass objects were more expensive than their earthenware counterparts but inherently less valuable than those made of precious metals. Glass workshops, which were situated outside the city walls of Jerusalem, produced such vessels for a clientele that included both Jews and Christians. The former selected designs impressed with menorahs, shofars (ram's-horn trumpets), and other religious images, while the latter could choose from jugs adorned with crosses, fish, peacocks, and saints.

Three sides of this small pitcher feature representations of a monumental, gem-encrusted cross that was erected on the rock of Golgotha, the site of Christ's crucifixion, in the fourth century—the point at which Christianity became officially sanctioned within the Roman Empire. This very same image appears on a contemporaneous coin of the Byzantine emperor Heraclius (cat. 3), a coincidence that reveals the extent to which the cross had come to serve as an icon of Jerusalem itself. Sixth-century pilgrims described steps leading up to the site from the Church of the Holy Sepulchre, and it appears likely that this jug was intended to hold oils procured there.[2]

C.M.N.

## 7. *Fragment with Nasrid Coat of Arms*

c. 1400

Spain, Andalucía

Silk and gilt-animal-substrate-wrapped silk, warp-float-faced 4:1 satin weave with plain interlacings of secondary binding warps and supplementary patterning wefts; 42 x 19.7 cm (16 ½ x 7 ¾ in.)

Restricted gift of Mrs. Edwin A. Seipp, 1950.1149

THE NASRID DYNASTY RULED THE kingdom of Granada in southern Spain for nearly two and a half centuries (c. 1250–1500) and was the last major Muslim dynasty on the Iberian Peninsula. While the Nasrids alternated between war and uneasy armistice with Christians to the north, they forged tentative alliances with their Muslim neighbors in North Africa. Despite this rather turbulent

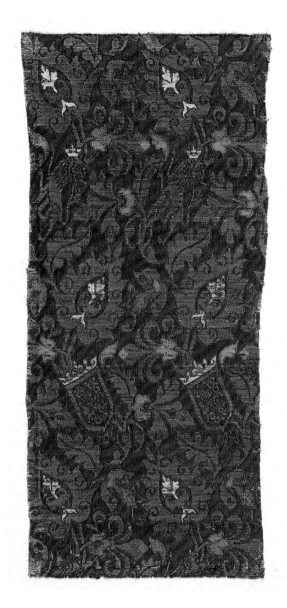

political climate, the court at Granada played host to the great scholars and artists of the day. The royal chancery directed architecture and ornament while poet-viziers bequeathed beautiful literary works to posterity. The single most impressive monument of Nasrid rule is Granada's Alhambra, or "red castle," which boasts spectacularly intricate interiors and magnificent courtyards with gardens and fountains.

Along with another silk fragment in the Art Institute's collection (cat. 8), this example testifies to the refinement of the textile arts in Islamic Spain.[1] Silk, long

recognized as the richest and finest fiber to be woven into cloth, is fashioned here in a floral pattern featuring prancing lions and an alternating shield-and-pomegranate motif. These shields bear the Nasrid coat of arms with a Kufic inscription declaring "Glory to Our Lord the Sultan." This text, as well as the crowns adorning the shields and lions, indicates that the fabric was used by members of the royal house. Other fragments from the same textile are preserved in museums in Barcelona, Brussels, London, and Madrid.[2]

C.M.N.

## 8. *Fragment of Doña Leonora's Mantle*

1275/1300

Spain, Andalucía

Silk and gilt-animal-substrate-wrapped silk, bands of weft-faced plain weave with inner warps and bands of two-, three-, and four-color complementary wefts, weft-faced plain weave with inner warps

33.9 x 12.1 cm (13 3/8 x 4 3/4 in.)

Restricted gift of Mrs. Chauncey B. Borland, 1950.1150

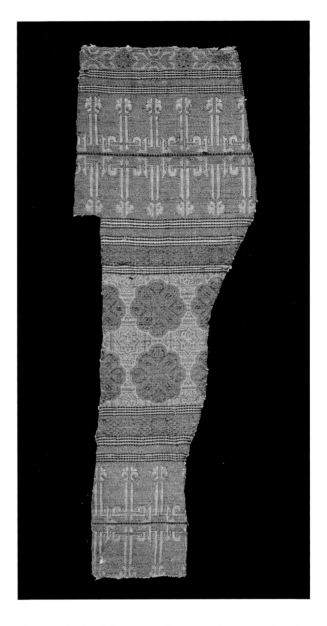

LUXURY TEXTILES PRODUCED IN ISLAMIC Andalucía were so highly valued by Christians living in northern Spain—and indeed throughout Europe as a whole—that they were sought by the nobility and worn not only in life but also in death. Such was the case with this woven silk fragment, found in the tomb of Doña Leonora Ruiz de Castro, wife of Don Felipe, son of King Ferdinand II of Léon and Castile (r. 1217–52).[1] The couple was buried together at Villacazar de Sirga in Palencia province, their tombs set on either side of the main altar in the sanctuary of a fortress-temple dedicated to the Virgin Mary. The miraculous powers of Our Lady of Villasirga are recorded in the *Cantigas de Santa Maria*, a collection of songs attributed to King Alfonso X the Learned (r. 1252–84), Don Felipe's brother. These works were written in Galician, a Romance language, but utilized the *zajal*, a poetic form of Hispano-Arabic origin.

Such cultural hybridity reflects the temper of Alfonso's lively court, in which Christians, Jews, and Muslims were active participants. Despite this climate of interchange, Christian armies fought to expand their domain during his reign and were only stopped at the border of the Islamic kingdom of Granada. Involved in his own protracted battle with Alfonso, in 1272 Don Felipe offered his services to Muhammad I, head of the Nasrid dynasty (see cat. 7). One year later, he and his men fought for Muhammad II, and documentary evidence suggests that they were richly rewarded with horses, weapons, and clothing, which perhaps included the splendid mantle from which this fragment survives.

The brocaded silk fragment, possibly woven in the province of Granada, bears an elegant geometric design

further enriched with gold thread. Framing a band of circular medallions are two rows of an inscription in Kufic, a stylized Arabic script. The text repeats the word *baraka* (blessing). The exotic origin of silk, the most precious of natural fibers, further underscores this garment's international characteristics. According to legend, Byzantine monks carried silkworms from China to Constantinople in hollow walking sticks; with the spread of Islam, sericulture was transported to the Middle East and North Africa and, in 710, to the Iberian Peninsula.

C.M.N.

## 9. *Hispano-Moresque Lusterware Plate*

1475/1500
Spain, Valencia
Luster-glazed ceramic; diam. 44.8 cm (17 ⅝ in.)
Mr. and Mrs. Martin A. Ryerson Collection, 1937.842

THE ISLAMIC CRAFTSMEN OF Andalucía, in southern Spain, excelled in the production of luxury ceramics as well as rich textiles (see cats. 7–8). The famous lusterware from the coastal town of Málaga was originally made for the Nasrid nobility but soon became especially appreciated abroad.[1] In 1289, for example, Eleanor of Castile, wife of King Edward I of England, ordered more than fifty pieces.

By the mid-thirteenth century, some of these artisans migrated from Andalucía to the prosperous Christian kingdoms in the north of Spain, particularly to the town of Manises, near the port of Valencia.[2] There they plied their trade, creating a golden pottery that was striking in appearance and prized both for its opulent elegance and practical utility. Large dishes such as this one were used for carrying food

during feasts but also served as impressive decorative objects when displayed on sideboards. Their glittering appearance appealed to aristocratic users during the fifteenth century, when gold was in short supply.

The most common motif on Hispano-Moresque pottery is a Christian coat of arms surrounded by Moorish ornament. While such items were often ordered to commemorate marriages, the crest on this plate cannot been attributed to a particular family. Its rampant griffin, a heraldic device that recalls the lions on the Art Institute's Nasrid textile (cat. 7), is framed by a dot-and-stalk pattern that resembles a stylized Arabic script; the plate is divided into eighteen compartments by raised, petal-like ribs.

C.M.N.

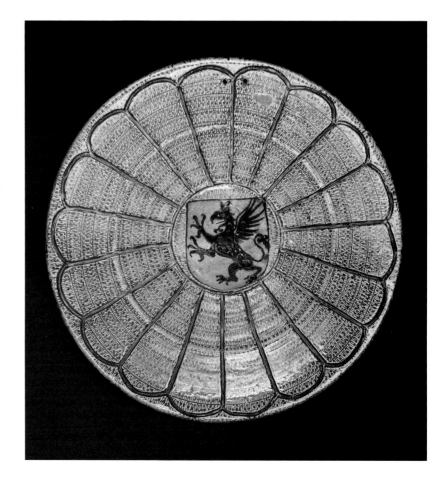

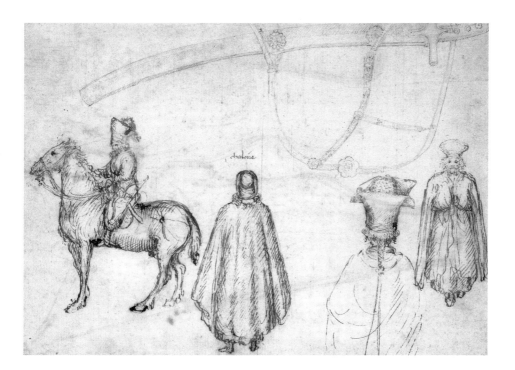

## 10. *Sketches of the Emperor John* VIII *Paleologus, a Monk, and a Scabbard*

1438
Antonio Pisano, called Pisanello
(Italian, c. 1395–c. 1455)
Pen and brown ink on ivory laid paper; 18.9 x 26.5 cm
(7 7/16 x 10 7/16 in.) max.
Inscription: at center, in pen and brown ink, *chaloîre* (monk)
Margaret Day Blake Collection, 1961.331

A RARE TREASURE FOR AN American collection, this is a pivotal sheet in the early history of drawing, created by a man considered "without a doubt the greatest early Renaissance artist to have hailed from northern Italy."[1] Documenting the regalia of the Emperor John VIII Paleologus (r. 1423–48) and his retinue, it is an eyewitness account of the Council of Ferrara and Florence in 1438. The council was convened by Pope Eugenius IV in 1437 in an attempt to unify the Western and Eastern branches of the Christian church. On the recto of this sheet, shown here, John VIII, the second-to-last Byzantine monarch, appears astride a horse at left, exotically dressed and holding a bow and scabbard. In the center, a Greek ecclesiastic is identified by a word best

transcribed as *chaloîre* (a phonetic variation on the Greek *kalogeros*, or monk). On the right, seen from behind, is a figure in a tall hat that may portray the emperor in a different exotic garment, which he would have worn to suggest the rich variety and splendor of the Islamic cultures under his rule.[2] The belt, bow, bow case, leather-sheathed saber, and quiver that appear on both sides of the sheet depict the ruler's hunting gear, which was of Mamlûk or Ottoman origin.[3]

Two distinct styles of draftsmanship are evident on the sheet, testifying to different modes and uses of drawing and distinct stages in the creative process. On the one hand, the weapons are executed in the meticulous style of medieval model books. Exquisitely rendered, these volumes offered large, precise examples that artists could copy and employ in paintings of the elegant, ornamental International Gothic style from which Pisanello's work emerged. Newer and more exciting is the spontaneous, slightly messy quality of the smaller figure studies, which the artist drew from life. All at once, his hasty line captures movement, documents the costumes of the emperor's entourage, conveys the excitement of the occasion, and breaks into a new epoch of art as experience.
S.F.M.

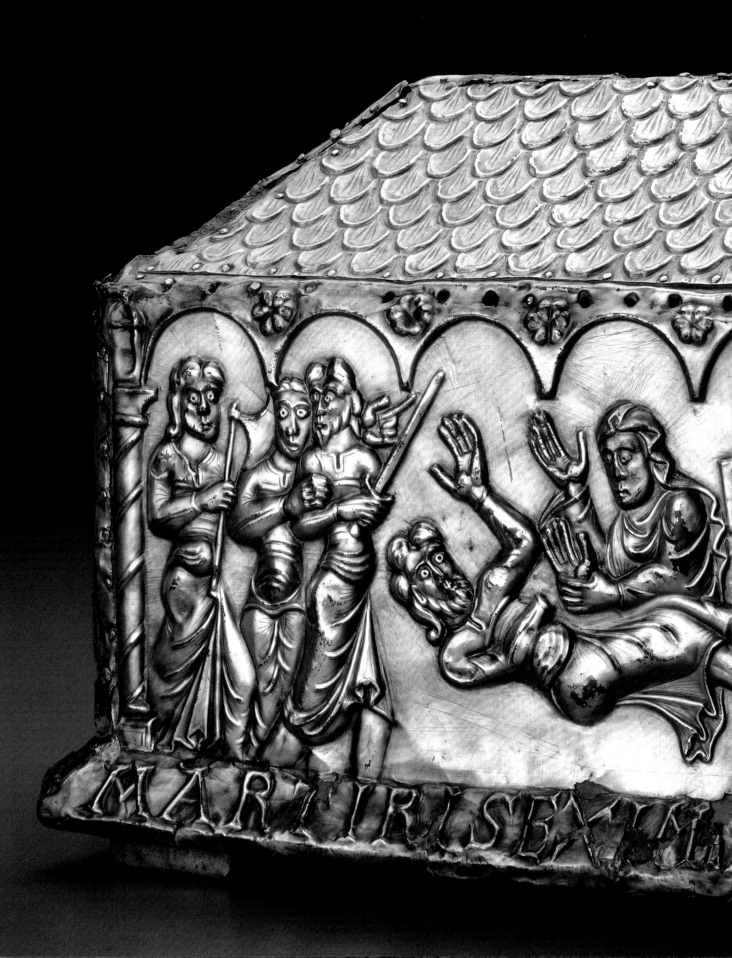

# THE TWELFTH CENTURY

Throughout the twelfth century, great monasteries were at the center of intellectual and artistic life in Europe. At the beginning of the 1100s, the economy was overwhelmingly agrarian and depended upon the feudal system, in which aristocratic landowners oversaw vast estates. By the end of the century, however, feudalism began to give way as trade and industry were regenerated through the Crusades and pilgrimage, both of which were encouraged by the papacy and by the powerful religious orders whose influence transcended geographic, political, and social boundaries. While some pilgrims traveled to Jerusalem and Rome, many others followed the routes leading to the shrine of Saint James at Santiago de Compostela in northwest Spain, greatly enriching the ecclesiastical sites along the way. Other important religious houses, such as the great Benedictine abbey of Cluny in Burgundy, originally enjoyed the bountiful support of regional patrons. Soon, however, monks became adept land managers in their own right, overseeing large holdings that generated great wealth. With this, they were able to devote themselves more fully to perfecting the art and music that accompanied the performance of religious services.

This age of monasteries gave rise to an international aesthetic with distinct regional variations, a style that modern art historians have long referred to as "Romanesque." This term was first applied to architecture from the tenth to twelfth century but was subsequently used to describe other works of art. While Romanesque buildings are known for their rounded arches (as opposed to the pointed arches of the later Gothic), a geometrical articulation of mass and space is also readily visible in other media, including sculpture and painting.

Not surprisingly, a number of twelfth-century texts chronicle contemporary artistic achievements. In one famous example the Abbot Suger of Saint-Denis, near Paris, reveled in the details of his campaign to enlarge his church and outfit it splendidly. In another contemporary treatise, a monk calling himself "Theophilus" provided detailed recipes for producing works of art in various media, from enamel and glass to gold and silver. Yet not everyone in the twelfth century was as pleased with this outpouring of creativity at monastic centers. In one invective, Bernard of Clairvaux, a member of the ascetic Cistercian order, questioned the spiritual qualities of these "costly polishings" and "curious carvings" even as he inadvertently invoked their beauty:

> We see candelabra standing like trees of massive bronze, fashioned with marvelous subtlety of art, and glistening no less brightly with gems than with the lights they carry. What, think you, is the purpose of all this? The compunction of penitents, or the admiration of beholders? O vanity of vanities, yet no more vain than insane![1]

Opposite: Cat. 11 (detail).

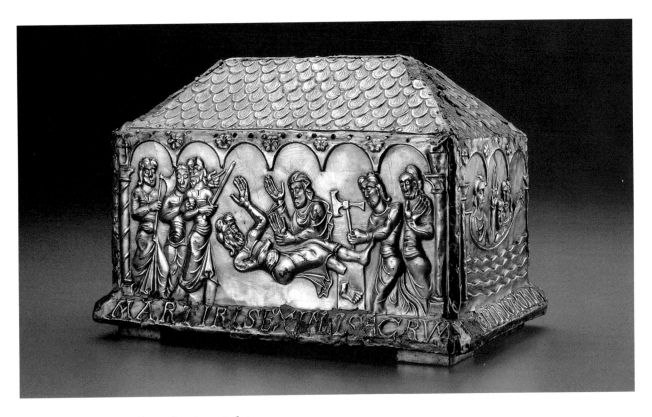

## 11. *Reliquary Casket of Saints Adrian and Natalia*

12th century
Spain, Léon
Silver and oak core; 15.9 x 25.4 x 14.5 cm (6 ¼ x 10 x 5 ¾ in.)
Inscriptions: *MARTIRIS EXIMINI SACRUM* (Sacred [relic] of
the exalted martyr); *QUI MARTIR FACTUS SPREVIT EUM*
([Adrian] was made a martyr, [Natalia] removed him);
*[JA]CET HIC ADRIAN* (Here lies Adrian)
Kate S. Buckingham Endowment, 1943.65

THIS RELIQUARY SHRINE REPRESENTS THE gruesome martyrdom of Saint Adrian.[1] According to legend, Adrian was a Roman imperial officer in Nicomedia, now Izmit, Turkey.[2] It was there, in the year 304, that he witnessed the bravery of a group of Christians who were being brutally beaten. Impressed by their valor, he decided to convert—at that time, an action punishable by imprisonment and death. His wife, Natalia, already a secret Christian herself, visited Adrian in prison and then accompanied him to the executioner's block, where he was dismembered. Rescuing his severed hand, she managed to keep it from being burned with the rest of his body.

The cult of Saint Adrian, which had also come to incorporate Natalia, was introduced to the Iberian Peninsula in the seventh century and grew increasingly popular; eventually at least thirty-six religious sites counted him as their patron saint.[3] Recently scholars have pointed to one of these, the monastery of Saint Adrian de Boñar, as the place of origin for this shrine.[4] Located just east of Léon in northern Spain, the community enjoyed the patronage of the royal family, which included Count Gisvado and his wife, Leuvina. The couple had acquired relics in Rome and later offered them to the monastery, which they established in the year 920.

The version of Adrian's story portrayed on this casket, which is boldly worked in silver repoussé, begins and ends with the two small, end panels. On one side, visible here, we find Natalia and her companions in a boat on their way to Constantinople from Nicomedia; she safeguards the saint's hand, which dominates the center of the scene. This crucial episode, however, seems

almost secondary to the two larger images of Saint Adrian's martyrdom that appear on the sides of the shrine. In one, also illustrated here, he is attacked by guards who wield fearsome swords and axes, cutting off two of his extremities. Both Adrian and Natalia raise their arms in an impassioned gesture, drawing our attention to the severed hand at the heart of the composition. Below, the inscription *MARTIRIS EXIMINI SACRUM* (sacred [relic] of the exalted martyr) underscores the spiritual importance of the relics contained within.

Relics, the physical remains of a saint, held enormous spiritual importance for the specific places in which they were held.[5] Since relics were the metonymic embodiments of a holy person, it was believed that saints were living members of the community and could perform miracles on behalf of locals and visitors alike. It was also thought that, during the Second Coming, Christ would pull the saints up to their salvation first and that anyone buried near an altar containing a relic would naturally be next in line.

C.M.N.

## 12. *Plaque with Bishop*

1180/1210
Germany, Lower Rhine, Cologne, or Belgium, Meuse River Valley
Circle of Nicholas of Verdun (French, active 1181–1205)
Gilt copper and champlevé enamel; 15.2 x 6.4 cm (6 x 2 ½ in.)
Kate S. Buckingham Endowment, 1943.88

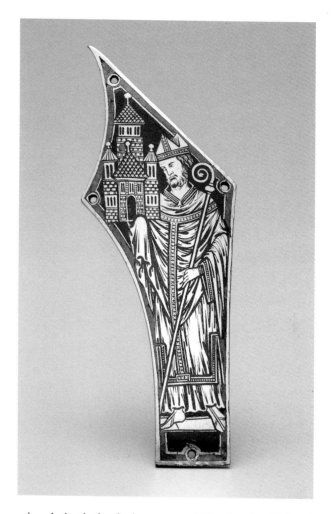

THE FINEST EXAMPLE OF MEDIEVAL enameling in the Art Institute's collection, this plaque was produced slightly later than the museum's three Mosan enamels (cats. 13–14). While those works represent ancient figures of authority such as Old Testament patriarchs and New Testament apostles, this one depicts a highly influential contemporary figure: a bishop.[1] Outfitted in episcopal finery, he proudly boasts the emblems of his rank, the mitre crowning his head and the crozier, or staff, in his left hand. Despite the bishop's great stature in medieval society, this scene still accords ultimate authority to the heavens. Bowing his head in a gesture of humility, he holds a model of a building in his right hand, symbolizing a church that he has had constructed. The fact that his hand is covered by cloth, however, indicates the sacred nature of this gift to God and highlights the metaphysical separation between humans and the divine.

This work most likely formed the right half of an arch on a reliquary shrine. Due to its refined style and the technical virtuosity of its construction, scholars have compared the piece to the enameled plaques of the famous Klosterneuburg retable of 1181, which bears the name of its artist, Nicholas of Verdun. It has also been suggested that this plaque depicts Archbishop Bruno of Cologne (921–965) holding a model of the Church of Saint Pantaleon in that city.[2] Whoever it might represent, the work offers an enduring, idealized impression of ecclesiastical power in all its influence and largesse.

C.M.N.

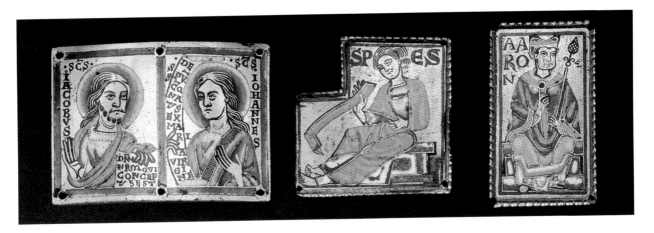

## 13. *Plaque with Saints James and John*

1160/80
Belgium, Meuse River Valley
Gilt copper and champlevé enamel; 5.1 x 5.6 cm (2 x 2 3/16 in.)
Inscriptions: *Saint James*: at left, *S[AN]C[TU]S IACOBUS*
(Saint James); at lower right, *D[OMI]N[U]M. N[OST]R[U]M.
QUI.CONCEPTUS EST* (Our Lord, who was conceived);
*Saint John*: at right, *S[AN]C[TU]S IOHANNES* (Saint John); at
left, *DE.SP[IRITU]. S[AN]C[T]O. NATUS.EX.MARIA.VIRGINE*
(of the Holy Spirit, born of the Virgin Mary)
Kate S. Buckingham Endowment, 1943.87

## 14. *Plaques with Hope and Aaron*

1175/1200
Belgium, Meuse River Valley, or Germany, Rhineland
Gilt copper and champlevé enamel; *Hope*: 5.4 x 5.4 cm
(2 1/8 x. 2 1/8 in.); *Aaron*: 6.2 x 3.7 cm (2 7/16 x 1 1/16 in.)
Inscriptions: *Hope*: at top, *SPES* (Hope); *Aaron*: at left,
*AARON*
Kate S. Buckingham Endowment, 1943.75–76

---

IN THE TWELFTH CENTURY, THE monastic workshops of
the Meuse River Valley and the Rhine region—which
included the churches and monasteries in the diocese of
Liège and in the cities of Aachen and Cologne—produced
a variety of sumptuous ecclesiastical objects. In addition
to illuminated manuscripts and carved ivories, they cre-
ated luxurious metalwork that often included jewel-toned
enameled plaques.[1] In his treatise *On Diverse Arts*, the
author, "Theophilus," offered instructions on how to pro-
duce any number of objects, from illuminated manuscripts

to metalwork, including enamels. He attributed the creative
ability of contemporary artists to nothing less than divine
guidance, likening their work to that of their biblical prede-
cessors. Of King David, he remarked: "By pious reflection
he had discerned that God delighted in embellishment of
this kind, the execution of which He assigned to the power
and guidance of the Holy Spirit, and he believed that noth-
ing of this kind could be endeavored without His inspira-
tion."[2] It is likely that other medieval viewers would also
have recognized God's hand in the making of splendid
pieces such as these.

On one, saints James and John are pictured with scrolls
containing lines from the Apostles' Creed, which describes
the central tenets of the Christian faith.[3] According to leg-
end, each apostle contributed a portion of the creed during
Pentecost, an event that took place fifty days after Christ's
Resurrection. On that occasion the Holy Spirit descended
upon the apostles as tongues of fire, giving them the
miraculous ability to speak in foreign languages so that
they could spread the word of God.[4] This plaque is related
to one in the Museum of Fine Arts, Boston, which features
saints Andrew and Philip, likewise holding scrolls with
lines from the creed. Together with other enamels featur-
ing the rest of the apostles, these were probably positioned
around the sides of a portable altar, now lost.[5]

The Art Institute's collection also contains two other
Mosan or Flemish enameled plaques, one depicting a per-
sonification of Hope, and the other Aaron, the first high
priest of the Jews and the brother of Moses and Miriam.
Although not from the same series, they display a similarly
refined craftsmanship and brilliant palette.

C.M.N.

## 15. *Mass of Saint Gregory*

From an illuminated manuscript
1181/1200
Southern Germany, Weingarten Abbey
Tempera on parchment; 29.8 x 23 cm
(11 ¾ x 9 ¹¹/₁₆ in.)
Kate S. Buckingham Endowment, 1944.704

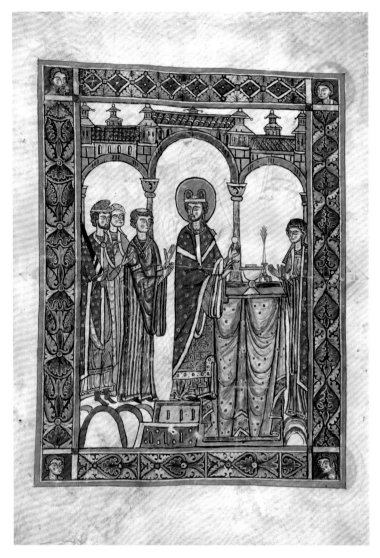

THIS DOUBLE-SIDED MANUSCRIPT LEAF is adorned with two archetypal images of Saint Gregory, a highly influential sixth-century pope who was also known as Gregory the Great. His writings, which include commentaries on several books of the Old Testament and *Pastoral Care*, a spiritual treatise for bishops and priests, were very popular during the early Middle Ages and could be found in monastic libraries throughout Europe. The recto of this leaf shows the saint in his role as author, working on a text as the Holy Spirit, appearing in the form of a dove, imparts divine inspiration by whispering in his ear.

The verso, seen here, boasts a unique and very early—quite possibly the first—representation of the Mass of Saint Gregory, a powerful evocation of Christ's presence at each celebration of the Mass.[1] The haloed saint appears at the center, holding the Host in one hand while pointing toward the chalice with the other. To the left stand three men, including an ecclesiastic and a member of the nobility, while a lone female watches beside the altar at the right. The latter figure is certainly the doubting matron mentioned in the *Life of Saint Gregory*, who did not trust that the bread and wine were truly transformed into the body and blood of Christ during the celebration of the Eucharist. After the saint asked for everyone's prayers that the woman might come to believe, there appeared miraculously upon the altar an object "that was like the fragment of a little finger covered with blood."[2] Here, the artist achieved an amazingly literal visual translation of this passage: Gregory performs Mass while the image of a finger can be seen floating in the chalice before him. The onlookers raise their hands in gestures of amazement.

This page may originally have served as an impressive frontispiece for a lost manuscript of the *Life of Saint Gregory*, written by Konradus at Weingarten Abbey between 1181 and 1200. Indeed, its style resembles that of other works from Weingarten, one of the most important centers of Romanesque manuscript painting in Germany. The saint would have probably approved of the artistic activities there, for he espoused the value of art as a didactic aid to the illiterate, a tool that might inspire religious sentiment just as effectively as scripture.[3] In the case of this image, art also prompts faith: for viewers, like the skeptical woman, seeing means believing.

C.M.N.

## 16. *Capital with the Adoration of the Magi*

1125/50

Northern Spain

Limestone; 34.5 x 61.5 x 22.8 cm (13 ⅝ x 22 ½ x 9 in.)

Inscription: on the base, *MARIA DE NO___ C___* (Maria of …)

Kate S. Buckingham Endowment, 1944.417

---

ACCORDING TO THE GOSPEL OF Matthew, when Jesus was born three wise men arrived in Jerusalem, saying "we have seen his star in the East, and have come to worship him" (Matthew 2:1–3). That act of homage forms the subject of this capital, which once adorned the top of a column in northern Spain, possibly Aragon.[1] There it would have been visible to monks and laypeople alike at a monastery positioned along one of the main routes to Santiago de Compostela in the west. That shrine, built upon the tomb of Saint James, rivaled Rome and Jerusalem as a pilgrimage center during the eleventh and twelfth centuries, and churches on the way housed a substantial number of travelers. Sculptures such as this one, found on capitals and at important entryways, were employed to impress, instruct, and admonish viewers of all kinds.

On the front, visible here, a kneeling king humbles himself before the Christ Child (now much damaged), who sits on his mother's lap. Directly above the king's head, set against a scroll-like arch, is a worn Star of Bethlehem. One of his companions appears at the right, holding a round container, while the other stands further on, along the thin right side. This last wise man, crowned and bearded, is placed in a stiff, frontal position, gazing directly outward. On the opposite side, behind the Virgin, is yet another figure—possibly a shepherd—who holds a staff and points upward with his left hand.

C.M.N.

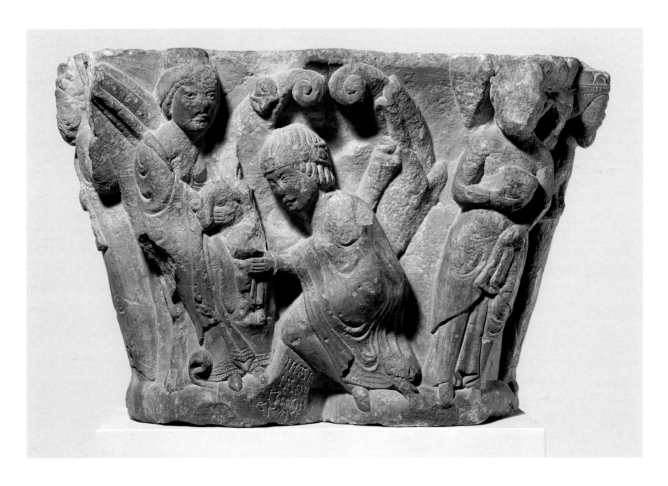

## 17. *Corpus of Christ*

c. 1150, with a later (?) addition of an
enameled cross
Belgium, Meuse River Valley, or
Germany, Rhineland
Gilt copper and champlevé enamel; corpus:
8.9 x 9.2 cm (3 ½ x 3 ⅝ in.);
cross: 17.8 x 13.3 cm (7 x 5 ¼ in.)
Inscription: atop the cross, *IH[ESUS].*
*C[HRISTUS]. NAZAREN[US]. REX IUDE-*
*ORU[M]* (Jesus Christ of Nazareth, King
of the Jews)
Kate S. Buckingham Endowment, 1943.70

THIS CORPUS, OR FIGURE OF the
crucified Christ, belongs to a series that
was inspired by the work of Rainer of
Huy. A south Netherlandish metalsmith
of great skill, Huy is widely believed to
have produced the magnificent brass
baptismal font in the cathedral at Liège.
Because of its close stylistic similarities to
the font, a small bronze crucifix of 1110/20,
now in the Schnütgen Museum, Cologne,
has also been attributed to his hand.[1]

The Art Institute's *Corpus of Christ,*
which is stylistically related to that cru-
cifix, possesses an expressiveness that is
heightened by a number of refined details. For instance,
its unknown maker took great care to enliven Jesus's face,
endowing it with a melancholy vividly conveyed in the
wide, open eyes, complete with marked pupils. Adding
texture to the otherwise smooth finish are Christ's finely
chiseled beard and hair, his patterned loincloth, and his
taut, sinewy arms and protruding ribs. The heavy weight
of his own body is suggested by overly long, extended
arms and a contrapposto stance. While the artist clearly
acknowledged Jesus's physical suffering, he refused to
concentrate on the agonizing details of his death; indeed,
this relatively early representation of Christ on the cross
exists in marked contrast to later, harsher medieval images
of the Passion (see cat. 55).

Some scholars have questioned the authenticity of the
enameled cross. However, a similar Mosan corpus in the
National Gallery of Art, Washington, D.C., which is cau-
tiously assigned to the twelfth century, is also paired with
an enameled cross like this one, ornamented with inter-
locking, heart-shaped palmettes.[2] The inscription, often
found on medieval crucifixes, names Christ as the "King
of the Jews" and refers to the charges posted on the
cross by his Roman captors.

C.M.N.

# THE THIRTEENTH CENTURY

By the beginning of the thirteenth century, a dramatic, new style known in the Middle Ages as *Opus francigenum*, or French work, was quickly transforming Europe's artistic landscape. The movement flourished under the Capetian kings of France, including Louis IX (r. 1226–70), who was determined to transform his capital, Paris, into a new Holy Land. Between 1241 and 1248, he sponsored the construction of a jewel-like chapel to house relics he had acquired from abroad. This building, the Sainte-Chapelle, displays all of the characteristics associated with the new style that we, in the tradition of Renaissance historians, call "Gothic": pointed arches, flying buttresses, tracery windows, walls of stained glass, and the use of innovative masonry technologies. What originated in France quickly spread to neighboring countries. Henry III of England (r. 1216–72), for example, rebuilt Westminster Abbey in 1245, while the first plans for Cologne Cathedral were drawn up by Master Gerhard three years later.

The rise of cathedrals coincided with the growth of urban centers, greater economic development, and an increasingly complex social hierarchy that included merchants and craftsmen. Often members of specialized guilds, painters and sculptors enjoyed high status; in addition to making luxury goods for noble clients, they were also understood to be in the service of Christ and the saints. Nicola Pisano, who carved the pulpit in the baptistery at Pisa in 1260, displayed a self-conscious pride in his creation, which he signed, "may so gifted a hand be praised as it deserves." Cathedral architects were also especially honored. The epitaph of Pierre de Montreuil, master of the works at Notre-Dame in Paris, remembered him as a "doctor of stone," an honorific worthy of a university scholar.[1]

A number of important events influenced the shape of religious life in the thirteenth century. In 1215 the Fourth Lateran Council of the Roman Catholic Church codified the doctrine of transubstantiation, which holds that, during the Eucharist, bread and wine are truly transformed into the body of Christ. The Mass became increasingly theatrical from that point onward and the Host was elevated so that all in attendance could see. Meanwhile, new monastic orders, most notably the Dominicans and Franciscans, began to place great emphasis on the emotional aspects of religion. Saint Francis of Assisi himself received the stigmata, or wounds of Christ, while a crucifix at the Church of San Damiano in Assisi spoke to him in a vision, saying "go and repair my house." Such direct communication with the divine inspired others, including lay people, to imitate Christ in their own personal devotions.

Opposite: Cat. 23 (detail).

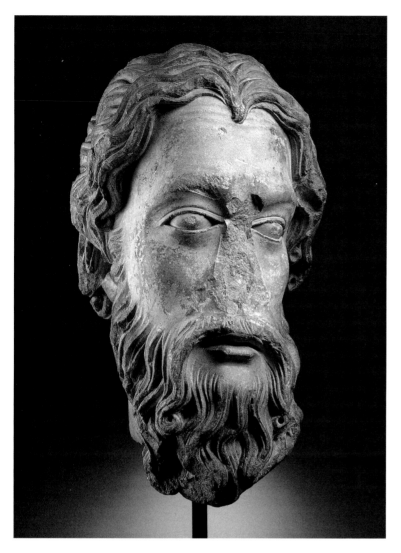

## 18. *Head of an Apostle*

c. 1210
France, Paris, Cathedral of Notre-Dame
Limestone with traces of polychromy; 43.2 x 25.5 x 26 cm
(17 x 10 ¼ x 10 ¹⁄₁₆ in.)
Kate S. Buckingham Endowment, 1944.413

ARGUABLY THE MOST IMPORTANT PIECE of Gothic sculpture in an American collection, this imposing head comes from a full-length figure that formed part of the Last Judgment Portal of Notre-Dame Cathedral in Paris. A confident reworking of ancient and Byzantine models, it bears all the stylistic hallmarks of sculpture from around the year 1200.

Medieval sculpture from Notre-Dame was purposefully damaged during the French Revolution, and it was probably during the Reign of Terror—when royalty, members of the nobility, and even politicians were guillotined—that this apostle was himself "beheaded" in an attempt to diminish his visual impact and symbolic power. Nevertheless, monumental proportions, prominent cheekbones, and dramatically rendered hair and beard combine to give this surviving fragment a commanding presence.

The object's true origin was the subject of heated debate for several decades. However, recent scholarship and scientific investigation—namely neutron activation analysis, in which samples are taken and then bombarded in a nuclear reactor—placed it securely at Notre-Dame.[1] Part of the earlier mystery stemmed from an unverifiable dealer's report that the head was found in 1852 during the excavation of the boulevard Hausmann, at the intersection with boulevard Malesherbes.[2] In 1880 a very eroded limestone body, now in the Musée Carnavalet, Paris, was found in the Seine beneath the Pont du Double, near Notre-Dame. Earlier, an attempt was made to link this body to the Art Institute's head; although this connection is no longer generally accepted, it may be that the body, like the head, originally came from the cathedral.[3] More recently, the discovery of sculptural fragments from Notre-Dame's Gallery of Kings, dated to between 1220 and 1235, has provided an important point of stylistic comparison and allowed for a more precise dating of the head.[4]
C.M.N.

## 19. *Virgin and Child*

1270/80
Unidentified master (Italian, Florentine, active 1275/1300)
Tempera and gold leaf on panel; 81.7 x 47.8 cm (32 ⅛ x 18 ⅞ in.)
Mr. and Mrs. Martin A. Ryerson Collection, 1933.1034

THIS PANEL'S BROAD, LINEAR STYLE and its bold presentation of the Virgin and Child are typical of pictures produced by a number of popular painters active in Florence and Tuscany toward the end of the thirteenth century. Of these, the present work most closely compares to a more elaborate composition in the Florentine church of San Leonine a Panzano, which may have been executed by the same artist or workshop.[1] Apart from their stylistic affinities, the works display the same combination of Byzantine iconographic types—the Virgin's frontal pose, for instance, recalls the regal Virgin *Nikopeia* (literally, "she

who gives victory"), while the three-quarter pose of the Christ Child relates to that of the Virgin *Hodegetria*, "she who shows the way" to God.[2] In both paintings, the Christ Child appears as a wise young emperor, offering his blessing with two fingers held together, symbolizing the union of God and man, in him; in the other hand he holds a scroll, the *mappa*, which signifies his complete knowledge and command of the world.

The irregular formats of panels such as this one, on which the Virgin's head and halo extend into a carved lobe, became common in Florentine altarpieces during the later thirteenth century. This popularity was exemplified by the famous *Virgin and Child Enthroned* (1270/75?), probably by Coppo di Marcovaldo or his workshop, in the Church of Santa Maria Maggiore.[3] The Art Institute's picture was obviously cut down at the sides and, more drastically, on the bottom, which eliminated not only Mary's right hand and the Christ Child's feet but perhaps the entire lower half of the Virgin's body, which would have rested on a low throne. Some sense of what may have been lost can be gained by referring to the paintings in San Leonine a Panzano and Santa Maria Maggiore. The placement of the Virgin's right arm in this work suggests that, before it was cropped, her hand gently held her son's foot, a tender gesture sometimes found in paintings of the period.

L.J.F.

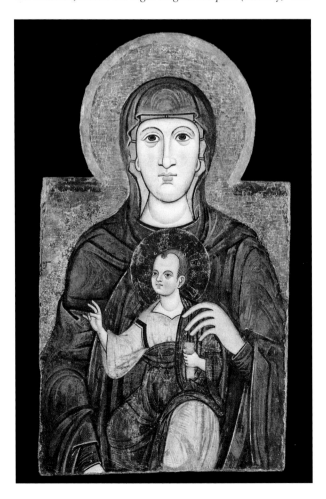

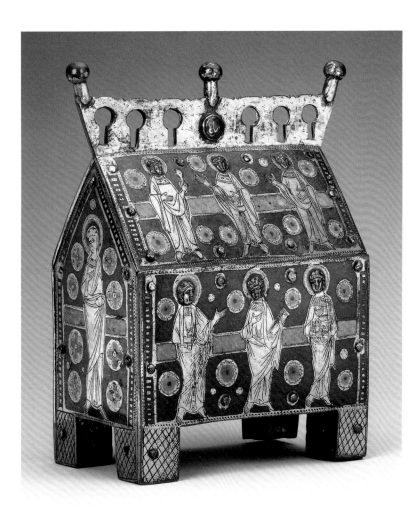

## 20. *Reliquary Casket*

1200/25
France, Limoges
Gilt copper, champlevé enamel, and wood core;
15.6 x 13.3 x 6.8 cm (6 ⅛ x 5 ¼ x 2 ¹¹⁄₁₆ in. )
Kate S. Buckingham Endowment, 1943. 72

AS DISTINCTIVE AS MOSAN AND Rhenish enamels (see cats. 12–14) are, so too is the variety produced in the Limousin region of central France. This reliquary casket or *châsse*, with its vivid blues, green, red, and yellow, is typical of the objects created at the prolific workshops in and around the city of Limoges. By the middle of the twelfth century, area goldsmiths excelled in the relatively new technique of champlevé, in which depressions are gouged into copper and then filled with colored powder that is then fired. This approach is more economical than the older cloisonné process and allows for the use of enameling on a much larger scale.[1] By the end of the same century, *Opus lemovicense* (Limoges work) was gaining an international reputation, and documentary sources indicate that ornamentation with enamel was considered as precious as that with gemstones.[2]

On the front of this casket appear six haloed saints holding books or scrolls, gesturing as though speaking to one another. These golden figures stand against a turquoise and dark blue background interspersed with decorative floral medallions. Their hands, feet, and garments are engraved, while separately cast and applied heads lend them something of a three-dimensional appearance. Another, similar saint appears alone on either end, and the back is decorated with a pattern of quatrefoils, or four-lobed flowers, set within medallions. The object's original wood core survives, as do traces of a red cross, a motif commonly painted on the inside of Limoges caskets as a sort of maker's mark.

Because this reliquary features a scene of saints in general rather than one holy person in particular, it was most likely produced on speculation rather than commissioned, as were some of the most magnificent examples of Limoges work. The casket's nonspecific iconography would have made it appropriate for any number of churches, as it could have housed the relics of virtually any saint. The market for objects such as this was potentially very large, since every consecrated altar had to contain the relics of the church's patron saint, or, even better, those of a number of saints.[3]

C.M.N.

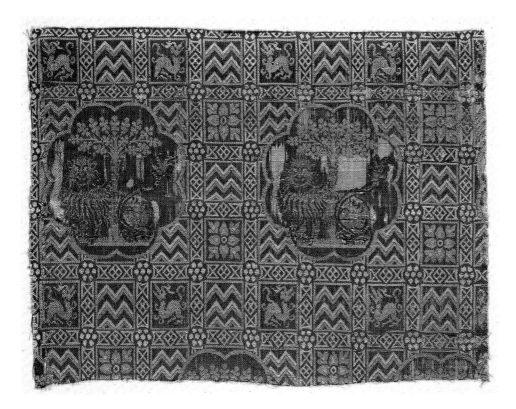

## 21. *Silk Fragment with Lions*

13th/14th century

Italy

Silk and gilt-metal-strip-wrapped silk, warp float-faced chevron 2:1 twill weave with plain interlacings of secondary binding warps and patterning and brocading wefts; 22.95 x 30.4 cm (9 x 12 in.); weft repeat 14.3 cm (5 ⅝ in.)

Gift of Mrs. Chauncey B. Borland, 1958.521

WITH ITS VIVID PALETTE OF blue, gold, and green, this silk fragment recalls medieval metalwork, particularly enamels (see cats. 12–14, 20).[1] Furry lions appear within double-lobed quatrefoils, surrounded by a background pattern of chevrons, dragons, and flowers. The fact that the cats were worked in gold heightens the textile's resemblance to metalwork, especially since the thick gold threads were wrapped around other ones, causing the creatures to stand out in relief.

In the Middle Ages, Italy was a great center for sericulture, the raising of silk worms. Positioned advantageously for Mediterranean commerce, manufacturers gained technical knowledge from the East and incorporated a number of Asian stylistic motifs into their products. Trade was encouraged, especially during the reign of Kublai Khan (1260–94), the Mongol emperor who founded the Yuan dynasty in China. Indeed, the very name of the arduous overland route from Europe to China—the Silk Road—emphasizes the economic importance of the traffic in silk. Italian travelers such as Marco Polo would have witnessed the exchange of silk textiles in the bazaars along the silk route and in important trading centers such as Khinsai (modern Hangzhou), a port on the East China Sea.

During the later Middle Ages, guilds controlled the manufacture of silk in Italy. They, in turn, were at the mercy of merchants who imported raw silk, oversaw all aspects of its transformation into luxury textiles, and negotiated their eventual sale and export. The names of towns such as Venice and Lucca are repeatedly mentioned in period documents concerning the silk industry. Although we do not know exactly where this textile was made, we do know that the market for woven treasures such as this one included ecclesiastical institutions and noble families.

C.M.N.

## 22. *Initial* M *with Saint Matthew as Scribe,* *Initial* L *with the Tree of Jesse*

From a Latin Vulgate Bible (f. 267v)

c. 1240

France, Paris

Gold leaf and tempera on parchment; 22.5 x 15 cm

(8 7/8 x 5 15/16 in.)

B. F. Ferguson Fund, 1915.524

DURING THE THIRTEENTH CENTURY, THE Bible, the most important book of the medieval era, received drastic modifications to its format, text, and decoration. Examples from the earlier Middle Ages were enormous, multivolume codices (bound books) written in large, spacious script and decorated with elaborate miniatures.[1] Those imposing tomes, created in monastic *scriptoria* or manuscript workshops, served as monumental state-

ments of a religious community's corporate identity.[2] It was in the 1200s that lay craftsmen in Parisian ateliers began producing small, one-volume codices, which were often tiny enough to fit into the palm of a hand.[3] Scribes gave the biblical text a standardized look, placing red- and blue-ink headers into the upper margins in order to mark the beginning of each book of Scripture in a highly visible way; they also used uniform chapter numbers to separate the text into sections of relatively equal length. Illuminators, meanwhile, began to replace large, full-page miniatures with smaller initials that were "historiated," or ornamented with condensed biblical narratives and images of sacred authors and characters. Its small size and easily accessible text made this new type of Bible extremely popular among medieval readers, who used their Bibles to study theology, compose sermons, and celebrate the Mass and other liturgical rituals.[4]

One such book, decorated with eighty-two historiated initials, is now in the Art Institute's collection. In the first of two particularly fine examples, both appearing on the same page, Saint Matthew appears in a lavishly adorned letter *M* that marks the opening of his own Gospel. The Evangelist is shown in the act of transcribing God's word, which is delivered by a winged man, a symbol traditionally associated with him.[5] The initial is decorated with gold leaf and blue paint made from lapis lazuli, and begins a short prologue that briefly identifies Matthew as the author and explores the main themes of his text. Signaling the Gospel's actual start, however, is a larger, equally sumptuous *L* containing an image of the Tree of Jesse. This motif is a visual representation of Isaiah 11:1–3, in which the prophet foretold that a messiah would spring from the house of Jesse, the father of King David. Growing from Jesse's loins is a stylized family tree with roundels holding Christ, the Virgin Mary, and her Old Testament ancestors. A fitting illustration to the first book of the Gospels, it connects the New Testament with the Old and captures the book's opening verses, which recount Christ's lineage.

L.K.B.

## 23. *Scenes from the Story of Noah and the Ark*

From a pictorial preface to a psalter (ff. 15v–16r)

c. 1250

Northern France or Flanders

Gold leaf and tempera on parchment; 17 x 12 cm
(6 ¹¹/₁₆ x 4 ¹¹/₁₆ in.)

Purchased from the W. M. Voynich Collection, 1915.533

IN THE BOOK OF GENESIS, God singled out Noah for his virtue, directing him to build an ark in order to save himself, his family, and two of every animal from the impending flood. Noah obediently followed these orders, and his vessel floated safely on the swollen waters for over a year. After they dissipated, Noah disembarked from his ship and planted a vineyard. These two miniatures are from a series of six, all chronicling the story of Noah and contained within a manuscript now in the Art Institute.[1] On the left, Noah and his relations escape the swiftly rising flood, while on the right

the ark floats safely as a dove returns with an olive leaf, suggesting the appearance of dry land and the promise of renewed life. While the artist presented each scene as a distinct moment, he unified the two illustrations by using the same colorful ark, stylized water, and gold-leaf background in both.

Unlike the historiated initials in the portable Bible (cat. 22), which supplemented the main experience of reading a text, these full-page miniatures were themselves the primary means of relaying religious stories.[2] In its original form, the cycle of lively images from which these miniatures are taken would have recounted, in chronological order, central events from a single tale.[3] Some of the well-known biblical narratives contained in the manuscript as a whole include the expulsion of Adam and Eve from paradise, the exploits of Joseph in Egypt, and the Last Supper.

The manuscript itself probably once prefaced a psalter,[4] or book of Psalms, which both the laity and reli-

gious communities would have used on a daily basis during the Divine Office.[5] Such prefatory cycles supplemented the Psalms with dramatic events from the rest of the Bible, chronicling humankind's fall from grace, relating stories of faith and perseverance, and culminating with Christ's triumphant return. In this setting, images operated as more than simply visual paraphrases of key episodes from the Scriptures; instead, they served a didactic function by presenting viewers with biblical models of proper and improper behavior. Noah, for instance, offers a fitting image of trust as he encourages his family to climb the ladder to safety. The rising waters highlight the effects of sin, since the great flood was brought on by the moral corruption that God perceived among Noah's contemporaries.

L.K.B.

## 24. *The Flagellation and Crucifixion of Christ*

From an illuminated psalter

c. 1239

Germany, Lower Saxony, Brunswick

Tempera and gold on parchment; 17.5 x 11 cm
(6 ⅞ x 4 ⁵⁄₁₆ in.)

S. A. Sprague Fund, 1924.671

IN CONTRAST TO THE SORROWFUL image of Christ's death painted by the Master of the Bigallo Crucifix (cat. 25), this more violent depiction possesses a markedly different tone, emphasizing Jesus's intensely human suffering. At top, Christ is mercilessly scourged by two soldiers as blood streams from open gashes on his arms, legs, and torso. Pontius Pilate, the Roman procurator of Judea, observes the brutal act at left, his authority indicated by his seated posture; his cross-legged position follows the medieval conventions for representing a judge. A soldier and a Hebrew priest, distinguished by his pointed cap, appear behind him. At bottom, the nearly lifeless Christ is further tor-

mented by the Roman soldiers Stephaton and Longinus: one pierces his side with a spear while the other taunts him with a vinegar sop. The Virgin and Saint John the Evangelist stand to the sides, mournful witnesses to the event.

This single leaf comes from a lavishly illustrated psalter that may originally have been made as a wedding present for Helen, the daughter of Duke Otto of Braunschweig.[1] She married Duke Hermann II of Thuringia, the only son of the princess-turned-saint Elizabeth of Hungary, in 1239. The modern name for the manuscript, the Arenberg Psalter, pays homage to its much later owner, the Duke of Arenberg.[2]

Psalters were the devotional manuals of choice for noble laypeople until they were supplanted in popular-

44

ity by Books of Hours (see cat. 49) around the end of the fourteenth century. In addition to containing all 150 Psalms, psalters also included supplemental texts of various kinds, including calendars for the liturgical year, the Litany of the Saints, the Little Office of the Virgin, and other devotional texts and prayers. They also contained scenes from both the Old and New Testaments that served as visual inspirations to private devotion.[3] While consulting her psalter during daily prayers, Helen of Thuringia would have been encouraged to consider—in graphic detail—the enormity of Christ's suffering and sacrifice as she encountered this bold image of his Passion.

C.M.N.

## 25. *Crucifix*

1255/65
Master of the Bigallo Crucifix
(Italian, active 1225/65)
Tempera and gold leaf on panel; 191 x 127 cm
(75 ¼ x 50 ⅛ in.)
Inscription: above the head of Christ, *IC XC*
(Jesus Christ)
A. A. Munger Collection, 1936.120

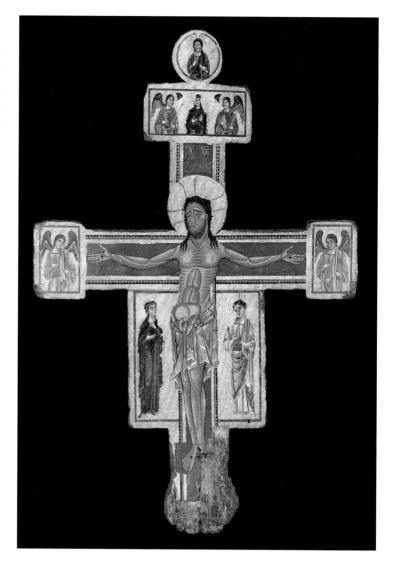

ONE OF THE MOST IMPORTANT works from thirteenth-century Italy in an American collection, this painting captures the emergence of a more naturalistic idiom out of the Byzantine artistic tradition. The artist presented the crucified Christ with eyes closed, in an iconographic type known as *Christus patiens* (literally, Christ enduring), flanked by the Virgin Mary and Saint John the Evangelist. Scepter-wielding angels occupy each end of the cross arms and also accompany another image of Mary, who is shown in the rectangular terminal at top. Above is a roundel containing Christ the Redeemer, offering blessings. A rooster appears at the bottom, beneath the footrest, where it is perched on a mound presumably symbolizing Golgotha, the hill outside Jerusalem where Christ was crucified.

Before the painting's base was damaged, it almost certainly included two more figures on either side of the bird. One of these was the apostle Peter, who, according to the Gospel of Mark, denied knowing Jesus three times as the cock crowed (Mark 14:66–72). The other was his questioner, a maidservant of the high priest Caiphas. Although the remains of her image are visible at the bottom left, we can infer the original presence of both figures from their appearance on two very similar crucifixes executed by the same artist. One of these is preserved in the Palazzo Barberini, Rome, and the other in Florence's Museo del Bigallo, from which the unknown master's appellation is derived.[1]

The artist, probably a Florentine who was familiar with progressive aesthetic trends in the nearby town of Lucca, subtly departed from the highly stylized conventions of Byzantine art.[2] In rendering Christ's musculature, he altered the strictly linear system of Byzantine painting into a slightly less abstract description of anatomy, delicately modeled with light and shadow. He also suggested a sense of weight and gravity not found in Byzantine works, particularly in the drape of the robes and in Christ's lower abdomen and loincloth.

This attempt to suggest Christ's physical presence, his carnality, is especially significant given the liturgical context in which the crucifix was meant to be viewed. Whether displayed on the rood screen (the barrier that separated laity from clergy) or suspended above or behind the altar, the painting would have appeared, from the perspective of the congregation, to be over the altar. Thus installed, the work would have emphasized the doctrine of transubstantiation, the actual transformation, on the altar, of the eucharistic Host into the body and blood of Christ.

L.J.F.

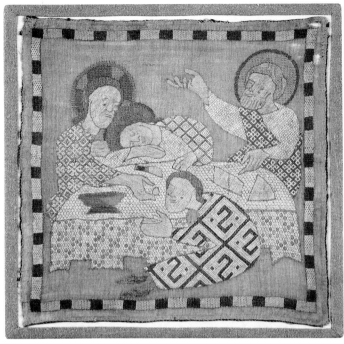

## 26. *Antependium Panel Depicting the Last Supper*

1300/10

Germany, Lower Saxony

Linen, plain weave; pulled thread work with silk and linen in chained border, overcast, and two-sided Italian cross stitches; embroidered with silk and linen in satin, single satin, stem, and stem filling stitches; couching; edged with tape of silk, plain weave; left selvage present; 38.3 x 39.4 cm (15 1/8 x 15 1/2 in.)
Purchased from the Field Museum of Natural History, 1907.765

THIS DEPICTION OF THE LAST Supper foreshadows the momentous event to come: the Crucifixion. Christ, seated at left, reaches for a morsel of bread, seeming to offer it to the apostle Judas Iscariot, the only figure pictured without a halo. A bowl sits on the table between them, contributing to a literal rendering of the Gospel account in which Jesus says of the man who will betray

him, "It is one of the twelve, one who is dipping bread in the same dish with me" (Mark 14:20).

The scene's quiet drama is heightened by the expressive, elongated hands of Christ and his followers, including Saint Peter, who raises his right arm as though to boldly proclaim, "Even if I must die with you, I will not deny you" (Matthew 26:35), an oath he later fails to keep. Saint John, seated at the center, is overcome with sleep and rests against Jesus, enacting a nonbiblical detail found in *Meditations on the Life of Christ*, a devotional treatise popular in the thirteenth century.[1] That text, like this panel, encouraged its beholders to contemplate the events in Jesus's life as a part of their own spiritual practice.

This square work was originally used as an altar cloth or hanging that accompanied similar pieces, all depicting different scenes from the Life of Christ.[2] Made by nuns in a Lower Saxon convent, it would have served as a visual focus for their piety during religious services.[3] It is currently the earliest example of German needlework in the museum's collection and is typical of *Opus teutonicum*, or German white work, which was constructed of white linen accented with colored silk or wool. Displaying their skill on this panel, the embroiderers gave decorative emphasis to the representations of textiles

themselves, including the checked table-cloth and the boldly patterned mantels of Jesus and his three disciples.

C.M.N.

## 27. *Corpus of Christ*

13th century
Catalonia
Walnut with traces of polychromy and gilding; 201.9 x 165.1 cm (79 ½ x 65 in.)
Gift of Kate S. Buckingham, 1926.120

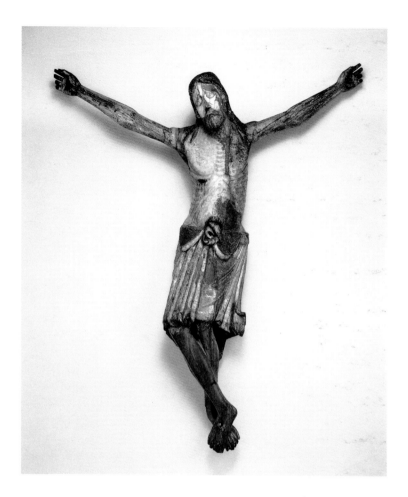

IN THE EARLY MIDDLE AGES, Christ was represented as a triumphant, undying figure on the cross. But a later shift in theology profoundly changed this iconography: Saint Francis of Assisi (1181–1226), among others, emphasized Jesus's humanity and suffering, a new way of thinking that shaped the look of objects such as this corpus.[1] Here, the emaciated figure of Christ appears dramatically contorted, as though the weight of his agony has stretched his limbs to their limits. His abdomen is pulled taught and his ribs protrude, while traces of red pigment emphasize the bloody wound in his side. Although traces of gilding remain in the beard, hair, and drapery, the figure's overall visual effect is certainly not one of glory, but rather defeat: Jesus's head hangs limp and his eyes are closed.

This corpus is believed to be from the church of Santa Maria dels Turers in the Catalan town of Banyoles, and was probably made at a workshop in the high valleys of the Pyrenees, at Urgell or at Eill la Vallin in Lérida.[2] A remarkably similar work, now in the Detroit Institute of Arts, was most likely the product of the same atelier.[3] This piece was originally hung above the transept of a church, directly over the cross altar, where it was in full view of the lay congregation. Worshipers were therefore encouraged to meditate on Christ's suffering and sacrifice as they gazed upon it. One popular medieval treatise, exactly contemporary with this corpus, even encouraged readers to pretend that they were actually witnesses to the Crucifixion:

> With your whole mind you must imagine yourself present and consider diligently everything done against your Lord. . . . Behold, the Lord Jesus is crucified and extended on the cross so that each of his bones can be numbered. . . . On all sides, rivers of his most sacred blood flow from his terrible wounds. He is so tortured that he can move nothing except his head. Those three nails sustain the whole weight of his body. He bears the bitterest pain and is affected beyond anything that can possibly be said or thought.[4]

C.M.N.

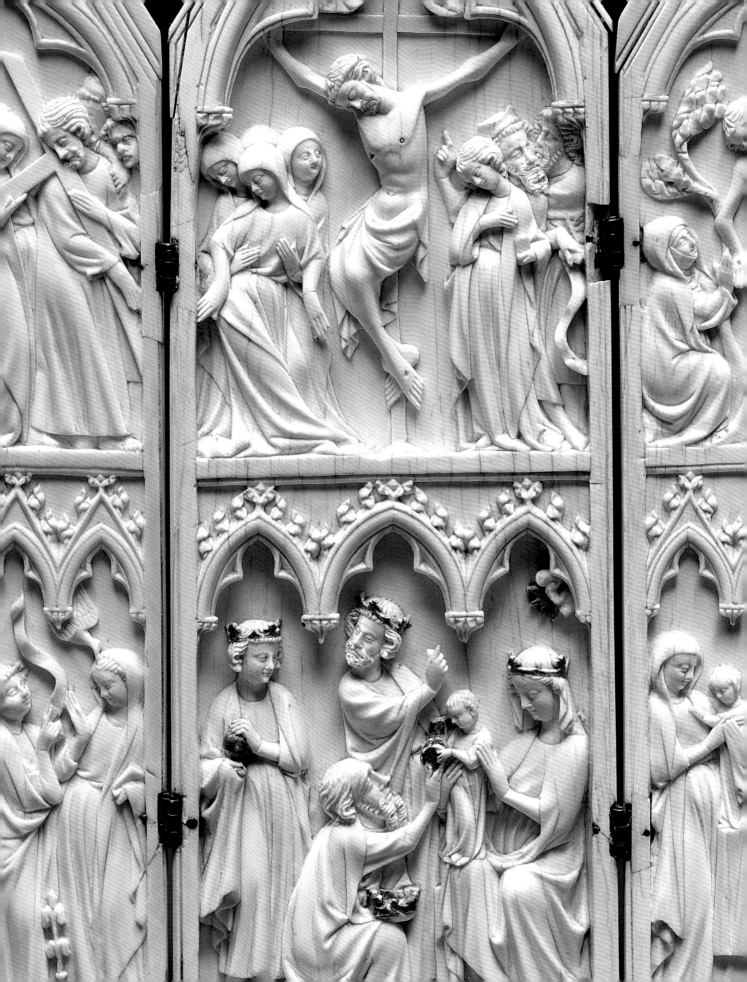

# THE FOURTEENTH CENTURY

The fourteenth century is remembered as a time of great calamities. The first wave of the Great Plague hit Europe in 1348, swiftly wiping out one third of the population, and smaller outbreaks continued to surface over the next few decades. As if that were not enough, France and England began a protracted series of conflicts, better known as the Hundred Years War, which lasted intermittently from 1337 to 1453. Rather than turning away from their own mortality, which must have seemed both inevitable and close at hand, survivors embraced it through pageants such as the Dance of Death, in which "skeletons" led ghoulish graveside festivals. Visual artists also responded to this new interest in the macabre, readily meeting the demand for exaggerated images of Death, as well as Christ's Passion, his wounds, and the physical suffering of saints.

The church endured its own share of trials, which were to eventually weaken its dominance of all aspects of European society. From 1305 to 1377, the popes lived in Avignon in southern France. When an Italian pope, Gregory XI, was elected, Avignon became the home of a series of rival antipopes, whose legitimacy was backed by France and its allies; England and its supporters remained loyal to the pope in Rome.

Despite its tumultuous events, this period also witnessed dramatic artistic developments, including the appearance of great literary works in a number of vernacular languages, including Dante Alighieri's *Divine Comedy* (1314/20) and Geoffrey Chaucer's *Canterbury Tales* (1387/ 1400). At the same time, secular architecture began to rival the ecclesiastical as grand houses, elaborate squares, and impressive city walls came to mark the rapidly expanding urban centers. The social standing of artists continued to rise, as architecture, painting, and sculpture became recognized as intellectual activities, and those who practiced them were lauded as gentlemen and scholars in their own right.

Increasingly, wealthy individuals and secular institutions began to supplant the church in the role of artistic patron. One excellent example is Enrico Scrovegni, a prominent citizen of Padua who built a private chapel dedicated to the Virgin, now known as the Arena Chapel, in around 1305.[1] The walls and vaults were decorated by Giotto, who executed a renowned cycle of frescoes in which weighty figures encounter one another within a unified pictorial plane. The painter suggested further spatial relationships through the use of receding landscapes. Such innovative techniques drew praise from contemporary writers including Giovanni Boccaccio, who, in his *Decameron* (1349–51), praised Giotto as having "had a mind of such excellence that there was nothing given by Nature . . . which he, with style or pen or brush, could not paint."[2]

Opposite: Cat. 35 (detail).

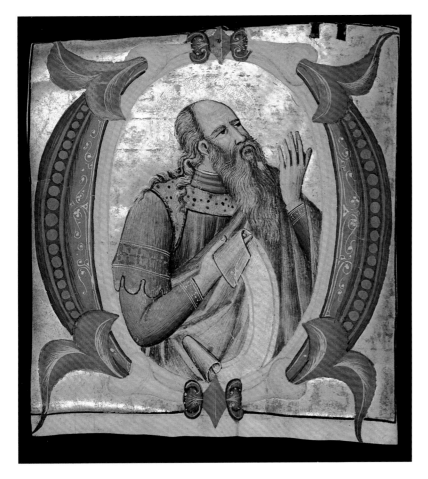

### 28. *Historiated Initial* O *with Moses*

From an illuminated gradual
1392/99
Don Silvestro dei Gherarducci (Italian, 1339–1399)
Tempera and gold leaf on parchment; 15 x 14 cm (5 ¹⁵/₁₆ x 5 ½ in.)
W. Moses Willner Fund, 1915.550

Don Silvestro dei Gherarducci, the artist responsible for this inspired vision of Moses, was a monk and also a prior at the Camaldolese monastery of Santa Maria degli Angeli in Florence. In his *Lives of the Most Eminent Painters, Sculptors, and Architects* (1568), Giorgio Vasari credited Don Silvestro with illuminating twenty choir books for his own religious community along with several others for the Camaldolese monastery of San Michele in Murano (near Venice), where the volume containing this leaf was originally used.[1] In addition to his work as an illuminator, scholars have attributed several panel paintings to his hand. Don Silvestro, Lorenzo Monaco (see cat. 32), and another monk, Don Simone Camaldolese, together comprised the most important school of painting in late-medieval Florence.[2]

This section was cut from a brilliantly decorated gradual, now lost. Graduals were books containing the sung portions of the Mass, and this one covered the part of the church year from the first Sunday in Advent to Holy Week.[3] Here, Moses appears in an initial *O* that marked the introit to the Mass for the second Sunday after Epiphany: "Omnis terra adoret dues" (Let all on earth worship you, O God).[4] Moses himself is represented in the act of adoration, gesturing and lifting his gaze to heaven as though communicating with God; he holds in his right hand a scroll, an iconographic trope that denotes both speech and his status as a figure from the Old Testament. Many of Don Silvestro's choir books were dismembered in the Napoleonic era, when the treasures of many ecclesiastical sites were plundered. A number of the master's other impressive initials survive in various collections including those of the Cleveland Museum of Art, the Laurentian Library in Florence, and the Pierpont Morgan Library, New York.[5]

C.M.N.

## 29. *Fragment from an Orphrey Band with Saint Matthew*

1360s
Italy, Florence
Linen, plain weave; embroidered with silk
and gilt- and silvered-metal-strip-wrapped
silk in split and surface satin stitches;
laidwork, couching, and padded couching;
17.3 x 14.1 cm (6 ⅞ x 5 ½ in.)
Inscription: *DEUS* (God)
Robert Allerton Endowment, 1992.742e

AT THE SAME TIME THAT a master painter
could create images on parchment or
panel (see cats. 28, 32), so too could he
engage in the design of lavish ecclesiastical
textiles. Needlework was not relegated to
the realm of minor arts in the Middle
Ages but was instead considered equal to
painting in prestige and desirability. We
know, in fact, that painter-craftsmen were
directly employed to produce the skillful
underdrawings that served as guides for needle workers.
As the Florentine painter and writer Cennino Cennini
noted in his *Craftsman's Handbook* of 1437:

> You sometimes have to supply embroiderers with designs of
> various sorts. And for this, get these masters to put cloth or
> fine silk on stretchers for you, good and taut . . . take your
> regular charcoals and draw whatever you please.[1]

The relationship between different artistic media in
late-medieval Florence can be seen by comparing this
orphrey-band fragment with a nearly contemporaneous
image from an illuminated choir book (cat. 28). As with
that depiction of Moses, this bust of Saint Matthew
shows the bearded apostle set against a golden back-
ground. Similarly, the Evangelist holds a scroll, this time
with the word *Deus* (God) embroidered on it, a direct
reference to words from his Gospel (27:46): "Deus meus,

Deus meus, ut quid dereliquisti me?" (My God, my
God, why have you forsaken me?).

This piece, along with others from the same band,
was part of a chasuble (a sleeveless garment) or a cope (a
semicircular cape); both garments are worn by priests
celebrating the Mass.[2] The term *orphrey* is derived from
the Latin *auriphrygium*, or embroidered gold needle-
work, and now denotes an ornamental border richly
embellished with gold thread. Saint Matthew is one of
fourteen surviving figures from the band, several of
whom are identifiable by the words they speak or the
objects they hold. These include Christ (with a cruci-
form halo), Saint Paul (holding a sword), Saint Mark
(with a scroll inscribed *Initium. S*), Saint John (with a
scroll inscribed *In princip[io])*, and Saint Margaret
(holding a cross).[3]

C.M.N.

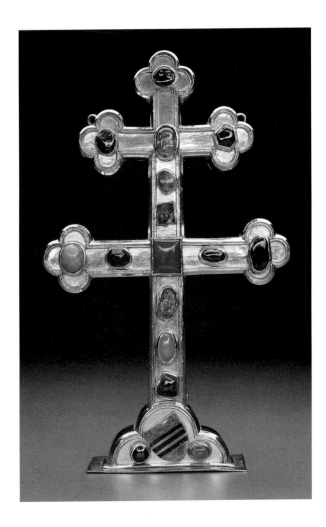

## 30. *The Veltheim Cross*

c. 1300
Germany, Lower Saxony, Brunswick
Gilt silver, enamel, and gems; 20.5 x 12.8 cm (8 1/16 x 5 1/16 in.)
Gift of Mrs. Chauncey McCormick, 1962.92

THIS PROCESSIONAL CROSS COMES FROM the *Welfenschatz*, or Guelph Treasure, formerly housed in the Cathedral of Saint Blaise in Brunswick, Germany. An august collection of liturgical art ranging in date from the eleventh to the fifteenth century, it benefited greatly from the patronage of the Brunon and then the Guelph families.[1] The treasure grew over the course of three centuries, with an inventory drawn up in 1482 listing 140 objects.

The Reformation placed the Guelph Treasure in a perilous position. Members of the ducal House of Brunswick-Lüneburg, staunch supporters of Catholicism and heirs to the treasure, did what they could to ensure the safety of these works of art, and, more importantly, the saintly relics contained within them. In the seventeenth century the family was forced to move the collection to their court chapel in Hanover to keep it out of harm's way, and by the late eighteenth it was officially declared to be their private property. Faced with financial difficulties following World War I, Duke Ernst August II decided to sell the objects and began negotiating with agents in the 1920s; the treasure was sold to a consortium of dealers after the German government launched a failed attempt to keep it intact and within the country. On tour in the United States in 1931, the Guelph Treasure, by then comprising eighty-five pieces, captivated the press and the general public alike, drawing record crowds and glowing reviews at venues in New York, Philadelphia, Cleveland, Chicago, and San Francisco. *Art News*, for example, rightly called it "the greatest group of medieval objects ever offered for sale in this country and one of the best documented and authenticated collections of its kind in the world."[2] While they were on view in Chicago, Mrs. Chauncey McCormick purchased four of the eight pieces now in the Art Institute's collection, including this work and a reliquary monstrance (cat. 31).[3]

Housing the relics of roughly thirty saints, this cross is named for the noble Veltheim family, whose coat of arms appears on its base.[4] One scholar has suggested that the piece was made to celebrate the Veltheims' 1326 founding of the Convent of Saint Anna in Brunswick and that it entered the cathedral treasury sometime after that.[5] Alternatively, the family may have presented it directly to the Cathedral of Saint Blaise. A patriarchal cross, with a short arm above a long one, it is ornamented with fifteen colorful cabochons of amethyst, carnelian, chalcedony, labradorite, blue sapphire, and topaz.
C.M.N.

## 31. *Monstrance with Tooth of Saint John the Baptist*

1375/1400
Germany, Lower Saxony, Brunswick
Gilt silver; 45.5 x 14.6 cm (17 7/8 x 5 3/4 in.)
Rock crystal, 900/1000
Egypt (Fatimid dynasty)
Inscription: on the foot, *dens Johannes baptiste*
(Tooth of John the Baptist)
Gift of Mrs. Chauncey McCormick, 1962.91

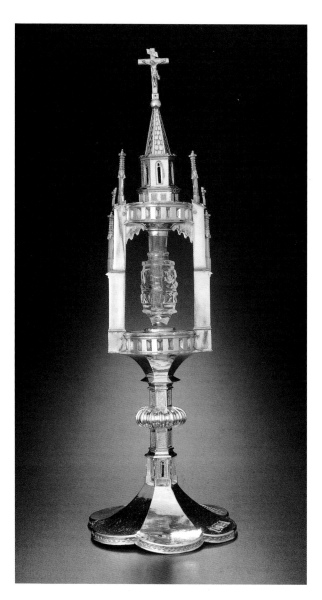

LIKE THE VELTHEIM CROSS (CAT. 30), this fourteenth-century monstrance was originally part of the Guelph Treasure.[1] Monstrances—from the Latin *monstrare*, to show—became increasingly popular in the later Middle Ages because they rendered their precious contents visible. Liturgical developments that began in the thirteenth century called for the public display of relics during the celebration of the Mass. This was a great shift away from earlier practice, as indicated by the twelfth-century casket of saints Adrian and Natalia (cat. 11), which did not display its relics per se, but instead relied upon narrative imagery to suggest their presence.

Made of gilt silver, the monstrance takes the form of a Gothic edifice, complete with two wide buttresses and a small chapel surmounted by a cross. This structure forms an elaborate architectural frame for a translucent rock crystal vessel holding the relic, which is identified as a tooth of Saint John the Baptist by an inscription on the foot and by a small piece of paper tucked into the relic's linen wrapping (see fig. 1).[2]

The rock crystal bottle was carved in Egypt during the Fatimid dynasty (909–1171) and is ornamented with a square-and-leaf design in high relief.[3] Al-Biruni, an early-medieval scholar and scientist from Persia, considered rock crystal "the most precious of stones" and particularly valued its ability to unite "the fineness of air with the quality of water."[4] The Fatimids clearly shared an appreciation of the rare stone, as they were avid collectors of rock crystal objects. When dire financial straits forced the caliph al-Mustansir (r. 1035–94) to sell off his palace treasury in the 1060s, tens of thousands of these pieces flooded the bazaars of Cairo; Egyptian merchants

FIGURE 1. The relic itself, removed from its linen wrapping.

found willing buyers at the courts of Byzantium, Sicily, and Muslim Spain. At about this time, rock crystal flasks such as this one, which was originally intended to hold perfume, began to enter ecclesiastical collections in Germany, where they were often incorporated into new works of art. This particular vessel could have been acquired by any number of means—trade, plunder, or the exchange of diplomatic gifts.

C.M.N.

## 32. *Processional Cross*

1392/93
Lorenzo Monaco (Italian, 1370/75?–1423/24?)
Tempera and gold leaf on panel; 57.3 x 28 cm (22 ½ x 11 in.)
Inscription: atop the cross, *ICXC* (Jesus Christ); on the scroll held by the figure at the foot of the cross, *[MISE]RERE MEI D[EUS]* (Have mercy upon me, O God)
Mr. and Mrs. Martin A. Ryerson Collection, 1933.1032

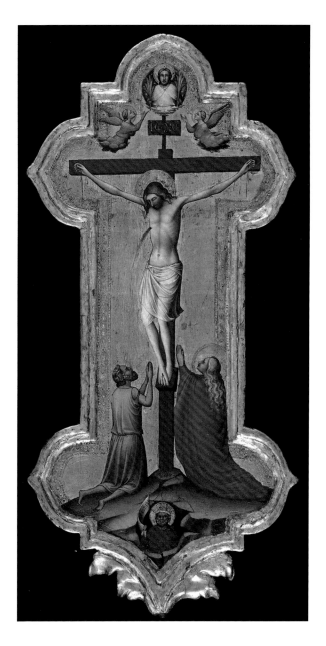

LONG ATTRIBUTED TO A FOLLOWER or contemporary of Lorenzo Monaco, this delicate masterpiece of Florentine Gothic painting has recently come to be recognized as a work by the master himself.[1] Although he appears to have been the dominant painter and manuscript illuminator in Florence for at least two decades, very little is known for certain about the artist, whose given name was Piero di Giovanni. As a young man he apparently studied painting with Giotto's highly productive follower Agnolo Gaddi, and learned the illuminator's craft under the tutelage of the famed painter and miniaturist Don Silvestro dei Gherarducci at the scriptorium of Santa Maria degli Angeli in Florence (see cat. 28). In 1391 Piero took his vows at that monastery, changing his name to Lorenzo Monaco— Lawrence the Monk. The artist subsequently exercised a virtual monopoly over Camaldolese painting in Florence, and his refined style, which featured radiant, high-keyed colors, sinuous lines, and exquisite detail, eventually exerted an influence well beyond the city.

In this work, probably a relatively early effort, Lorenzo presented a crucified Christ flanked by the kneeling figures of Mary Magdalene, in red, and an unidentified hermit. Dressed in a coarse, brown tunic, he is not crowned by a halo, as a saint would be, but by rays that mark him as a *beatus*, one who has been beatified but not canonized. At the top of the panel, two angels venerate the glorified or risen Christ, who grasps palm fronds in each hand, denoting his victory over death and the promise of eternal life. Emerging from the rock of Golgotha, at bottom, is a bust-length figure of the Old Testament patriarch King David, who bears a scroll with the abbreviated inscription *[MISE]RERE MEI D[EUS]*, referring to a verse from Psalm 50 that translates as

"Have mercy upon me, O God, according to thy loving kindness; according unto the multitude of thy tender mercies blot out my transgressions."[2] In a contemporary religious context, this particular psalm would have been understood as referring to the Catholic Church's practice of selling indulgences and the remission of sins. King David's appearance in depictions of the Crucifixion is very rare; more often, a pelican was included at the foot of the cross as a symbol of sacrifice, pricking its breast to feed its young on its own blood.

Despite the intimate inspection that its scale and composition invite, the panel's unusual shape and the worn, round hole drilled in its bottom indicate that it was once affixed to a tall pole and carried in procession around a church.[3] Sometimes such objects were installed in stands beside the altar during the celebration of the Mass.

L.J.F.

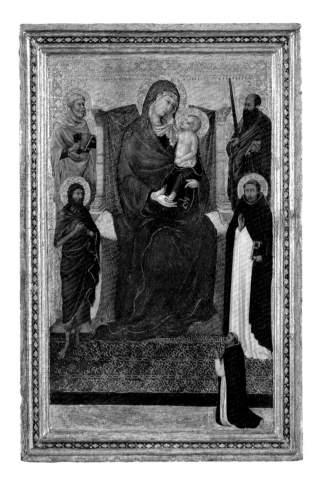

## 33. *Virgin and Child Enthroned with Saints Peter, Paul, John the Baptist, Dominic, and a Donor*

1325/35
Attributed to Ugolino di Nerio (Italian, documented 1317–27)
Tempera and gold leaf on panel; 43.4 x 29.1 cm
(17 ⅛ x 11 ⁷⁄₁₆ in.) including frame
Mr. and Mrs. Martin A. Ryerson Collection, 1937.1007

THIS SMALL, EXQUISITE PANEL WAS probably created in the workshop of Ugolino di Nerio, who appears to have been a disciple of the eminent Sienese painter Duccio di Buoninsegna. Scholars have debated if, or to what degree, Ugolino himself may have been involved in the picture's execution.[1] A shadowy figure, he is mentioned in only a few scant documents but is known to have received prestigious commissions for the high altars of two major Florentine churches, Santa Croce and Santa Maria Novella. Fragments from the Santa Croce altarpiece and other pictures attributed to Ugolino, including this one, have strong stylistic affinities to the paintings of Duccio, particularly in the elegantly attenuated figures and the meandering gold lines on the hems of their garments.[2]

Ugolino's paintings typically feature a rich variety of punch marks impressed into the gold background, and this panel includes several patterns that are found in other works from his shop.[3] Since punch tools sometimes passed from one artist's atelier to another, however, this coincidence provides additional but not conclusive evidence that *Virgin and Child Enthroned* was made in Ugolino's studio. Be that as it may, the types of punching seen here, as well as the geometric design and molding of the frame, are nevertheless characteristic of Sienese paintings produced in the second quarter of the fourteenth century.

The hinge marks on the left edge of the panel indicate that it was once the right wing of a diptych; the left wing, which is lost, probably depicted the Crucifixion. This work's small scale and the faux-marble painting on its reverse suggest that the diptych functioned as a folding, portable altarpiece for private worship. The patron, who appears kneeling in devotion at the lower right, was

undoubtedly a member of the Dominican order. It is for this reason that the artist granted the figure of Saint Dominic special prominence. Placed directly above the patron, slightly larger than the other saints and more frontally posed, Dominic intercedes between the viewer and the Virgin and Child.[4]

L.J.F.

## 34. *Orphrey Band Fragment with Saints Barbara and James*

1350/1400
England
Linen, plain weave; underlaid with linen, plain weave; embroidered with silk and gilt-metal-strip-wrapped silk in satin, padded satin, and split stitches; couching; 34.3 x 18.4 cm (13 ½ x 7 ¼ in.)
Restricted gift of Mrs. Walter Byron Smith, 1972.397

THE EARLIEST EXTANT PIECES OF needlework from the Middle Ages are of English origin, with several even pre-dating the Norman Conquest of 1066.[1] Just after the conquest, one of the most famous of all medieval embroidered textiles, the Bayeux Tapestry, was made for Odo, Bishop of Bayeux in northern France and half-brother of William the Conqueror. It chronicles in detail the historic Battle of Hastings, in which Duke William of Normandy defeated Harold II and became the ruler of England. England continued to dominate in needlework during the centuries that followed, so much so that the embroidered textiles originating there became known as *Opus anglicanum*, or English work. By the 1200s many examples were acquired by members of the nobility and by church officials throughout Europe. The production of English work was the domain of professional artisans, both men and women, whose livelihood was strictly regimented by the rules of the guilds, as was the case for contemporary metalworkers, painters, and sculptors. Before they could be considered masters, they toiled for long years as apprentices, perfecting the intricacies of their art.

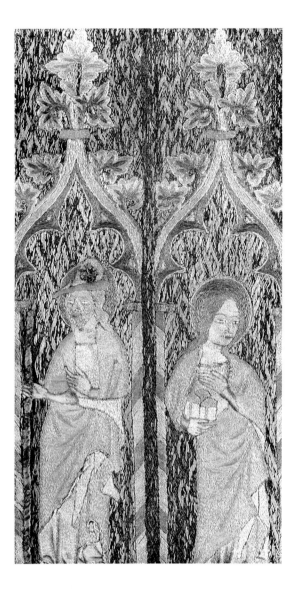

This *Opus anglicanum* fragment was once part of an orphrey band, an ornamental border adorning an ecclesiastical vestment. Enframed by architectural niches are saints James and Barbara, both much revered in the Middle Ages. James, at left, is shown in the guise of a pilgrim, carrying a staff and wearing a cap decorated with a scallop shell, the particular mark of one who visited the great shrine dedicated to him at Compostela in northwestern Spain. Next to him stands Barbara, who carries a model of a tower; this alludes to her imprisonment by her father, Dioscorus, during which she converted to Christianity.

C.M.N.

## 35. *Triptych with Scenes from the Life of Christ*

1350/75
Probably Germany, Lower Rhine, Cologne
Ivory and gold pigment; 25.7 x 17.5 cm (10 1/8 x 6 15/16 in.)
Mr. and Mrs. Martin A. Ryerson Collection, 1937.827

THIS IVORY TRIPTYCH, WITH ITS episodes from the Infancy and Passion of Christ, encourages viewers to meditate upon Jesus's majesty, humanity, and suffering.[1] The wings on either side can be opened and closed like a book, allowing users to "read" its imagery while praying

or meditating. The pictures themselves are arranged in a chronological sequence from left to right, starting on the bottom with the Annunciation, the Adoration of the Magi, and the Presentation in the Temple. The narrative continues on the top with the Road to Calvary, the Crucifixion, and the Noli Me Tangere.

Images carved in ivory were highly prized devotional tools in the Gothic era. In works such as this one the scenes were generally executed on a very intimate scale, requiring users to look closely and engage deeply, as though personally entering into the action. This attentive, imaginative relationship with art was also encouraged by medieval texts such as *Meditations on the Life of Christ*, which admonished readers to imagine themselves standing alongside the Wise Men, paying homage to the infant Jesus.[2] Triptychs and other small devotional objects could be kept on the altar of a private chapel or on a stand in a bedroom, where laypeople would consult them, along with illuminated psalters and Books of Hours (see cats. 24, 49), as they recited prayers at various times throughout the day.

While Paris has long been recognized as a great center for ivory carving in the Gothic era, scholars have recently increased our knowledge of workshops in England, Germany, and Italy.[3] This triptych was most likely made by a master artist and his atelier working in Germany, probably in Cologne. The art historian Richard H. Randall, Jr., has named this otherwise unknown man the "Berlin Master," a reference to his work on a triptych now in Berlin's Staatliche Museen.[4]

C.M.N.

## 36. *The Ayala Altarpiece*

1396
Northern Spain
Tempera on panel; retable: 257 x 668 cm (101 ³/₁₆ x 262 in.);
frontal: 116 x 290 cm (45 ⅝ x 114 ½ in.)
Gift of Charles Deering, 1928.817

PEDRO LÓPEZ DE AYALA, POET, historian, and councilor
to the king of Castile, commissioned this monumental
altarpiece for his family's funerary chapel in the Domin-
ican convent of San Juan de Quejana in northern Spain.
He ordered it in 1396 when he was well on in years but
still deeply involved in service to his king; he undertook
embassies to France in the 1390s and was appointed con-
stable of Castile in 1399. The altarpiece is composed of a
frontal—a panel decorating the face of the altar table
itself—and a massive, horizontal retable that originally
rose above the altar and filled the width of the plain con-
vent chapel in Quejana.

By ordering the altarpiece to be made in the service of
God and the Virgin Mary, as the inscription just above the

altar table states, Ayala was no doubt mindful of his own
spiritual well-being as well as that of his wife and chil-
dren, and ancestors. When he commissioned the work, he
knew that he and his wife, Leonor de Guzmán, would be
buried in the convent chapel, as his parents had been
before him. Indeed, the life-size, recumbent tomb figures
of the Ayala family and a copy of the altarpiece are still
the church's major ornaments.[1] This painted ensemble, a
remarkable example of an intact early altarpiece in an
American collection, embodies an important aspect of
late medieval piety, namely the creation of endowments
to plead for the salvation of a donor and his family and to
preserve their memory.

The donors are much in evidence, as is often the case
with such commemorative commissions. The coats of
arms of the chancellor and his wife are displayed in alter-
nation on the frames of both the retable and the frontal.
On the former, Ayala and his son kneel before Saint
Blaise at the left of the lower register, while his wife and
daughter-in-law are shown before Saint Thomas Aquinas
on the far right; all are identified by inscriptions that

appear to float up from their mouths. Two other members of the family kneel beneath the crucified Christ in the center of the upper register.

The retable presents a chronological narrative of stories from the lives of Christ and the Virgin, adjusted to place the Crucifixion at the center. The sequence includes, from left to right, the Annunciation, the Visitation, the Nativity combined with the Annunciation to the Shepherds, the three kings from the Adoration of the Magi, the Presentation, and the Flight into Egypt. Above, reading in the same direction, are scenes of the twelve-year-old Jesus preaching in the Temple, the Marriage at Cana, the Resurrection, the Crucifixion, the Ascension, Pentecost, and the Assumption of the Virgin. Most remarkably, the Virgin and Child are not depicted in the Adoration of the Magi, the central scene in the lower register of the retable. In this crucial spot, where the priest would have stood to celebrate Mass, is painted a small, thronelike construction topped by an angel. This served as background for a precious gilt statue of the Virgin and Child, which contains a relic of the Virgin's hair. This work, given to the convent by the chancellor's uncle and still in Quejana, apparently stood in for the figures of the Virgin and Child in the Adoration scene. The most honored part of the ensemble, it was the center of the altarpiece and the special object of the Ayala family's devotion.[2]

Despite Ayala's cosmopolitan connections, he was content to honor the traditions of his family in a provincial visual idiom: the altarpiece is remarkably old-fashioned in style, harking back to the clear forms and simple arcaded framework of the early fourteenth century.

M.W.

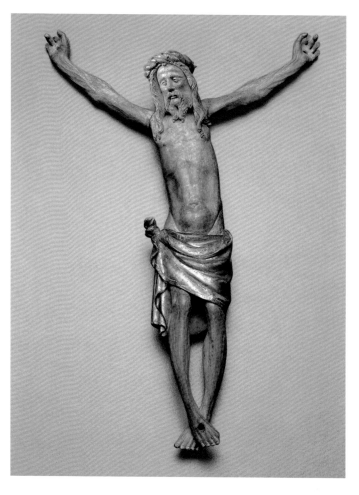

## 37. *Corpus of Christ*

13th century
Jacques de Baerze (Netherlandish, active 1383–92)
Walnut with traces of polychromy and gilding; h. 27.9 cm (11 in.)
Gift of Honoré Palmer, 1944.1370

THIS CORPUS OF CHRIST WAS originally positioned at the center of the large Altarpiece of the Crucifixion that Philip the Bold, Duke of Burgundy, commissioned for the Charterhouse of Champmol, near Dijon in eastern France. The weight of Christ's body and the protracted agony of his death are rendered palpable by his elongated torso, distended stomach, and the exaggerated, taut musculature of his forearms. The bent neck and heavy eyelids add to the scene's pathos.

Philip the Bold founded the Carthusian charterhouse in 1385 to house his tomb and those of his family. One of

the most famous monasteries of late-medieval Europe, it was unrivaled in wealth, size, and artistic decoration. Detailed accounts of its construction reveal that Jacques de Baerze, a south Netherlandish artist, sculpted two works for its interior, the Altarpiece of the Crucifixion and the Altarpiece of Saints and Martyrs.[1] In 1392 the pair was transported from Dijon to Ypres, where de Baerze's countryman, the great artist Melchior Broederlam, painted and gilded them. Seven years later the finished altarpieces were returned to Dijon and ceremoniously installed in the charterhouse.

The Charterhouse of Champmol was closed during the French Revolution; afterward, the Altarpiece of the Crucifixion was housed in several different locations in Dijon, where it suffered neglect and damage before entering the collection of the Musée des Beaux-Arts, Dijon, in 1819. It was restored in the mid-nineteenth century, and it was most likely at this time that a smaller replica of this corpus was set in place of the original.[2]

C.M.N.

## 38. *Christ's Appearance after the Resurrection*

From a pictorial New Testament

c. 1350

Northern France

Tempera and gold leaf on parchment; 28 x 20 cm (11 1/16 x 7 7/8 in.)

The Brewster Fund, 1922.3

---

HIGHLIGHTED IN GOLD, DELICATE GOTHIC arches frame each of the four images on this fragment, which illustrates Christ's appearance to his followers after rising from the dead. Roman numerals written next to these pictures not only connect each with a short caption in French but also guide the viewer's eye. At the upper left, the first in the series depicts Christ's appearance to the three Marys and combines several different Gospel

accounts of the events surrounding his resurrection.[1] The next scene, to the right, conflates two moments from the Gospel of Luke in which Jesus meets several pilgrims on the road to Emmaus and later dines with them. Similarly, the third image, located at the lower left, merges Christ's first appearance to his disciples with the incredulity of Thomas, as recounted in John's Gospel. The final picture is based on an account in Luke that tells how Jesus appeared to his disciples and shared a meal of fish with them.[2]

The thirteenth and fourteenth centuries saw the rise of Bible picture books such as the *Bible of the Poor*, the *Mirror of Human Salvation*, and the *Moralized Bible*.[3] This leaf was originally part of one such manuscript, a lavishly illuminated New Testament that relied primarily on images rather than text.[4] Because of their extensive

decorative cycles, it is believed that most Bible picture books were typically made for the religious edification and delight of a wealthy, educated laity. While pictures and captions familiarized readers with key moments of Scripture, they also provided visual support for church doctrine. The four images on this page, for instance, underscore the fundamental Christian belief that Jesus died on the cross and rose from the tomb three days later. Although there is no biblical source describing the moment of Christ's resurrection, this page certainly provided its readers with a visual record of his physical return. Its illustrations also offered medieval viewers models of faith, reminding them that, like the New Testament characters depicted, they must believe in Christ's resurrection in order to achieve eternal salvation.

L.K.B.

## 39. *Diptych with Scenes from the Life of Christ*

1340/60
France, Paris
Ivory; 21.3 x 21.6 cm (8 ⅜ x 8 ½ in.)
Kate S. Buckingham Endowment, 1970.115

THIS HINGED IVORY DIPTYCH SHOWS four scenes from the Life of Christ in a fashion strikingly similar to that of a contemporaneous Parisian manuscript leaf also in the Art Institute's collection (cat. 38).[1] As on that leaf, each of these vignettes is accentuated by an elegant architectural frame: a series of three-lobed arches, each ornamented with floral elements, distinguishes both the singular importance of each event and its unique, evocative power.

Unlike those on the illuminated page, however, these images cannot be read in a booklike manner, from left to right. Instead, the narrative sequence moves from top to bottom on each side, with representations of the Nativity, the Adoration of the Magi, the Crucifixion, and the Deposition. This nonchronological style of ordering prompts viewers to draw thematic comparisons between the facing panels.[2] On top, for example, the Nativity of Christ is juxtaposed with his death, emphasizing the theological point that his human birth would lead to the salvation of humankind through his ultimate sacrifice. The bottom scenes both show Jesus being presented with expensive unguents: as a child, at left, he receives frankincense, incense, and myrrh from the Magi, while at the right his lifeless body is anointed with myrrh and aloe by Nicodemus as it is placed within the tomb.

C.M.N.

## 40. *Mirror Case with Falconry Scene*

1325/50
France, Paris
Ivory; diam. 8.2 cm (3 5/16 in.)
Kate S. Buckingham Endowment, 1949.211

WITH ITS SCENE OF A lady and gentleman hawking, this ivory mirror back captures the chivalric manners of courtly society in fourteenth-century France. With birds of prey perching on their gloved hands, the pair ride out on prancing horses, attended by a servant who holds at bay three eager hunting dogs. Fantastic creatures appear in all four corners of the case; although heavily worn, human faces are still visible on two of them. This combination of man and beast evokes the symbolic meaning of the chase, which was often used as a visual metaphor for romantic desire and pursuit. At any moment, we know, the falcons and the dogs will be unleashed—a not-so-subtle allusion to the couple's own amorous inclinations. The popular literature of the time, which included ancient tales and Arthurian legends, also made clever use of metaphors, puns, and double meanings to portray the vision of all-consuming, unattainable love that captivated the nobility throughout medieval Europe.[1]

More mirror cases survive than any other type of secular ivory from the Middle Ages. Carved on one side, they possess grooves on the back into which polished metal disks were inserted. They were also squared on the side so that they could be handled easily and set upright; mirror cases were also pierced, as this one was, to allow for hanging. In the Gothic era, ivory was procured from the "Swahili corridor" on the East African coast, named for the enterprising merchants who channeled precious materials to clients from Europe to China.[2]

C.M.N.

## 41. *Virgin and Child with Scenes from the Life of Christ*

1320/40
Unidentified master (Italian, Veneto-Riminese, active 1300/50)
Tempera and gold leaf on panel; center panel: 63.8 x 46.8 cm (25 1/8 x 18 3/8 in.); left wing: 63.8 x 22.7 cm (25 1/8 x 8 5/16 in.); right wing: 63.8 x 23 cm (25 1/8 x 9 1/16 in.)
Denison B. Hull Restricted Fund, 1968.321

ALTHOUGH CREATED IN THE VENETO region of northern Italy, this relatively well-preserved triptych owes its style and format to both Byzantine art and works by the famous Sienese master Duccio di Buoninsegna. The three-part structure, with its large central picture and stacked narrative scenes on the wings, recalls Byzantine carved ivories.[1] Byzantine painting, meanwhile, is the ultimate source for the emphatically linear vocabulary of anatomy and costume and the simplified, highly stylized landscape elements. Yet these features may well have come to the Veneto by way of Siena, in Tuscany: this type of painted trip-

tych appears to have originated in that city, and the physiognomies of the Virgin and of some of the narrative figures resemble those in Duccio's oeuvre. Certain aspects of the coloring, notably the presence of plum, blue, green, and red throughout, and the use of a rich brown for the hair, are especially characteristic of paintings produced in and around the northern Italian town of Rimini, including those by the accomplished Giovanni da Rimini.[2]

Above the tender, cuddling Virgin and Child, in the spandrels of the arch, the artist presented a scene of the Annunciation. On the left wing, in descending order, appear the Nativity with the Adoration of the Magi, the Presentation of Christ in the Temple, and the Mocking and Flagellation of Christ. The right wing features, from top to bottom, representations of the Crucifixion, the Resurrection with the Noli Me Tangere, and the Ascension of the Virgin. The work retains numerous Byzantine details in these scenes, including the appearance of a cave, rather than a shed, in the Nativity, and a rendering of Christ stepping out of the tomb in the Resurrection. Yet despite these narrative conventions, which are also present in other Italian paintings of the period, the artist demonstrated a sensitive, creative approach to some of his subjects that suggests his familiarity with the most important examples of narrative painting of that time, including Duccio's Maestà Altarpiece (1308–11) in Siena or even Giotto's frescoes in the Arena Chapel (c. 1305), Padua.[3] Appended to the Nativity, for instance, is a touching portrayal of two maidservants preparing a bath for the Christ Child, one testing the temperature of the water with her hand. No less moving is the pose of Saint John in the Crucifixion, heavily burdened and knotted by his grief.

L.J.F.

# THE FIFTEENTH CENTURY

The International Gothic style dominated the pictorial arts at the turn of the fifteenth century. Easily recognizable by its elegant, elongated figures and by its practitioners' ability to suggest ephemeral qualities of light and atmosphere through the use of bright colors and rhythmic lines, this aesthetic was created by artists who traveled from one center of aristocratic life to another. They carried the movement from the papal court at Avignon to the rest of Europe, including major cities such as Paris, Prague, and London, and also to the courts of influential dukes in Anjou, Berry, and Burgundy.

One such locale was Dijon, in eastern France, which became a new artistic capital. Philip the Bold, Duke of Burgundy, established a family necropolis near the town at the Charterhouse of Champmol, hiring leading artists of the day to ornament the monastery with tomb sculpture and elaborately carved and painted altarpieces. Another great patron of the arts was Jean, Duke of Berry, brother of King Charles v of France (r. 1364–80), who owned two castles in Paris and at least seventeen others in the duchies of Berry and Auvergne. An inventory made at his death in 1416 records an astounding collection that included illuminated books, clocks, relics and reliquaries, jewelry, tapestries—and hunting dogs. In the cities, meanwhile, wealthy merchants commissioned important works for their local churches. In Nuremberg, for instance, Hans Imhoff the Elder engaged Adam Kraft to carve a great stone tabernacle for the Church of Saint Lawrence, which still maintains a great deal of its late-Gothic appearance.[1] Such commissions were intended as acts of piety but also served to elevate a patron's status within his or her community.

The fifteenth century was marked by events that included the Battle of Agincourt in 1415, during which English longbow archers overwhelmed a superior French army. The year 1453, meanwhile, marked the effective end of the Byzantine Empire as the victorious forces of the Ottoman Emperor Mehmet II (r. 1451–81) marched into Constantinople. Yet the most dramatic vehicle for change in Europe was neither the sword nor the pen, but the printing press. Johannes Gutenberg's Bible, printed in Mainz in 1456, is undoubtedly the best-known product of this new technology, which made the rapid dissemination of both text and image suddenly possible. For several decades before, however, other printers had been producing woodcuts in much the same fashion, enabling individuals to own devotional pictures that they could carry with them, tack on their walls, and use as tools in their own quest for salvation.

Opposite: Cat. 56 (detail).

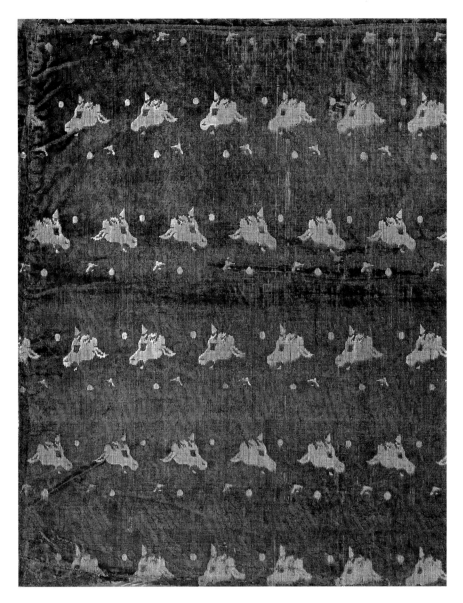

THIS VELVET PANEL PRESERVES an all-over pattern that depicts what is most likely the heraldic device of a noble family: the heads of eagles and oxen, connected by floral stems that the animals clasp in their mouths. That the piece displays this *impresa*, or crest, indicates that it was specially ordered; that it was woven in three colors, the product of the most sophisticated technique, confirms its status as a luxury item commissioned by a discerning patron.[1] It must originally have been part of a lavish garment that would have been worn to celebrate only the most special of occasions.

The richest of all textiles is velvet, which enjoyed enormous popularity in fifteenth- and sixteenth-century Europe, particularly in Italy and Spain. One of the fabric's attractions was its intrinsic complexity and variation: in it, weavers were able to create a ground weave and its pile, pattern, and texture, all at the same time. The colors have lost none of their original brilliance and visual power: the vibrant red of the birds, for example, is mirrored in the startling hue of the oxen's eyes. The white areas are worn off, indicating that the pile is completely gone. This may have been caused by a chemical reaction on the white silk threads.

C.M.N.

## 42. *Velvet Panel with Ox Heads and Eagles*

1400/50
Italy
Silk, plain weave with three-color supplementary pile warps forming cut solid velvet; left selvage present; 49 x 59.9 cm (23 ⅝ x 19 ¼ in.)
Kate S. Buckingham Endowment, 1954.12

## 43. *Portion of a Chasuble*

1483/93?
Probably Italy, Florence
Silk, warp-float-faced satin weave with three-color
complementary pile warps forming solid cut velvet;
52.7 x 22 cm (20 ¾ x 8 ⅝ in.)
Inscribed: *JUSTUS UT [PALMA] FLOREBIT*
(The just will flourish like the palm)
Gift of Martin A. Ryerson through the Antiquarian Society of
The Art Institute of Chicago, 1895.8470

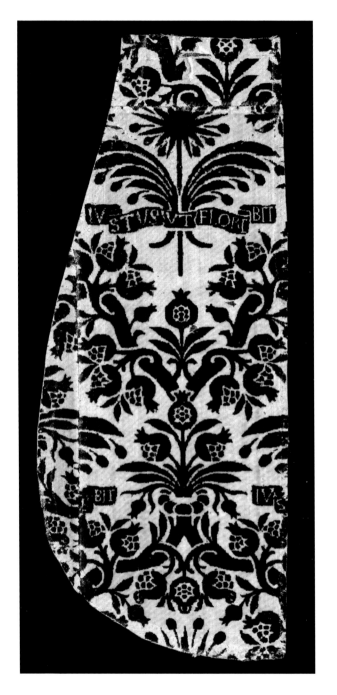

LIKE THE ART INSTITUTE'S PANEL with ox heads and eagles (cat. 42), this velvet fragment is decorated with the emblem of a member of the patrician family that commissioned it—in this case the Soderini of Florence. Made of silk, it represents the highest level of textile production in fifteenth-century Italy.[1] The panel was woven in three colors, with deep green and vibrant red set against a golden background. Its pattern depicts palm fronds, pomegranates, and banderoles reading *Justus Ut [Palma] Florebit* (The just will flourish like the palm), words taken from Psalm 91 and sung while the celebrant makes his entrance during Mass.

Originally part of a chasuble, a garment worn by priests, this piece was most likely made for Piero di Tommaso Soderini during the early stages of his multifaceted career. Soderini became a prior in 1481 but went on to hold a number of prestigious political appointments. Because he was a favorite of Piero di Lorenzo de' Medici, the de facto leader of Florence, he was chosen to serve as ambassador to the French court in 1493. Nine years later he was elected *gonfaloniere*, or chief magistrate, for life by Florentines eager for stability following the expulsion of the incompetent Piero di Lorenzo and the execution of the preacher Savonarola, who had established a democratic republic after the Medici were overthrown. Soderini, however, ruled for only ten years before the Medici returned and sent him into exile. After this, he lived in Dalmatia for a time until the Medici Pope Leo x summoned him to Rome, where he resided until his death in 1522.

C.M.N.

## 44. *Marriage Casket with Scenes from Classical and Romance Literature*

1390/1400
Italy, Venice
Bone, cow horn and hoof, and wood; h. 33 cm (13 ¹⁵/₁₆ in.);
w. of base 28.6 cm (11½ in.)
Bequest of Mrs. Gordon Palmer, 1985.112

THIS CASKET IS TYPICAL OF the high-quality items that the Embriachi workshop in Venice produced for wealthy patrons in Northern Italy and Burgundy.[1] It boasts impressive *certosina* work (an inlay of bone, horn, and stained woods) and also exhibits convex panels of carved bone that depict scenes from various myths and period romances. Episodes from several different stories—among them the Judgment of Paris and Giovanni Fiorentino's *The Simpleton* (1378)—appear here in a disjointed fashion, which suggests that the box was probably reassembled haphazardly sometime after the Middle Ages.

Caskets of this sort would have been used to hold jewels and documents and were often presented as lavish bridal gifts; some still retain traces of polychromy and gilding. In addition to secular objects, the Embriachi atelier also produced domestic items for devotional use, including house altars, diptychs, and triptychs. These, along with wedding caskets, were produced on speculation and sold as stock items.

The Embriachi family, a group of cosmopolitan entrepreneurs and carvers, crafted a prodigious number of such objects for the Italian and international markets. They were also responsible for several important liturgical pieces—among others, a large triptych with biblical scenes commissioned by the Bishop of Pavia and an altarpiece that Philip the Bold, Duke of Burgundy, gave to the Charterhouse of Champmol (see cat. 37).[2] While they were certainly skilled artisans, the Embriachi were also members of a rising merchant class. Baldassare di Simone d'Aliotto degli Embriachi, for instance, was a dealer of jewels in England, France, and Spain and also worked in Venice as a *cambiatore*, a political broker and banking agent, for the Duke of Milan. Although the Embriachi were active into the 1430s, other north Italian workshops continued to make items modeled on their works for some time thereafter.

C.M.N.

## 45. *Bust of a Young Man in Profile*

1430/40
Giovanni Badile (Italian, 1379–1448/51)
Metalpoint on cream laid paper, prepared with
grayish white ground over red chalkwash ground, laid down
on blue wove paper; 24.1 x 17.4 cm (9 ½ x 6 ⅞ in.)
Inscription: recto, upper center, in pen and brown ink, *joane
badile • 2 •* (?) *prete* (priest)
Margaret Day Blake Collection, 1957.79

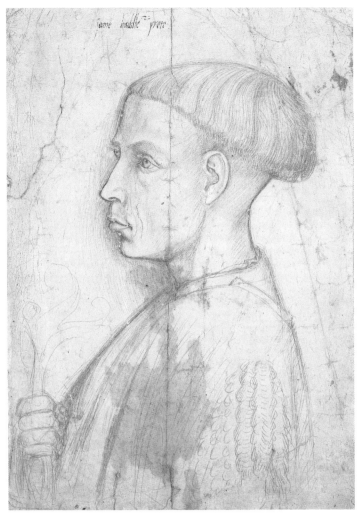

WHEN THIS DELICATE METALPOINT DRAWING entered the Art Institute in 1957, it was considered a rare, early masterpiece of portraiture from the circle of Rogier van der Weyden, the major Flemish artist of the mid-fifteenth century. Now it is recognized as an example of the refined artistry of fifteenth-century Verona, cradle of Italian draftsmanship.[1]

The drawing depicts, in profile, a young man with a protruding lower lip. Sporting a short, bowl-like haircut, he wears a simple garment embellished with thin, embroidered trim. He seems to be holding before him a plant or staff that is barely but evocatively suggested; both his ear and his long, distinctive nose, however, are described in emphatic lines and vivid detail.

The inscription above the sitter's head appears to have been written by the Veronese painter Antonio Badile and can be found on other drawings that he is believed to have gathered from various family members and organized into an album around 1500. The Badile were a dynasty of artists active in Verona from the fourteenth through the sixteenth century. One notable member of the family was Giovanni Badile the Elder, a follower of Stefano da

Verona, a painter who was instrumental in easing the International Gothic style toward that of the early Renaissance. Judging from the inscription, this drawing appears to have been executed by one of his sons, who shared the same name.[2] The abstraction of the subject's simplified body and the regularity of his hairstyle recall visual formulas of the medieval era. The new humanism, however, reveals itself in the keen attention to personalizing detail in the slight turn of his head, his deeply expressive facial features, and the glimpse of a bit of undergarment at the back of his neck.

The work's medium is particularly suited to its role as a harbinger of early Renaissance draftsmanship. Metalpoint is executed by dragging a fine point (often made of silver or copper) across a prepared ground—usually a sheet of paper coated with a mixture of glue and bone-marrow dust. The technique results in an oxidized line that is very fine and brittle and that cannot be corrected; at the same time, it reveals the talents of a virtuoso draftsman and underscores the preciousness of the drawn line. For those reasons it was favored by some of the great Florentine artists of the day, although later largely abadoned until the twentieth century.

S.F.M.

## 46. *The Gentleman*

Plate Five of *Tarocchi: The Ranks and Conditions of Man*, E Series

1465/67

Master of the E-Series Tarocchi (Italian, Ferrarese, active c. 1465)

Engraving on ivory wove paper; image: 17.8 x 10 cm (7 x 3 ¹⁵/₁₆ in.); sheet: 18.4 x 10.4 cm (7 ¼ x 4 ⅛ in.)

Inscription: below the image, in the plate, • *ZINTILOMO* (gentleman) • *V* •

Gift of Mr. and Mrs. Potter Palmer, Jr., 1924.39.37

THIS DELICATE ENGRAVING, PART OF a group of fifty images resembling playing cards, dates from the early years of printmaking in Italy. Probably created in Ferrara in the mid-1460s, the enigmatic series to which it belongs is organized into five thematic groups: Ranks and Conditions of Man, Apollo and the Muses, Liberal Arts, Virtues, and Celestial Spheres. It is not clear whether the prints were actually intended for a game, since their substantial size would make them awkward to handle and shuffle as a deck. Scholars have concluded that these are not tarot cards; indeed, at the time the word *tarocchi* simply meant "picture cards." If used for a game at all, they suggest, it would have been for one that was somehow educational in nature.[1]

Every card is marked in the bottom margin with both Roman and Arabic numerals. Within each thematic cluster the subjects are ordered hierarchically; thus, the lowest card in the Ranks and Conditions of Man, *The Beggar*, corresponds to the lowest position on the social ladder, while the highest card is *The Pope. The Gentleman*, shown here, falls into the middle of the deck between *The*

*Merchant* and *The Knight*. Although no directions for using the tarocchi have survived, it seems clear that part of their purpose was to help users memorize hierarchies and logical systems of classification. In fact, they appear designed to teach a particularly medieval view of the universe in which everything was imagined to be linked together in the Chain of Being, visualized as a kind of ladder leading from earth to heaven.[2] Situated firmly within this structure, the gentleman is shown engaged in hunting, a popular pastime for members of the nobility, and he possesses the proper trappings of his station: a servant, dogs, and a falcon.

There are two versions of the tarocchi deck, which are almost certainly the work of two different artists. The E Series, named for the letter found in the lower-left-hand corner of the first thematic group, is thought to be the original. The second version is the so-called S Series, a free copy of the earlier deck in which most of the subjects appear in reverse.[3] The refined decorative technique used by the engraver of the E Series points to his training in the metalwork crafts, from which intaglio printmaking evolved in mid-fifteenth-century Italy.

M.T.

## 47. *Pendant with Head of John the Baptist*

15th century

France

Gold, enamel, and carnelian; 6.2 x 4.7 cm (2 7/16 x 1 7/8 in.)

Inscription: *SANCTE JOHANNES BAPTISTA ORA PRO*

(Saint John the Baptist, pray for . . .)

Gift of Marilynn B. Alsdorf, 1992.301

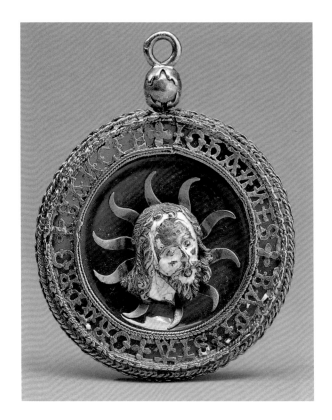

IN CONTRAST TO THE STRIKING, almost shocking, image of Christ in the Art Institute's *Man of Sorrows* woodcut (cat. 55), the elegant appearance of this pendant belies its gruesome subject: the severed head of Saint John the Baptist.[1] According to Gospel accounts, King Herod was so charmed by Salome's dance at a banquet that he offered her anything she wanted; at her mother's prompting, the young woman requested John's head on a platter. Salome was the daughter of Herod's sister-in-law Herodias, whom he had taken as his own mistress. When the Baptist spoke out against their illicit relationship he immediately incurred the couple's wrath.

Here, John's face is rendered in white enamel and set upon a carnelian charger, where it sends forth golden rays like the sun. The encircling inscription implores the saint to act as an intercessor, presumably on behalf of the pendant's wearer. Europeans became increasingly devoted to John the Baptist from the thirteenth century onward, and imagery of this sort proliferated in a range of objects and media, from small pilgrimage badges to ornate dishes housed in church treasuries. In France, for example, the cathedral at Amiens had a relic of the saint—a portion of his skull—mounted on a silver platter elaborated with precious gems. The inventory of Jean, Duke of Berry, notes that he possessed a similar skull that was affixed to a jasper plate decorated with gold and precious stones.[2] Meanwhile, at the Cathedral of Saint Blaise in Brunswick, Germany, another relic of Saint John was preserved and displayed in a gilt silver reliquary (cat. 31).

C.M.N.

## 48. *Retable and Altar Frontal*

c. 1468

Spain, Burgo de Osma

Linen, plain weave; appliquéd with linen and silk, plain weaves; silk, plain weave with supplementary pile warps forming cut solid velvet

Retable: embroidered with silk floss and creped yarns; gilt-and-silvered-metal-strip-wrapped silk in brick, bullion, chain split, stem, and a variety of satin stitches; laidwork, couching; padded couching; seed pearls and spangles; 165.2 x 200.8 cm (65 x 79 in.)

Altar frontal: embroidered with linen, silk, gilt-metal-wrapped silk in satin and split stitches; laidwork, couching; padded couching; spangles; 88.8 x 202.3 cm (35 x 79 ⅝ in.)

Inscriptions (reconstructed): altar frontal: along top, *O HOMO RECORDARE QUIA PRO TE IH[ESU]S HEC TOR-MENTA PASUS EST* (Remember, O man, that Jesus suffered these pains for you); along bottom, *RESUREXIT DOMINUS IUSTUS VERE ET APARIVIT SIMONI* (The Lord is indeed risen and appeared to Simon)

Gift of Mrs. Chauncey McCormick and Mrs. Richard Ely Danielson, 1927.1779

---

THIS EMBROIDERED RETABLE AND ALTAR frontal was made for Pedro de Montoya, who served from 1454 to 1475 as Bishop of Osma, a city on Spain's central plain.[1] As was customary with painted and carved altarpieces, the upper portion, or retable, was fashioned as a triptych with three scenes from the Life of Christ. Here, seen from the left, are visible the Nativity, the Virgin and Child enthroned, and the Adoration of the Magi. The lower portion, known as an altar frontal or *ante-pendium*, features a central scene of the Resurrection, which is flanked by six apostles. One of this textile's particularly impressive features is the degree of surface depth that master embroiderers were able to achieve by employing the *or nué* technique over heavily padded areas. In this process, workers laid gold threads over a plain-woven foundation in a horizontal manner, fastening them with tightly couched silk threads. Thanks to their efforts, the colonnettes and vaults that separate the different vignettes take on an architectural appearance.

Montoya's coat of arms, which is featured prominently in the medallions around the retable's outer edge, consist of ten silver leaves set against a blue ground and surmounted by the green hat of his episcopal office. It was in reward for his valiant service in the Spanish civil wars of the fifteenth century that Montoya was named Bishop of Osma, a position that made him both the city's religious head and its political overlord. In 1456 he endowed the town with a wall, no doubt in the hope of protecting his domain from the ongoing unrest that plagued Castile and Aragon until the marriage of Ferdinand and Isabella brought peace to the region in 1469. After that, the bishop turned his attention to enriching his cathedral.

Montoya constructed several small chapels for the building, and, in the early 1470s, added a library to house his large collection of manuscripts. It was during this campaign of improvements that the Art Institute's retable and altar frontal entered the collection of the cathedral, where it was probably installed in a small chapel dedicated to Saint Peter.[2] Prior to that, Montoya had used the work as his own foldable, traveling altarpiece.

The altarpiece was moved and mutilated over the course of the next few centuries and was eventually acquired by the Chicago industrialist Charles Deering.[3] Deering had it shipped back to Spain, to his estate at Sitges, near Barcelona, where he hoped to establish an art center. When this dream proved elusive, he transferred his collection to his estate in Florida. His daughters, Marion Deering McCormick and Barbara Deering Danielson, bequeathed this treasure to the Art Institute following his death in 1927. C.M.N.

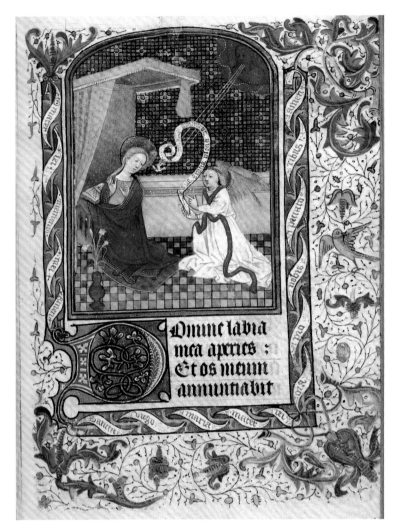

## 49. *The Annunciation*

From a Book of Hours (f. 36r)

1440/45

Belgium, Ghent or Tournai

Tempera and gold leaf on parchment; 19 x 13 cm (7 ½ x 5 ⅛ in.)

Gift of Mrs. J. J. Borland and friends, 1915.538

THIS ORNATELY DECORATED PAGE COMES from a Book of Hours, by far the most popular book of the Middle Ages and Renaissance.[1] Produced in vast numbers throughout Europe from the mid-thirteenth through the sixteenth century, such volumes took on varied appearances depending on the region and period in which they were made. This example has been attributed to the workshop of the prolific Master of the Ghent Privileges, who was active in mid-fifteenth-century Belgium.[2] Despite differing decorative styles, every Book of Hours centered upon the Hours of the Virgin, a sequence of prayers recited at precisely set times of the day and night. Guided by the text, readers asked Mary in heartfelt terms to hear their petitions, take pity on them, and plead their case to Christ, who ultimately could not deny his own mother's wish.

On this page, the prayers read at Matins, the early morning service that commences the Hours of the Virgin, begin "Lord, thou shalt open my lips, and my mouth shall sing thy praise; God, come to my assistance; Lord, hasten to help me."[3] These opening words set the tone for the rest of the personal devotions. The scene accompanying the first set of prayers is the Annunciation to the Virgin. Here, the artist captured Mary turning gracefully away from her open book, startled by the arrival of the archangel Gabriel. The angel points to a banderole bearing the partially erased phrase *Ave maria, gratia plena, dominus tecum,* or "Hail Mary, full of grace, the Lord is with you." This message announces to the young woman that she will soon become the mother of Jesus. Above, a small dove descends from God the Father on thin rays of light, marking this as the moment of Christ's miraculous conception.

In addition to providing visual pleasure, decorations such as these served both practical and spiritual purposes. Images helped readers navigate by highlighting the beginning of different parts of the text. For instance, each of the sections in this example is introduced with a different episode from the infancy of Christ.[4] The text included on Gabriel's banderole and in the twisting scroll surrounding the main image not only recalls the angel's words to the Virgin but also serves as a reminder of the Hail Mary, the canonical prayer said before each and every hour. Quietly reading, the Virgin herself presents a model of devotional contemplation.

L.K.B.

## 50. *Christ Carrying the Cross*

1420/25

Master of the Worcester Carrying of the Cross
(South German, active 1420/30)

Oil on panel; 24.6 x 19.5 cm (9 $^{11}/_{16}$ x 7 $^{11}/_{16}$ in.);
image: 23.9 x 18.7 cm (9 $^{7}/_{16}$ x 7 $^{3}/_{8}$ in.)

Charles H. and Mary F. S. Worcester Collection, 1947.79

IN THE LATE MIDDLE AGES, particularly in Germany and parts of the Netherlands, it was commonplace for the episodes of Christ's Passion to be described with exaggerated brutality, both in mystical literature and in art. Like the gentler subjects of the Nativity and the relationship of Christ and his mother, such texts and images were intended to encourage an empathetic identification with the human aspect of Christ's nature. The recitation of suffering in Psalm 22 was taken as prophetic of the events leading up to the Crucifixion.[1] That Psalm, which begins with the question "My God, my God, why hast thou foresaken me?"—words also uttered by Christ from the cross—contains vivid descriptions that were enacted in scenes of the Passion, verses such as "Packs of dogs close me in, and gangs of evildoers circle round me; they pierce my hands and feet; I can count all my bones."

This small panel is the only remnant of what was presumably a series of multiple scenes making up an altarpiece. Soldiers beat and mock the central figure of Christ as he shoulders his cross on the way to Calvary. The Virgin and other followers, shown at the extreme left, are likewise mocked by the crowd. The painter was not interested in representing the clear relationship of different figures in space. Instead, he created a lively pattern that emphasizes the essential action of each figure and its corresponding emotional state. The heads and hands of the background soldiers establish a jagged rhythm against the gold ground. The angular pose of the prominent, pigtailed soldier derives from the force with which he pulls on Christ's robe and strains against the rope that binds his victim's waist. The yellow-clad soldier at left strikes a similarly complex pose, activated like that of a dancer; it highlights his coarse expression and gesture. Between these two exaggerated, disreputable tormentors, the form of Christ seems to dissolve, a model of resignation.

This small panel is the only painting attributed to this masterful artist, who takes his name from it. Several drawings have been attributed to him, however, and the influence of his balletic, foreshortened figures has been traced in the work of painters in Munich, Regensburg, and other south German centers.[2]

M.W.

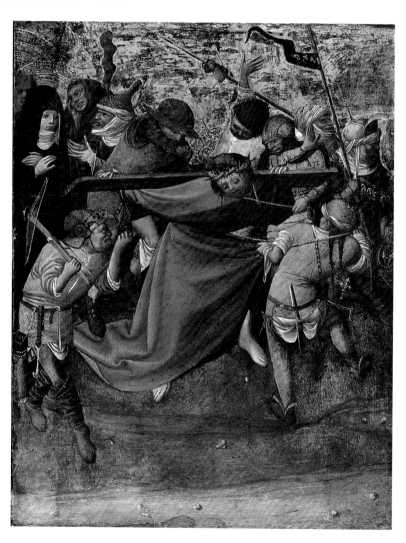

## 51. *Christ on the Living Cross*

1420/30
Follower of the Master of Saint Veronica
(German, active 1395/1415)
Oil on panel; 48.2 x 28.7 cm (19 x 11⅜ in.);
image: 40.7 x 23.3 cm. (16 x 9 3/16 in.)
Charles H. and Mary F. S. Worcester Collection,
1936.242

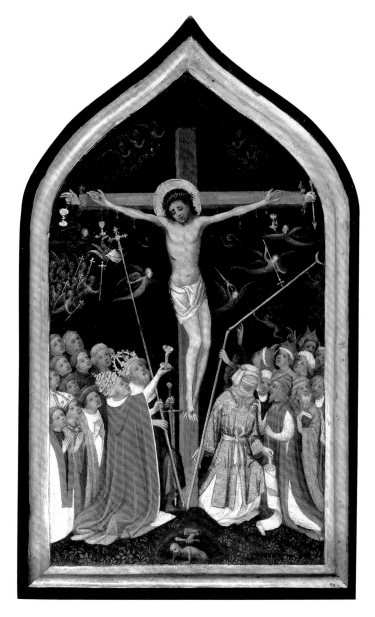

THIS PAINTING, WITH ITS SWEET, doll-like figures, was made in the great ecclesiastical center of Cologne, probably in the third decade of the fifteenth century. Its imagery reflects the tensions and dramatic changes of the early fifteenth century, when the Catholic Church was threatened both within and without. Since 1378 it had been divided, with rival claimants to the papacy established in Avignon and Rome, and a third pope elected in 1409. In eastern Europe the Turks actively threatened Christian lands, while Jan Hus's radical reform movement in Bohemia challenged much church doctrine.

The Living Cross, an iconographical type that first appeared around 1400, explicates the essential role of Christ's sacrifice and the Eucharist in the scheme of salvation.[1] The church, as the beneficiary of Christ's sacrificial death, is represented at his favored right hand under the cross, while the covenant of the Old Testament, now rendered obsolete, appears at his less-favored left side. Hands growing out of the cross's ends dramatize this scheme. At the bottom a hand with a club overcomes death; on Christ's right, another blesses the crowd representing the church; and a third, on his left, aims an arrow at the people of the old covenant, headed by a blindfolded high priest. It is clear from other images of the Living Cross that a hand emerging from the top beam originally held a key to the gate of heaven, but this area has been damaged.[2] A swarm of tiny angels expand the stark symbolism of the theme, catching Christ's blood in chalices and carrying the fight to a crowd of devils.

The picture's small scale suggests that it was made for a member of a religious order, who would have used

it as a focus of private devotion. This patron must have been particularly concerned with the continued unity of the church, since the new and old covenants, usually represented by the female figures Ecclesia (Church) and Synagoga (Synagogue), are replaced here by crowds of the faithful. On the side of the church, they are led by a pope and a dignified, bearded emperor who together hold up the standard of Ecclesia. This collaboration probably refers to the active role played by the Holy Roman Emperor Sigismund (r. 1433–37) in the Council

of Constance (1414–17), which negotiated an end to the schism in the church and elected a single pope, Martin V.[3] In any case, this work's combination of dogma, symbolism, and intense emotion is in keeping with this period of transition, one hundred years before the more decisive changes of the Reformation.

M.W.

## 52. *The Last Judgment*

From Jean Chapuis, *Seven Articles of Faith*
c. 1470
Maître François (French, active 1460–85)
France, Paris
Tempera and gold leaf on parchment; 27 x 17.2 cm
(10 ⅝ x 6 ⅜ in.)
Ada Turnbull Hertle Fund, 1957.162

THIS IMAGE OF THE Last Judgment underscores Jesus's role as the majestic ruler of heaven and earth.[1] Christ sits enthroned upon a rainbow and encircled within a mandorla of light, while an angel commands that the dead rise and be judged. Jesus oversees the separation of the saved and the damned, which is carried out by several angels below and announced in the banderoles that flank him on either side, reading "Come ye blessed of my father" and "Go to the eternal fire ye accursed."[2] While the angels on the left gently escort the blessed toward heaven, the cursed are forced into a gaping chasm filled with grimacing demons, at right.

Seated on either side of Jesus is his holy tribunal, which includes various saints and apostles, several of whom can be identified by their placement and the objects they carry. Directly to the left is the Virgin Mary, the heavenly defender who requests her son's benevolence and mercy on behalf of humankind. On the right sits Saint John the Evangelist holding a chalice with a serpent; he is positioned slightly in front of Saint John the Baptist, who is dressed in animal skins, and Saint Peter, who holds the keys to heaven. This scene originally illustrated a copy of Jean Chapuis's *Seven Articles of Faith*, a fourteenth-century poem

that explored the moral implications of Jesus's life from his birth to his eventual second coming.[3] While the complete manuscript is now lost, this was probably the last of seven full-page miniatures that signaled the beginning of each section of the work.

On the basis of its style, this large leaf has been associated with the Maître François.[4] Like others attributed to that artist, it demonstrates his delicate use of grisaille coloring and an expert application of minute stippling to construct solid, sculptural figures whose individual reactions are carefully rendered. The Maître François takes his name from a letter written by Robert Gauguin, an eminent scholar, to Charles de Gaucourt, a humanist and governor of Amiens. Referring to "the most distin-

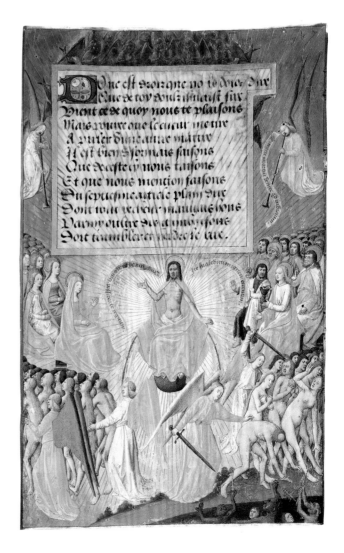

guished painter François," Gauguin even compared his achievements to those of the famed Greek painter Apelles. There is often little record of late-medieval artists, which makes Gauguin's reference to this master's identity all the more valuable.[5]

L.K.B.

## 53. *Chasuble Front with Orphrey Cross*

Chasuble Front
Italy, Florence
15th century
Silk, plain weave with supplementary facing wefts, twill inter-lacings of secondary binding warps and supplementary facing wefts forming weft loops in areas and supplementary pile warps forming cut, pile-on-pile voided velvet; 126.6 x 70.5 cm (49 7/8 x 27 3/4 in.)

Orphrey Cross
Bohemia or South Germany
15th century
Linen, plain weave; embroidered with silk and gilt- and silvered-animal-substrate-wrapped linen in bullion, outline, satin, and split stitches; laidwork, couching, and padded couching; edged with woven fringe and tapes; 112 x 57.7 cm (44 x 22 3/4 in.)
Grace R. Smith Textile Endowment, 1980.615

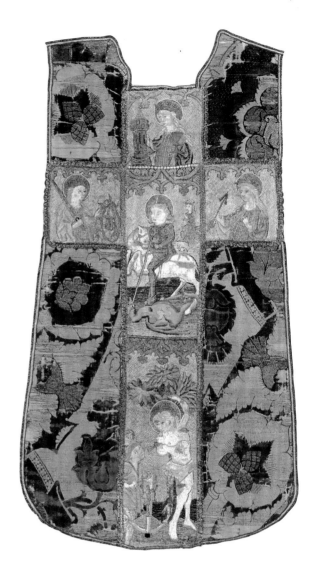

LIKE BERNAT MARTORELL'S PAINTING *Saint George Killing the Dragon* (cat. 54), the central panel of this garment testifies to the saint's appeal during the Middle Ages.[1] The piece decorates the center of a Bohemian or South German orphrey cross that was later attached to an Italian chasuble. Its fine needlework, accentuated with gold and silver thread, must have produced a dazzling effect when seen during a candle-lit Mass.

Here, Saint George appears along with four other popular saints. He is flanked by Catherine and Ursula on the left and right, while Barbara and Sebastian are positioned above and below. The small animal in the background of the central panel, visible between Saint George and the princess, is doubly significant. On the one hand, it may represent one of the sheep that was supplied to the hungry dragon each day; when these animals eventually failed to satisfy the monster's voracious appetite, a human sacrifice—the princess—was offered up. Yet the meek-looking creature might also allude to George's victory: once he had conquered the dragon, he asked the princess for her garter, placing it around the beast's neck so that she could lead it around like a lamb.

C.M.N.

## 54. *Saint George Killing the Dragon*

1434/35

Bernat Martorell (Catalan, c. 1400–1452)

Tempera on panel; 155.6 x 98.1 cm (61 ¼ x 38 ⅛ in.)

Gift of Mrs. Richard E. Danielson and Mrs. Chauncey B. McCormick, 1933.786

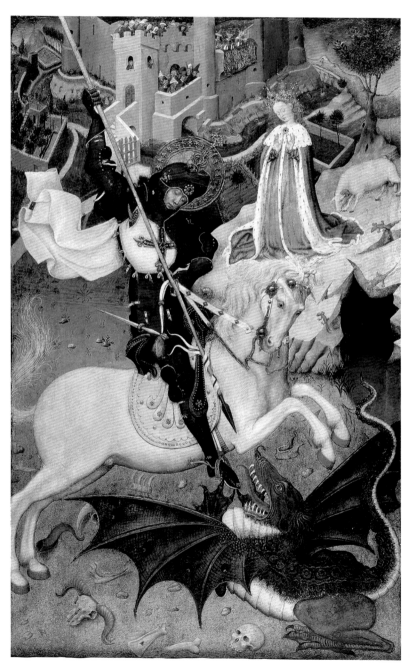

SAINT GEORGE WAS ONE OF the most popular saints in the Middle Ages, although the details of his life were even then regarded as uncertain.[1] An officer in the Roman army, he aided the city of Silena in Libya when it was threatened by a dragon, which demanded a daily offering of sheep as well as a youth or maiden. Fortuitously, the saint arrived just as the king's daughter was about to become the monster's next meal. In this painting the saint and dragon fill the picture field, while the rest of the elements of the story are fitted into the relatively flat background. The princess and the sheep appear at the upper right; above them, the king, queen, and townspeople watch from the ramparts. The ground plain is strewn with the skeletal remains of the dragon's victims.

This work was not intended as an independent painting but was rather the central, cult image of an altarpiece dedicated to Saint George. Four narrative scenes showing his gruesome martyrdom, now in the Musée du Louvre, Paris, were formerly arranged one above the other on either side of this panel.[2] As was typical for Catalan altarpieces, the central panel would have been crowned by an image of the Crucifixion, the whole supported by a base decorated with smaller narratives. The entire upper portion of the altarpiece would have been surrounded by a beveled frame called a *guardapolvos*, or dust guard, decorated with the patron's coat of arms.[3]

Although the early history of the altarpiece is undocumented, this patron was almost certainly the Catalan government, or Diputació, and its destination their chapel of Saint George, built in the 1430s in Barcelona's Palau de la Diputació. Related imagery in other surviving parts of the chapel decoration, including an embroidered altar frontal, support this identification, as does the Diputació's documented relationship to the altarpiece's painter, Bernat Martorell. In 1440 the body awarded him the hon-

orary title of *pintor banderer* (painter banner-bearer).[4]

Martorell, the leading Catalan painter in the early fifteenth century, has here combined the graceful, richly ornamented style known as International Gothic with selective, realistic details, creating in the altarpiece one of his finest works. In particular, he used a technique of gesso worked in relief to give a sculptural quality to this central panel. The halo, weapons, and the horse's harness are carved in relief and gilded, while the textures of the dragon's scaly skin are modeled in relief, but painted.

M.W.

## 55. *Man of Sorrows*

1465/70
Germany (School of Ulm)
Woodcut with hand-coloring in green, red, yellow, and brown, on cream laid paper mounted on vellum, laid down on oak book cover wrapped in hand-tooled leather with tooled metal hinges; 40.3 x 26.7 cm (15 7/8 x 10 1/2 in.)
Inscription: atop the cross, *INRI* (Jesus of Nazareth, King of the Jews)
Robert A. Waller Fund; gifts of Mrs. Tiffany Blake, Thomas E. Donnelley, in memory of Mrs. Emil Eitel, Mr. and Mrs. Edwin W. Eisendrath; William B. Eisendrath; Mr. and Mrs. William N. Eisendrath, Jr.; Carolyn Morse Ely; Alfred E. Hamill; Mrs. Arnold Horween; Frank B. Hubachek; and Mrs. Potter Palmer, 1947.731

THIS LARGE, BEAUTIFULLY PRESERVED WOOD-CUT survived because it was pasted onto the inside front cover of a devotional book, most likely a missal, where it was protected from light and damp. The designs on the tooled leather cover, which by the nineteenth century had become separated from the rest of the volume, suggest that the object once belonged to a convent library.

The Chicago *Man of Sorrows* was probably created in Ulm, an important early center of woodcut and book making in Germany.[1]

The art of the woodcut began to be practiced in Europe in the mid-fifteenth century, at about the same time that Johannes Gutenberg introduced movable type. Both new industries were fueled by the recent emergence of paper mills in Europe, which produced a less expensive and more absorbent printing surface than vellum. While many of the woodblocks carved in the first decades of printmaking were intended to serve as book illustrations, there was also a trade in single-sheet woodcuts such as this one. These images are often larger than those created for the burgeoning book trade and frequently depict subjects that were intended to assist people in their private spiri-

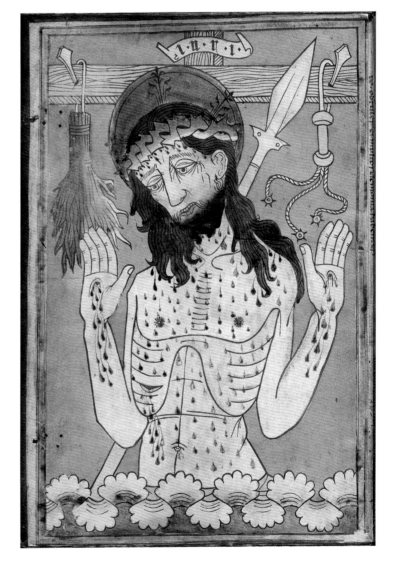

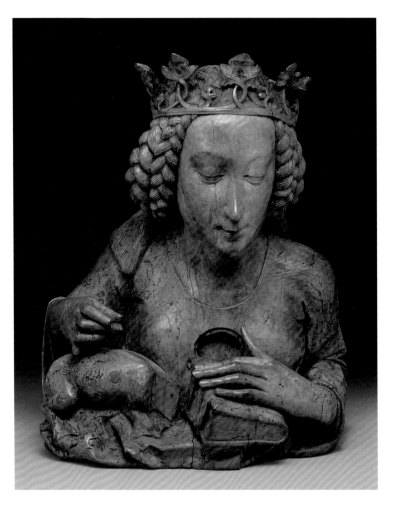

tual devotions, in the same way that altarpieces enhanced the prayers of churchgoers. Much more affordable than paintings, such prints would have been pinned to walls in private homes or pasted into Bibles and traveling chests. Light and portable, woodcuts bearing religious subjects were also carried by pilgrims as souvenirs of their journeys to holy sites. Because they were actively used in daily life, many early examples did not survive.

This monumental image is unique—no other impressions from the same block are known to exist. On the other hand, the theme of the Man of Sorrows, which focuses on Christ's wounds and the instruments of his torture, appears with some frequency in woodcuts of the period. Like more general images of the Passion, such works would have helped viewers better comprehend the sacrifice of the Lamb of God.[2] Images of the Crucifixion are also common in early single-sheet woodcuts, since both themes were effective in triggering a heightened emotional and spiritual response in devout individuals.

M.T.

## 56. *Reliquary Bust of Saint Margaret of Antioch*

1465/70
France, Alsace
Attributed to Nicolaus Gerhaert von Leyden (Netherlandish, active 1462–73) or a close follower
Walnut with traces of polychromy; 50.8 x 43.8 x 28 cm (20 x 17 ¼ x 11 in.)
Kate S. Buckingham Endowment, 1943.1001

THIS BUST OF SAINT MARGARET of Antioch was made for the Church of Saints Peter and Paul in Wissembourg, near Strasbourg, and was most likely positioned at the high altar along with similar reliquary portraits of saints Agnes, Barbara, and Catherine of Alexandria.[1] One of

the Fourteen Holy Helpers, Margaret was relied upon as the protector of motherhood and was especially invoked during labor and delivery. According to accounts of her life, she spurned the affections of the Roman prefect of Antioch, in Asia Minor, and was tortured and imprisoned. While in captivity, she encountered the Devil in the form of a dragon and was able to repulse him by making the sign of the cross—a well-known part of her story that was recalled by the cross this sculpted figure once held in its right hand. A relic of the saint, now lost, was contained by the cavity in its chest.

Nicolaus Gerhaert, whose documented career lasted barely more than a decade, was nevertheless one of the most influential sculptors of the late fifteenth century.[2] Living in Strasbourg, he is believed to have hailed from the Netherlands, and his style was certainly influenced by northern artists such as the painter Jan van Eyck and

the sculptor Claus Sluter. Gerhaert brought religious subjects to life with a sense of heightened realism, even earthiness. This image of Saint Margaret, for example, is remarkable for the irrepressible personality suggested by her lively expression and the unique details of her physiognomy—animated brow, pert nose, and pursed mouth.

The rediscovery of three of the Wissembourg reliquary busts in American collections during the twentieth century reads almost like a detective novel. Although we cannot be certain when the works left their first location, it was most likely some time after the French Revolution that the sculptures were taken to Strasbourg. Plaster casts were made around 1870, and the originals were then restored and placed on the market. By 1894 the bust of Saint Margaret had surfaced in a private collection in Paris, its provenance apparently forgotten. In 1909 it was listed as being a sixteenth-century German sculpture and once again sold.[3] A year later the newspaper magnate William Randolph Hearst purchased the piece in Paris, at which time it was mistakenly thought to be the product of a sixteenth-century Spanish workshop. In the same year, the New York financier J. Pierpont Morgan acquired the busts of saints Barbara and Catherine and gave them to the Metropolitan Museum of Art. In 1913 the great art historian Wilhelm Vöge studied the four plaster casts, still on view at the cathedral museum in Strasbourg, and attributed them to Gerhaert's circle. Soon afterward the two busts in the Metropolitan were recognized as constituting half of the original Wissembourg group.[4]

In 1943 a European scholar made an equally important and even more surprising discovery while researching objects formerly in the Hearst collection: beneath a layer of late-nineteenth-century painting, he found none other than Saint Margaret, the third member of the Wissembourg ensemble. Soon afterward the Art Institute purchased the reliquary bust, turning it over to an expert conser-

vator, who revealed the extraordinarily refined carving and surface treatment that make this one of the museum's prized possessions.[5]

C.M.N.

## 57. *Two Musicians (The Music-Making Couple)*

1470/80
Master b x g (German, active 1470/90)
Round engraving, printed on ivory laid paper; diam. of image to borderline: 8.9 cm (3 ½ in.); sheet: 9.5 x 9.2 cm (3 ¾ x 3 ⅝ in.)
Amanda S. Johnson and Marion Livingston Endowment, 2000.408

THE ENGRAVER OF THIS CHARMING roundel is known today only by the initials *bxg*, which he used to sign his plates. Probably practicing in or near Frankfurt in the Middle Rhine region, he produced some forty-six works, five or six of which are copies after the celebrated

German painter and engraver Martin Schongauer. Numerous others appear to be based on prints or drawings by the Housebook Master, a talented and original draftsman.[1] As many of that artist's originals are now lost, bxg's engravings are also valuable records of his contemporary's lively imagination. Master bxg's prints are extremely rare; *Two Musicians*, for example, survives in only two impressions, one in the Art Institute and the other in the Ashmolean Museum, Oxford. Fewer than ten of his prints are recorded in North American museum collections.[2]

What is particularly striking about the master's body of work is that he explored secular topics in virtually all of his engravings in an era when the majority of printed images depicted religious themes. Moreover, he seems to have gravitated toward subjects that comment on the relationship between the sexes. *Two Musicians*, also known as *The Music-Making Couple*, is one of four round engravings that offer vignettes exploring the courtly ideal of love and marriage. Each work pictures a well-dressed pair engaged in a favorite pastime of young lovers, always in the intimate setting of a walled garden. Making music together is one of the traditional pleasures of the "garden of love," a place in which peace and beauty were imagined to be protected from the stress and trouble of the outside world. In *Two Musicians* the performance of a duet—in this case on lute and dulcimer—symbolizes romantic and conjugal harmony.[3] The three other prints in the series include *Pair of Lovers by a Fountain*, *Two Card Players*, and *Repast in the Garden*; each of these images is known in only one surviving impression.[4]

Art historians have suggested that Master bxg might well have designed these four roundels himself, despite the fact that the figure types and iconography seem to link them to the work of the Housebook Master. In any case, the former's firm, straightforward engraving style is quite distinct from the light, sketchy burin work of the latter, giving rise to the suggestion that bxg was trained in a goldsmith's atelier.[5]

M.T.

## 58. *"The Lovers" Tapestry*

1490/1500
Switzerland, Basel
Hemp, wool, and silk, slit and double interlocking tapestry weave; 78.9 x 105.3cm (31 ⅛ x 41 ½ in.)
Inscriptions: at left, *Ich spil mit üch in trüwe* (I love you faithfully); at right, *des sol üch niemer rüwen* (I hope you will never regret it)
Gift of Kate S. Buckingham, 1922.5378

WITH ITS AMOROUS COUPLE AND vibrant color palette, this tapestry presents an elegant image of courtly love.[1] A fashionable man and a lady—the latter resplendent in a pointed headdress and a fur-trimmed gown of Italian velvet—sit side by side in a garden overflowing with lush vegetation. The theme of lovers in a garden became an increasingly popular one for tapestries and other arts in the fifteenth century, as suggested by the Art Institute's engraving of a music-making couple in a similar setting (cat. 57).[2]

In this tapestry, the flora reveals a mixture of the real and the imaginary: while some flowers and fruits are carefully rendered and based on a close observation of nature, other elements are more clearly products of fancy. Like the hunting scene on the Art Institute's ivory mirror back (cat. 40), this is a highly symbolic landscape. The garden's abundance, for example, serves as a powerful metaphor for the lovers' own desires. Fluttering between the two figures, a small songbird seems to echo their sentiments, which are captured on swirling bands above their heads. "I love you faithfully," proclaims the man, while his beloved answers, "I hope that you will never regret it." As if on a hunt, the man wears hawking gloves; with his left hand, he gestures to a falcon that fells another bird just in front of his companion. She, in turn, holds in her lap a small, speckled doe, a gesture that recalls other famous works such as the Unicorn Tapestries (c. 1500; Musée de Cluny, Paris), which depict wild animals as domesticated pets.[3] These images of trained and tamed beasts were perhaps intended to signal the reining in of strong passions.

Tapestries were used to cover the walls of castles, churches, and palaces in medieval Europe. In addition to their obvious decorative beauty, they also protected against drafts and provided insulation. This textile was created for the house of a wealthy merchant family in Switzerland and, as the lovers' declarations suggest, may originally have been intended as a wedding present. Its makers produced the sumptuous colors with natural dyes and imparted a rich, luminous quality by introducing silk into the weave, a technique first used in the fifteenth century.

C.M.N.

# List of Contributors

L.K.B.  Laura K. Bruck, *Northwestern University*

L.J.F.  Larry J. Feinberg, *Patrick G. and Shirley W. Ryan Curator in the Department of European Painting*

S.F.M.  Suzanne Folds McCullagh, *Anne Vogt Fuller and Marion Titus Searle Curator of Earlier Prints and Drawings*

C.M.N.  Christina M. Nielsen, *Andrew W. Mellon Curatorial Fellow, Department of European Decorative Arts and Sculpture, and Ancient Art*

M.T.  Martha Tedeschi, *Curator in the Department of Prints and Drawings*

M.W.  Martha Wolff, *Eleanor Wood Prince Curator of European Painting before 1750*

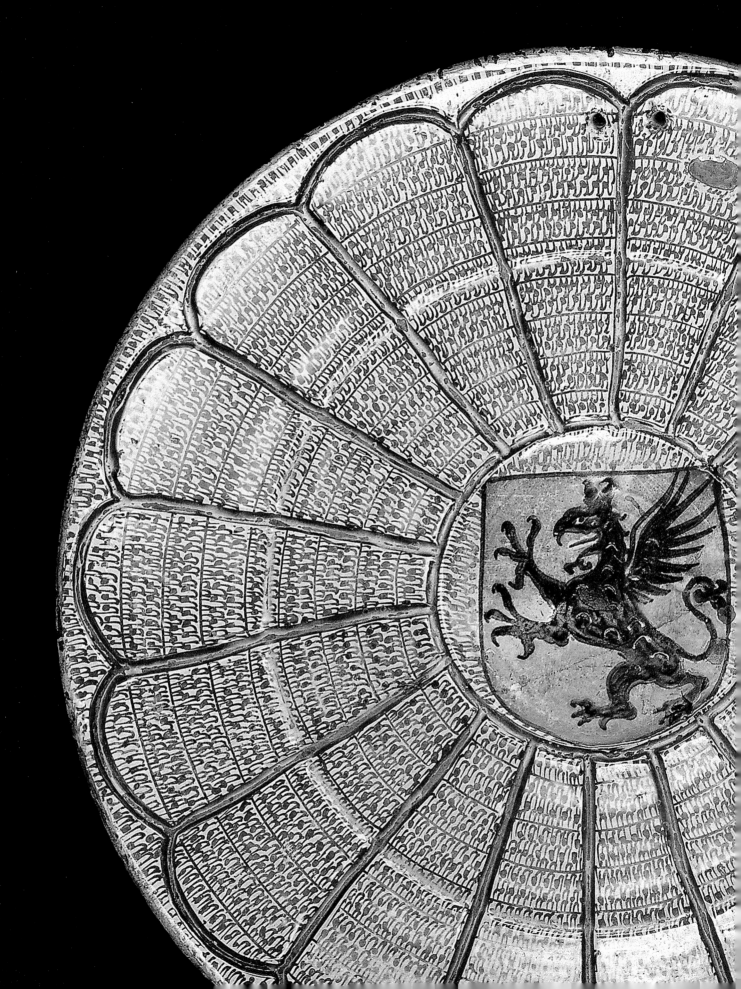

# Recommended Reading

The following publications will provide general readers with an excellent introduction to the art of the Middle Ages.

Camille, Michael. *Gothic Art: Glorious Visions*. Harry N. Abrams, 1996.

De Hamel, Christopher. *A History of Illuminated Manuscripts*. Phaidon, 1986.

Ettinghausen, Richard, Oleg Grabar, and Marilyn Jenkins-Madina. *The Art and Architecture of Islam: 650–1250*, 2nd ed. Yale University Press, 2001.

Landau, David and Peter Parshall. *The Renaissance Print, 1470–1550*. Yale University Press, 1994.

Lasko, Peter. *Ars sacra, 800–1200*. 2nd. ed. Yale University Press, 1994.

Little, Charles T. and Timothy B. Husband. *Europe in the Middle Ages: The Metropolitan Museum of Art*. Metropolitan Museum of Art, 1987.

Lowden, John. *Early Christian and Byzantine Art.* Phaidon, 1997.

Nees, Lawrence. *Early Medieval Art*. Oxford University Press, 2002.

Stokstad, Marilyn. *Medieval Art*. Harper and Row, 1986.

Opposite: Cat. 9 (detail).

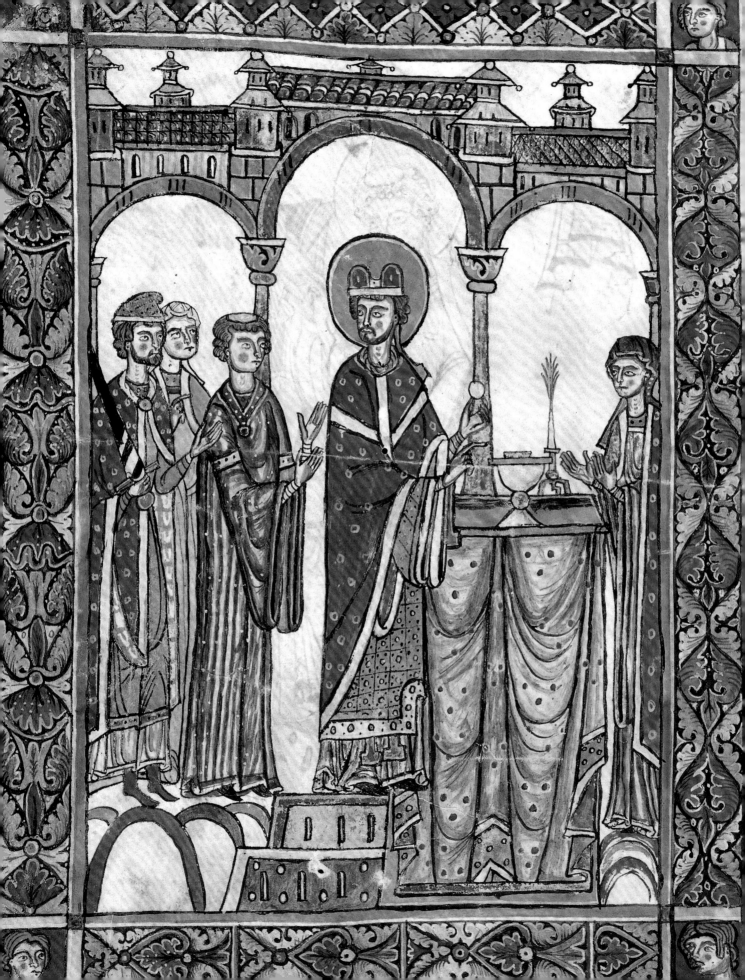

more on these themes in the earliest woodcuts, see Richard S. Field, *Fifteenth-Century Woodcuts and Metalcuts from the National Gallery of Art, Washington, D.C.* (National Gallery of Art, 1965), cats. 125–33, 229–30.

**56. *Reliquary Bust of Saint Margaret of Antioch*, pp. 81–82.**

1. For more on this work, see Stephen K. Scher in Dorothy Gillerman, ed., *Gothic Sculpture in America*, vol. 2, *Museums of the Midwest*, Publications of the International Center of Medieval Art 4 (Turnhout, Belgium: Brepols, 2001), p. 283I. Saint Barbara and Saint Catherine of Alexandria were invoked against fever and sudden death, and Saint Agnes to protect chastity.

2. For more on Gerhaert, see Michael Baxandall, *The Limewood Sculptors of Renaissance Germany* (Yale University Press, 1980); and Roland Recht, *Nicolas de Leyde et la sculpture à Strasbourg, 1460–1525* (Strasbourg: Presses universitaires de Strasbourg, 1987).

3. For the 1909 sale, see Hôtel Drouot, Paris, sale cat. (Nov. 1909), lot 414. For the busts of saints Margaret and Catherine in the Metropolitan Museum, see Recht (note 2), p. 344. The bust of Saint Agnes remains missing and is known only from the plaster cast, still in the Frauenhaus, Strasbourg.

4. See Wilhelm Vöge, "Über Nicolaus Gerhaert und Nicolaus von Hagenau," *Zeitschrift für Bildende Kunst* 24 (1912/13), pp. 97–108.

5. The Art Institute bought the bust from Gimbel Brothers department store in New York, which was acting as agent for the Armand Hammer Galleries in the sale of the Hearst collection. See curatorial files, Department of European Decorative Arts and Sculpture, and Ancient Art.

**57. *Two Musicians (The Music-Making Couple)*, pp. 82–83.**

1. Seven of bxg's prints are based on surviving works by the Housebook Master. On the latter and other artists working in his circle, see J. P. Filedt Kok, *Livelier than Life: The Master of the Amsterdam Cabinet, or The Housebook Master, ca. 1470–1500*, exh. cat. (Amsterdam: Rijksmuseum, 1985). Bxg is discussed on pp. 193–211.

2. See Richard S. Field, ed., *A Census of Fifteenth-Century Prints in Public Collections of the United States and Canada* (New Haven: Print Council of America, 1995). The largest representation of bxg's work, twenty prints, is found in the E. de Rothschild Collection in the Musée du Louvre, Paris. For more on the Ashmolean print, see Kok (note 1), cat. 101.1.

3. While many of the bxg's prints represent courtly men and women, even more numerous (and humorous) are peasant subjects, including *The Henpecked Husband* and *Peasant Pulling His Wife along in a Basket*; for illustrations of these works, see Kok (note 1), cats. 95, 102.

4. For illustrations of the love garden roundels, see ibid., cats. 98–101. *Pair of Lovers by a Fountain* is located in the Albertina, Vienna; *Two Card Players* in the Bibliothèque nationale, Paris. For illustrations, see ibid., cats. 98–100.

5. For bxg as designer of the roundels, see Kok (note 1), cats. 98–101. See also Alan Shestack, *Fifteenth-Century Engravings of Northern Europe from The National Gallery of Art, Washington, D.C.*, exh. cat. (National Gallery of Art, 1967), p. 140.

**58. "*The Lovers' Tapestry*," pp. 83–84.**

1. For more on this piece, see Christa C. Mayer, *Masterpieces of Western Textiles from The Art Institute of Chicago* (Art Institute of Chicago, 1969), pp. 23, 25; Anna Rapp Buri and Monica Stucky-Schürer, *Zahm und Wild: Basler und Strassburger Bildteppiche des 15. Jahrhunderts* (Mainz: Philipp von Zabern, 1990), pp. 271–72; and Christa C. Mayer Thurman, *Textiles in The Art Institute of Chicago* (Art Institute of Chicago, 1992), pp. 36, 38–39, 144.

2. For the symbolic significance of gardens, see Elisabeth Antoine et al., *Sur la terre comme au ciel: Jardins d'Occident à la fin du Moyen-Âge*, exh. cat. (Réunion des musées nationaux, 2002), esp. pp. 84–131.

3. For a general introduction to the Unicorn Tapestries, see Sutherland Lyall, *The Lady and the Unicorn* (London: Parkstone, 2000).

…Badile and dated to the period between July 1443 and May 1444. Those frescoes include copies of medallions by Antonio Pisano (see cat. 10), which underscore the connection between the two artists' ateliers around 1440.

**46.** *The Gentleman*, pp. 70–71.
1. For a discussion of the documentary evidence for the tarocchi's educational function, see Kristen Lippincott, "Mantegna's *Tarocchi*," *Print Quarterly* 3, 4 (Dec. 1986), pp. 357–59.
2. On the iconography of the tarocchi, see Jay A. Levenson, "Masters of the Tarocchi," in Jay A. Levenson, Konrad Oberhuber, and Jacquelyn L. Sheehan, *Early Italian Engravings from the National Gallery of Art*, exh. cat. (Washington, D.C.: National Gallery of Art, 1973), pp. 81–89. See also Laure Beaumont-Maillet, Gisele Lambert, and Francois Trojani, *Suites d'estampes de la Renaissance italienne dite Tarots de Mantegna ou, Jeu du Gouvernement du monde au Quattrocento Ferrara vers 1465* (Garches, France: Editions Seydoux, 1985).
3. Levenson (note 2) treats the two decks' organization, stylistic differences, and possible sources.

**47.** *Pendant with Head of John the Baptist*, p. 71.
1. For more on this pendant, see Maureen Kupsta in *Art Institute of Chicago Museum Studies* 25, 2 (2000), pp. 32–33.
2. See ibid., p. 33.

**48.** *Retable and Altar Frontal*, pp. 72–73.
1. For more on these objects, see Juan Cabré y Aguiló, "El retablo bordado de Don Pedro de Montoya, Obispo de Osma," *Archivo español de arte y arqueología* 5 (1929), pp. 1–20; Mildred Davison, "An Altarpiece from Burgo de Osma," *Art Institute of Chicago Museum Studies* 3 (1968), pp. 108–24; Christa C. Mayer, *Masterpieces of Western Textiles from The Art Institute of Chicago* (Art Institute of Chicago, 1969), p. 128; and Christa C. Mayer Thurman, *Textiles in The Art Institute of Chicago* (Art Institute of Chicago, 1992), pp. 27–29, 144.
2. It is listed as being in this chapel in an inventory of 1600; see Davison (note 1), p. 108.
3. The work was purchased in 1916 by the London dealer and collector Lionel Harris; see Davison (note 1), p. 122. Harris later sold it to French and Company, New York, who sold it to Deering. For more on Deering, see Walter Dill Scott and Robert B. Harshe, *Charles Deering, 1852–1927: An Appreciation, together with His Memoirs of William Deering and James Deering* (Boston: privately printed, 1929).

**49.** *The Annunciation*, p. 74.
1. For an illustrated introduction to the different parts of a Book of Hours and their use, see Roger Wieck, *Painted Prayers: The Book of Hours in Medieval and Renaissance Art* (George Braziller, 1997).
2. A thorough study of the Master of the Ghent Privileges is Gregory T. Clark, *Made in Flanders: The Master of the Ghent Privileges and Manuscript Painting in the Southern Netherlands in the Time of Philip the Good* (Turnhout, Belgium: Brepols, 2000).
3. The Latin reads "Domine labia mea aperies. Et os meum annuntiabit laudem tuam. Deus in adiutorium meum intende. Domine ad adiuvandum me festina." See Wieck (note 1), pp. 51–54, for a translation of the Matins prayers from the Hours of the Virgin and pp. 138–40 for the complete Hours of the Virgin in Latin.
4. These miniatures include f. 53, *Visitation* (Lauds); f. 65, *Nativity* (Prime); f. 72, *Annunciation to the Shepherds* (Tierce); f. 75, *Adoration of the Magi* (Sext); f. 80, *Presentation in the Temple* (Nones); and f. 85, *Massacre of the Innocents* (Vespers). For illustrations, see Clark (note 2), pp. 373–75, figs. 28–33.

**50.** *Christ Carrying the Cross*, p. 75.
1. For more on this, see James Marrow, *Passion Iconography in Northern European Art of the Late Middle Ages and Early Renaissance* (Kortrijk, Belgium: Van Ghemmert, 1979).
2. These drawings are discussed and illustrated in Otto Benesch, *Österreichische Handzeichnungen des XV. und XVI. Jahrhunderts, Meisterzeichnung 5* (Freiburg: Urban Verlag/R. and D. Colnaghi, 1936), nos. 17–21, 41–43, pp. 30–33.

**51.** *Christ on the Living Cross*, pp. 76–77.
1. For more on this theme, see Gertrud Schiller, *Iconography of Christian Art*, vol. 2, *The Passion of Jesus Christ* (Greenwich, Conn.: New York Graphic Society, 1972), pp. 158–61.
2. See, for example, ibid., fig. 528.
3. Bertalan Kéry's suggestion that the bearded figure in the tall, closed crown is a portrait of Sigismund is probably correct in a general sense, although it is unlikely to have been based on direct observations; see Bertalan Kéry, *Kaiser Sigismund: Ikonographie* (Vienna: A. Schroll, 1972), p. 72.

**52.** *The Last Judgment*, pp. 77–78.
1. For more on the Last Judgment in late-medieval art, see Emile Mâle, *The Gothic Image: Religious Art in France of the Thirteenth Century*, trans. Dora Nussey (1913; repr. Harper and Row, 1972), pp. 355–89; Louis Réau, *Iconographie de l'art Chrétien*, vol. 2, *Iconographie de la Bible* (Presses Universitaires de France, 1957), pp. 727–41; and Michael Camille, *Gothic Art: Glorious Visions* (Harry N. Abrams, 1996), pp. 92–104.
2. The Latin text on the angel's banderole reads "Surgite mortui venite ad iudicium" (Rise, dead, come to the judge); the banderole on the left reads "Venite benedicte patris mea," while that on the right reads "Ite maledicte in ignem internum."
3. For another leaf from the same manuscript, which depicts the Nativity and introduced the work's first section, see Sotheby's, London, *Western Manuscripts and Miniatures*, sale cat. (June 18, 1991), lot 26. Some scholars ascribe *Articles of Faith* while others attribute it to Jean Chapuis; see Leopold Delisle, "Les Heures de l'Amiral Prigent de Coëtivy," *Bibliothèque de l'École des Chartes* 61 (1900), pp. 188–89.
4. For more on the Maître François, see Margaret Manion, *The Wharncliffe Hours: A Fifteenth-Century Illuminated Prayer Book in the Collection of The National Gallery of Victoria, Australia* (Thames and Hudson, 1981), pp. 6–22; and Charles Sterling, *La Peinture médiévale à Paris, 1300–1500*, vol. 2 (Paris: Bibliothèque des arts, 1990), figs. 185–87, 192.
5. Gauguin was referring to a manuscript copy of Saint Augustine's *City of God* that Gaucourt commissioned; the manuscript is now in the Bibliothèque nationale, Paris, mss. fr. 18–19. For the letter, see *Epistolae et Orationes Roberti Gaguini*, Louis Thuasne, vol. 1 (Paris: E. Bouillon, 1903), p. 225; and Manion (note 4), pp. 8–9.

**53.** *Chasuble Front with Orphrey Cross*, p. 78.
1. For more on this object, see Christa C. Mayer Thurman, *Textiles in The Art Institute of Chicago* (Art Institute of Chicago, 1992), pp. 26–27, 143; and idem, "Some Major Textile Acquisitions from Europe and Egypt," *Art Institute of Chicago Museum Studies* 11 (1984), pp. 52–69.

**54.** *Saint George Killing the Dragon*, pp. 79–80.
1. Jacobus de Voragine acknowledged some confusion about the events in the saint's martyrdom. See Jacobus de Voragine, *The Golden Legend*, trans. William Granger Ryan, vol. 1 (Princeton University Press, 1993), p. 238.
2. These four works are discussed and illustrated in Mary Grizzard, "La Provenance du retable de saint Georges par Bernardo Martorell," *Revue du Louvre* 33 (1983), pp. 89–96, figs. 2–4.
3. For the formal conventions of Spanish altarpieces, see Judith Berg Sobré, *Behind the Altar Table: The Development of the Painted Retable in Spain, 1350–1500* (University of Missouri Press, 1989).
4. Arguments for this location are presented in Grizzard (note 2), and idem, *Bernardo Martorell, Fifteenth-Century Catalan Artist* (Garland Publishers, 1985), pp. 185–201, 445–56; additional evidence will be presented by Judith Berg Sobré in a forthcoming catalogue of the Art Institute's Netherlandish, German, Spanish, and French paintings before 1600.

**55.** *Man of Sorrows*, pp. 80–81.
1. Campbell Dodgson published this work almost fifty years ago, ascribing it to the Ulm school and writing that it "has few rivals in respect of size, excellence of execution and perfect preservation." See Campbell Dodgson, "An Undescribed Early Woodcut," *Burlington Magazine* 86, 505 (Apr. 1945), p. 94 (ill.).
2. This iconography also relates to the celebration of the Mass. Half-length depictions of Christ surrounded by the instruments of the Passion are associated with the Mass of Saint Gregory (see cat. 15), another popular subject of fifteenth-century woodcuts. One of the many miracles ascribed to the saint was an apparition of the suffering Christ behind the altar during Mass. For

tion of the Virgin apparently conform with those of Duccio's lost Maestà Altarpiece.

**34. *Orphrey Band Fragment with Saints Barbara and James*, p. 56.**
1. For more on early English needlework, see Donald King, "Embroidery and Textiles," in Jonathan Alexander and Paul Binski, eds., *Age of Chivalry: Art in Plantagenet England, 1200–1400*, exh. cat. (Royal Academy of Arts/Weidenfeld and Nicolson, 1987), pp. 157–61. For an introduction to the Bayeux Tapestry, see David M. Wilson, *The Bayeux Tapestry* (Knopf, 1985).

**35. *Triptych with Scenes from the Life of Christ*, p. 57.**
1. On this triptych, see Richard H. Randall, Jr., *The Golden Age of Ivory: Gothic Carvings in North American Collections* (Hudson Hills, 1993), pp. 56–57; idem, in Peter Barnet et al., *Images in Ivory: Precious Objects of the Gothic Age*, exh. cat. (Detroit Institute of Arts/Princeton University Press, 1997), pp. 204–205.
2. On ivories and devotional art, see Barnet (note 1), esp. pp. 11–14; on the properties of ivory and the scale of imagery, see Harvey Stahl, "Narrative Structure and Content in Some Gothic Ivories of the Life of Christ," in ibid., pp. 95–114. *Meditations on the Life of Christ* also influenced the imagery of an antependium panel in the Art Institute's collection (cat. 26).
3. See, for example, Elizabeth Sears and Charles T. Little in Barnet (note 1).
4. For a comparison of this triptych with the work in Berlin, see Randall in Barnet (note 1), pp. 204–205; and Randall (note 1), cat. 43.

**36. *The Ayala Altarpiece*, pp. 58–59.**
1. For the works of art still in Quejana, see Micaela J. Portilla, *Quejana: Solar de los Ayala* (Álava, Spain: Diputación Foral de Álava, 1983).
2. Ibid., pp. 21–24, ill. pp. 20 (in situ), 23.

**37. *Corpus of Christ*, pp. 59–60.**
1. For more on the two altarpieces, see Oswald Goetz, "Der Gekreuzigte des Jacques de Baerze," in *Festschrift für Carl Georg Heise zum 28. Juni 1950* (Berlin: Mann, 1950), pp. 158–67; Dorothy Gillerman, ed., *Gothic Sculpture in America, vol. 2, Museums of the Midwest*, Publications of the International Center of Medieval Art 4 (Turnhout, Belgium: Brepols, 2001), pp. 22–24; and Sophie Jugie in *Dukes and Angels: Art from the Court of Burgundy, 1364–1419*, exh. cat. (forthcoming, 2004), cats. 68–70.
2. The original sculpture came into the possession of François Dameron, a pupil of Paul Buffet, one of the restorers. By 1927 it had been acquired by the Parisian dealer Marcel Bing, who sold it in 1910 to Bertha Honoré Palmer. See curatorial files, Department of European Decorative Arts and Sculpture, and Ancient Art. The corpus remained in the Palmer family until 1944, when it was bequeathed to the Art Institute.

**38. *Christ's Appearance after the Resurrection*, pp. 60–61.**
1. These accounts include the appearance of Christ to Mary Magdalene in John 20:14–18 and the discovery of the empty tomb by the Holy Women in Matthew 28:1–8, Mark 16:1–8, Luke 24:1–11, and John 20:1–9. The caption accompanying this image identifies one of the Marys as Mary Magdalene. The specific identities of the other two women are somewhat unclear, since they are only referred to as "the two other Marys," who are sisters of Our Lady." Typically it is thought that the two other women who make up the trio are Mary, mother of James and Joseph, and Salome, mother of Zebedee's children. For more, see James Hall, *Dictionary of Subjects and Symbols* (Harper and Row, 1974), pp. 84, 155.
2. The scriptural sources for the second, third, and fourth images are Luke 24:13–35, John 20:19–29, and Luke 24:36–43, respectively.
3. For a discussion of Bible picture books, see Christopher de Hamel, *The Book: A History of the Bible* (Phaidon, 2001), pp. 140–65.
4. For other leaves from this manuscript, see Sotheby's, London, *Medieval Illuminated Miniatures from the Collection of the Late Eric Korner*, sale cat. (Sotheby's, June 19, 1990), lot 14. The Art Institute also owns two other leaves from this manuscript (1922.1–2).

**39. *Diptych with Scenes from the Life of Christ*, p. 61.**
1. For more on this ivory, see Richard H. Randall, Jr., *The Golden Age of Ivory*, p. 61.
2. For the nature of visual "narrative" on this and other carved ivories, see Harvey Stahl, "Narrative Structure and Content in Some Gothic Ivories of the Life of Christ," in Peter Barnet et al., *Images in Ivory: Precious Objects of the Life of Christ*, in Peter Barnet et al., *Images in Ivory: Precious Objects of the Gothic Age*, exh. cat. (Detroit Institute of Arts/Princeton University Press, 1997), pp. 95–114, esp. p. 104.

**40. *Mirror Case with Falconry Scene*, p. 62.**
1. For the impact of courtly literature on secular ivories, see Richard H. Randall, Jr., "Popular Romances Carved in Ivory," in Peter Barnet et al., *Images in Ivory: Precious Objects of the Gothic Age*, exh. cat. (Detroit Institute of Arts/Princeton University Press, 1997), pp. 63–79.
3. See Peter Barnet, "Gothic Sculpture in Ivory: An Introduction," in ibid., pp. 3–17, esp. pp. 3–4.

**41. *Virgin and Child with Scenes from the Life of Christ*, pp. 62–63.**
1. See Christopher Lloyd, *Italian Paintings before 1600 in The Art Institute of Chicago: A Catalogue of the Collection* (Art Institute of Chicago/Princeton University Press, 1993), p. 284; and Edward B. Garrison, *Italian Romanesque Panel Painting: An Illustrated Index* (Florence: L. S. Olschki, 1949), pp. 117–19.
2. See Rodolfo Pallucchini, *La pittura veneziana del Trecento* (Venice: Istituto per la collaborazione culturale, 1964), pp. 70–71; and Lloyd (note 1), p. 284.
3. While Duccio's altarpiece is lost, Giotto's celebrated frescoes are illustrated in Giuseppe Basile, *Giotto: The Arena Chapel Frescoes* (Thames and Hudson, 1993).

**The Fifteenth Century, pp. 64–65.**
1. For more on the Church of Saint Lawrence in Nuremberg, see Rainer Brandel, "Art or Craft?: Art and the Artist in Medieval Nuremberg," in Metropolitan Museum of Art, New York, and Germanisches Nationalmuseum, Nuremberg, *Gothic and Renaissance Art in Nuremberg, 1300–1550*, exh. cat. (Metropolitan Museum of Art/Prestel, 1986), pp. 54–58.

**42. *Velvet Panel with Ox Heads and Eagles*, p. 66.**
1. For more on this panel, see Christa C. Mayer, *Masterpieces of Western Textiles from The Art Institute of Chicago* (Art Institute of Chicago, 1969), pl. 44 (cover), p. 63; Christa C. Mayer Thurman, *Textiles in The Art Institute of Chicago* (Art Institute of Chicago, 1992), pp. 20–21; and Adèle C. Weibel, *2000 Years of Silk Weaving*, exh. cat. (New York: E. Weyhe, 1944), pl. 159, cat. 159. Velvets with the same pattern are held in a number of museums in Europe and America; see Monique King and Donald King, *European Textiles in the Keir Collection* (Faber and Faber, 1990), p. 54; and Mechthild Lemberg and Brigitta Schmedding, *Abegg Stiftung Bern in Riggisberg*, vol. 2, *Textilien* (Bern: P. Haupt, 1973), pl. 31.

**43. *Portion of a Chasuble*, p. 67.**
1. For more on this fragment, see Fanny Podreider, *Storia dei tessuti d'arte in Italia* (Bergamo: Istituto Italiano d'arti Grafiche, 1928) p. 154, fig. 175, *Bulletin of The Art Institute of Chicago* 41.1 (Jan. 1947), p. 7; Adèle C. Weibel, *Two Thousand Years of Textiles: The Figured Textiles of Europe and the Near East* (Detroit Institute of Arts/Pantheon, 1952), p. 236; and Christa Charlotte Mayer, *Masterpieces of Western Textiles from The Art Institute of Chicago* (Art Institute of Chicago, 1969), pl. 49, p. 73.

**44. *Marriage Casket*, pp. 68–69.**
1. For more on this casket, see Rebecca Price-Wilkin in Peter Barnet et al., *Images in Ivory: Precious Objects of the Gothic Age*, exh. cat. (Detroit Institute of Arts/Princeton University Press, 1997), pp. 281–82; and Richard H. Randall, *The Golden Age of Ivory: Gothic Carvings in North American Collections* (Hudson Hills, 1993), cat. 256.
2. For more on the family, see Antonia Boström, "Embriachi (Ubriachi)," in Jane Turner, ed., *The Dictionary of Art*, vol. 10 (Grove, 1996), pp. 178–80.

**45. *Bust of a Young Man in Profile*, pp. 69–70.**
Van der Weyden, who was active between roughly 1426 and 1464, infused religious feeling and human emotions into luminous, carefully observed compositions and portraits. For more on the attribution history of this drawing, see Suzanne Folds McCullagh and Laura M. Giles, *Italian Drawings before 1600 in The Art Institute of Chicago* (Art Institute of Chicago/Princeton University Press, 1997), cat. 6.
2. The work can be related stylistically to the frescoes in the Guariti Chapel of Santa Maria della Scala, Verona, executed by the workshop of Giovanni

the Dukes d'Arenberg, sale cat. (Jacques Seligmann, 1952).

3. See William G. Noel, "Psalters," in James R. Tanis, ed., *Leaves of Gold: Manuscript Illumination from Philadelphia Collections*, exh. cat. (Philadelphia Museum of Art, 2001), pp. 44–67; and Koert van der Horst, William Noel, and Wilhelmina C. M. Wüstefeld, eds., *The Utrecht Psalter in Medieval Art: Picturing the Psalms of David*, exh. cat. ('t Goy, the Netherlands: HES, 1996).

**25. *Crucifix*, pp. 45–46.**
1. These two works are discussed and illustrated in Edward B. Garrison, *Italian Romanesque Panel Painting: An Illustrated Index* (Florence: L. S. Olschki, 1949), cats. 470, 486; and Christopher Lloyd, *Italian Paintings before 1600 in The Art Institute of Chicago: A Catalogue of the Collection* (Art Institute of Chicago/Princeton University Press, 1993), pp. 146–51, figs. 3–4.
2. Lloyd (note 1), p. 149.

**26. *Antependium Panel Depicting the Last Supper*, pp. 46–47.**
1. See *Meditations on the Life of Christ: An Illustrated Manuscript of the Fourteenth Century; Paris, Bibliothèque nationale, Ms. Ital. 115*, trans. Isa Ragusa (Princeton University Press, 1977), p. 312.
2. For the reconstruction of the altarpiece and related panels, see Christa C. Mayer, "An Early German Needlework Fragment," *Art Institute of Chicago Museum Studies* 6 (1971), pp. 66–76; and Christa C. Mayer Thurman, *Textiles in The Art Institute of Chicago* (Art Institute of Chicago, 1992), p. 36, fig. 14.
3. For the role of visual art in medieval German convents, see Jeffrey F. Hamburger, *Nuns as Artists: The Visual Culture of a Medieval Convent* (University of California Press, 1997); and idem, *The Visual and the Visionary: Art and Female Spirituality in Late Medieval Germany* (Zone Books/MIT Press, 1998).

**27. *Corpus of Christ*, p. 47.**
1. For more on this corpus, see Janice Mann in Dorothy Gillerman, ed., *Gothic Sculpture in America*, vol. 2, *Museums of the Midwest*, Publications of the International Center of Medieval Art 4 (Turnhout, Belgium: Brepols, 2001), cat. 34.
2. Rafael Bastardes i Parera, "El Crucifix de Banyoles," *Quaderns d'estudis medievals* 19 (1982), p. 644.
3. See Janice Mann in Gillerman (note 1), cat. 130.
4. *Meditations on the Life of Christ: An Illustrated Manuscript of the Fourteenth Century* (note 1); cat. 130.

***The Fourteenth Century*, pp. 48–49.**
1. For an introductory discussion and illustrations of the Arena Chapel, see Giuseppe Basile, *Giotto: The Arena Chapel Frescoes* (London: Thames and Hudson, 1993).
2. Giovanni Boccaccio, *The Decameron*, trans. Richard Aldington (Dell, 1976), pp. 378–79.

**28. *Historiated Initial O with Moses*, p. 50.**
1. Giorgio Vasari, *Lives of the Most Eminent Painters, Sculptors, and Architects*, trans. Gaston du C. de Vere, vol. 2 (London 1912), p. 57.
2. See Laurence B. Kanter et al., *Painting and Illumination in Early Renaissance Florence, 1300–1450* (Metropolitan Museum of Art/Harry N. Abrams, 1994), pp. 220–306. For Don Silvestro's work, see also Mirella Levi D'Ancona, *The Illuminators and Illuminations of the Choir Books from Santa Maria degli Angeli and Santa Maria Nuova and their Documents* (Florence: Centro Di, 1994), esp. pp. 14–20; and idem, *The Reconstructed "Diurno Domenicale" from Santa Maria degli Angeli in Florence* (Florence: Centro Di, 1993).
3. See Gaudenz Freuler (note 2), pp. 157–64, esp. p. 158, fig. 57.
4. An introit is a Psalm fragment sung as the celebrant and other priests enter the church and approach the altar. The text written on the reverse of the leaf, "[Ser]vite domino [laetitia]" (Serve the Lord with gladness), is the introit to the Mass for the first Sunday after Epiphany.
5. See, for example, Freuler (note 3).

**29. *Fragment from an Orphrey Band with Saint Matthew*, p. 51.**
1. Cennino Cennini, *The Craftsman's Handbook*, trans. Daniel V. Thompson, Jr. (Dover, 1960), p. 105.
2. For more on this fragment, see Christa C. Mayer Thurman in Laurence B.

Kanter et al., *Painting and Illumination in Early Renaissance Florence, 1300–1450*, exh. cat. (Metropolitan Museum of Art/Harry N. Abrams, 1994), pp. 115–123; and idem, "The Beauty of Needlework," *Antiques* 151, 1 (1997), pp. 216–17.
3. For more on the reconstruction and the meaning of these inscriptions, see Christa C. Mayer Thurman and Jessica Barry in *Art Institute of Chicago Museum Studies* 29 (2003), p. 20.

**30. *The Velbheim Cross*, p. 52.**
1. For a history of the treasure, see Patrick M. de Winter, "The Sacral Treasure of the Guelphs," *Bulletin of the Cleveland Museum of Art* 72, 1 (Mar. 1985), pp. 128–38.
2. "Chicago," *Art News* 29 (Apr. 18, 1931), p. 24.
3. For these objects, see de Winter (note 1), pp. 139–42.
4. For more on this cross, see Wilhelm Anton Neumann, *Der Reliquienschatz des Hauses Braunschweig-Lüneburg* (Vienna: Alfred Holder, 1891), cat. 57; Otto von Falke, Robert Schmidt, and Georg Swarzenski, eds., *The Guelph Treasure: The Sacred Relics of Brunswick Cathedral Formerly in the Possession of the Ducal House of Brunswick-Lüneburg* (Frankfurt: Frankfurter Verlags-Anstalt, 1930), pp. 17–18, 87–88, cat. 48; and de Winter (note 1), cat. 41.
5. See Neumann (note 4), p. 109.

**31. *Monstrance with Tooth of Saint John the Baptist*, pp. 53–54.**
1. For more on this monstrance, see Wilhelm Anton Neumann, *Der Reliquienschatz des Hauses Braunschweig-Lüneburg* (Vienna: Alfred Holder, 1981), cat. 58; Otto von Falke, Robert Schmidt, and Georg Swarzenski, eds., *The Guelph Treasure: The Sacred Relics of Brunswick Cathedral Formerly in the Possession of the Ducal House of Brunswick-Lüneburg* (Frankfurt: Frankfurter Verlags-Anstalt, 1930), cat. 60; and Patrick M. de Winter, "The Sacral Treasures of the Guelphs," *Bulletin of the Cleveland Museum of Art* 72, 1 (Mar. 1985), cat. 59.
2. The writing on the paper reads *dens Johannes bapt.*
3. For this vessel, see Avinoam Shalem, *Islam Christianized: Islamic Portable Objects in the Medieval Church Treasures of the Latin West*, Ars faciendi 7 (Frankfurt: Peter Lang, 1996), cat. 11. For Fatimid art in general, see Anna Contadini, *Fatimid Art at the Victoria and Albert Museum* (V&A Publications, 1998); for rock crystal in particular, see ibid., pp. 16–38, and Kurt Erdmann, "Fatimid Rock Crystals," *Oriental Art* 3, 4 (1951), pp. 142–46; Al-Bīruni, quoted in Contadini (note 3); see also J. Ruska, "Bergkristall, Glas und Glasflüsse nach dem Steinbuch von el-Berūnī," *Zeitschrift der deutschen morgenländischen Gesellschaft* 90 (1936), pp. 322–56.

**32. *Processional Cross*, pp. 54–55.**
1. See Laurence B. Kanter et al., *Painting and Illumination in Early Renaissance Florence, 1300–1450*, exh. cat. (Metropolitan Museum of Art/Harry N. Abrams, 1994), cat. 28.
2. This passage is Psalm 50, verse 3 of the Vulgate, and Psalm 51, verse 1 of the authorized version of the Bible; see Christopher Lloyd, *Italian Paintings before 1600 in The Art Institute of Chicago: A Catalogue of the Collection* (Art Institute of Chicago/Princeton University Press, 1993), p. 88.
3. See Kanter (note 1), p. 228.

**33. *Virgin and Child Enthroned*, pp. 55–56.**
1. See Christopher Lloyd, *Italian Paintings before 1600 in The Art Institute of Chicago: A Catalogue of the Collection* (Art Institute of Chicago/Princeton University Press, 1993), pp. 260–61.
2. See, for example, fragments of the Santa Croce Altarpiece now in the National Gallery, London, and the Gemäldegalerie, Berlin. These are published, respectively, in Christopher Baker and Tom Henry, *The National Gallery Complete Illustrated Catalogue* (National Gallery Publications/Yale University Press, 2001), cats. 1188–89, 3373, 3375–78, 6484–86; and Gemäldegalerie, Berlin, *Catalog of Paintings, 13th–18th Century*, 2nd rev. ed., trans. Linda B. Parshall (Gemäldegalerie, 1978), cats. 1635a–c. Ugolino's altarpiece for Santa Maria Novella is now lost.
3. See Erling S. Skaug, *Punch Marks from Giotto to Fra Angelico: Attribution, Chronology, and Workshop Relationships in Tuscan Panel Painting*, vol. 2 (Oslo: IIC Nordic Group, Norwegian Section, 1994), no. 7.3. Cf. punch marks 347, 393, 621, and 650.
4. This hierarchical scale and distribution of the saints and the elevated posi-

Reiner von Huy," in ibid., pp. 251–62, esp. p. 253, no. 7; and idem, *Romanische Bronzekruzifixe* (Berlin: Deutscher Verlag für Kunstwissenschaft, 1992), p. 292, VII, Dio.

2. Block 1992 (note 1), p. 292. Objects conservators at the Art Institute of Chicago have recently begun scientific analysis of the enamel that will help to definitively address this piece's authenticity. For more on the Washington corpus, see Alison Luchs in Rudolf Distelberger et al., *Western Decorative Arts* (National Gallery of Art/Cambridge University Press, 1993), vol. 1, pp. 13–18.

**The Thirteenth Century, pp. 36–37.**

1. For more on Pisano and his inscription, see Marilyn Stokstad, *Medieval Art* (Harper and Row, 1986), pp. 359–61; for Montreuil's epitaph, see Michael Camille, *Gothic Art: Glorious Visions* (Harry N. Abrams, 1996), p. 175.

**18. Head of an Apostle, p. 38.**

1. For more on this work, see Dorothy Gillerman, ed., *Gothic Sculpture in America*, vol. 2, *Museums of the Midwest*, Publications of the International Center of Medieval Art 4 (Turnhout, Belgium: Brepols, 2001), pp. 9–11, with bibliography. The neutron activation analysis was conducted by the Limestone Sculpture Provenance Project, sponsored by the International Center of Medieval Art, New York.

2. The head was purchased by the Art Institute from Jacob Hirsch, New York, in 1944; see curatorial files, Department of European Decorative Arts and Sculpture, and Ancient Art.

3. For more on the body in the Musée Carnavalet and the Art Institute's head, see Eleanor S. Greenhill in Konrad Hoffmann, ed., *The Year 1200*, exh. cat. (Metropolitan Museum of Art/New York Graphic Society, 1970), cat. 14; and Gillerman (note 1), p. 10.

4. See François Giscard d'Estaing, Michel Fleury, and Alain Erlande-Brandenburg, *Les Rois retrouvées* (Paris: J. Cuénot, 1977), pp. 14–23.

**19. Virgin and Child, p. 39.**

1. This work, *Virgin and Child Enthroned between Saints Peter and Paul with Scenes from Their Lives*, is discussed and reproduced in Angelo Tartuferi, *La pittura a Firenze nel Duecento* (Florence: A. Bruschi, 1990), pp. 38, 52, 85–86; and Christopher Lloyd, *Italian Paintings before 1600 in The Art Institute of Chicago: A Catalogue of the Collection* (Art Institute of Chicago/Princeton University Press, 1993), pp. 89–93, fig. 1.

2. See Lloyd (note 1), p. 92.

3. For an illustration of this work, see Edward B. Garrison, *Italian Romanesque Panel Painting: An Illustrated Index* (Florence: L. S. Olschki, 1949), cat. 219.

**20. Reliquary Casket, p. 40.**

1. In the cloisonné technique cells are constructed from thin gold strips that are soldered onto a gold base and then filled with powdered enamel and fired.

2. For more on Limoges work, see Barbara Drake Boehm, "Opus lemovicense: La Diffusion des émaux limousines," in Elisabeth Taburet-Delahaye and Barbara Drake Boehm, *L'Œuvre de Limoges: Émaux limousins du Moyen Age*, exh. cat. (Paris: Réunion des musées nationaux, 1995), pp. 40–47.

3. For more on relics, see Patrick J. Geary, *Furta Sacra: Thefts of Relics in the Central Middle Ages* (Princeton University Press, 1978); and Marie-Madeleine Gauthier, *Les Routes de la foi: Reliques et reliquaires de Jérusalem à Compostelle* (Fribourg, Switzerland: Office du livre, 1983).

**21. Silk Fragment with Lions, p. 41.**

1. For more on this fragment, see Christa C. Mayer, *Masterpieces of Western Textiles from The Art Institute of Chicago* (Art Institute of Chicago, 1969), p. 50, fig. 31; and Christa C. Mayer Thurman, *Textiles in The Art Institute of Chicago* (Art Institute of Chicago, 1992), pp. 16, 143.

**22. Initial M with Saint Matthew as Scribe, p. 42.**

1. For a study of large-format illuminated Bibles of the eleventh and twelfth centuries, see Walter Cahn, *Romanesque Bible Illumination* (Cornell University Press, 1982).

2. For more on these workshops, see C. M. Kauffmann, *Biblical Imagery in Medieval England, 700–1550* (London: Harvey Miller, 2003), pp. 149–50.

3. For a discussion of these lay ateliers, see Robert Branner, *Manuscript Painting in Paris during the Reign of Saint Louis: A Study of Styles* (University of California Press, 1977). Although Branner did not include the Art Institute's Bible in his study, its decoration appears to be related to the style of the "Christina Atelier," which he named after a psalter once owned by Princess Christina of Denmark (now in the Kongelige Bibliotek, Copenhagen); see ibid., pp. 56–57.

4. For more on the use of portable Bibles, see Christopher de Hamel, *The Book: A History of the Bible* (Phaidon, 2001), pp. 131–36.

5. Early on in church history, the four beasts of the Apocalypse – the winged man, lion, ox, and eagle – became associated with the four Evangelists. Medieval commentators found an explanation for this connection hidden in the Gospels. Matthew's symbol was the man, for instance, because it is in his Gospel that Christ's human ancestry is described. For more, see James Hall, *Dictionary of Subjects and Symbols in Art* (Harper and Row, 1974), pp. 128–29.

**23. Scenes from the Story of Noah and the Ark, pp. 43–44.**

1. The other four leaves include ff. 13v–14r, which depicts Noah being told to build an ark by an angel and then constructing it; f. 17r, in which Noah and his family get off the ark; and f. 19v, in which Noah, having drunk too much wine, is discovered by his sons.

2. For a discussion of image over text in medieval picture Bibles, see Caroline S. Hull, "Rylands MS French 5: The Form and Function of a Medieval Bible Picture Book," *Bulletin of the John Rylands University Library of Manchester* 77 (1995), pp. 3–24. A few of the miniatures in this manuscript have French inscriptions; these were added soon after the manuscript was completed and for the most part identify the figures present and/or the event depicted.

3. Several of the miniatures from the Art Institute manuscript have been excised or reordered. Picture books such as this were particularly vulnerable to later collectors and owners, since images could be easily cut out and displayed as individual works. See Sandra Hindman et al., *Manuscript Illumination in the Modern Age: Recovery and Reconstruction*, exh. cat. (Mary and Leigh Block Museum of Art, Northwestern University, 2001), pp. 47–102.

4. The completeness of this manuscript has been debated. Caroline S. Hull maintained that it was never attached to a psalter and was conceived as an independent picture Bible; William Noel, however argued more convincingly that it is a prefatory cycle to a psalter, similar in form and content to a work in the Walters Art Museum, Baltimore. See Hull (note 2); William Noel, *The Oxford Bible Pictures: Gothic Ivory and Glowing Gold* (Lucerne: Faksimile Verlag, 2004), pp. 38–40; and Hanns Swarzenski, "Unknown Bible Pictures by W. de Brailes and Some Notes on Early English Bible Illustrations," *Journal of the Walters Art Gallery* 1 (1938), pp. 55–69.

5. The Divine Office is a series of prayers and psalms recited at set times throughout the day. It was originally designed so that the entire book of Psalms, composed of 150 verses, could be recited in its entirety every week. See Michelle Brown, *Understanding Illuminated Manuscripts: A Guide to Technical Terms* (J. Paul Getty Museum/British Library, 1994), pp. 50–51, 103–04.

**24. The Flagellation and Crucifixion of Christ, pp. 44–45.**

1. This work's parent manuscript is Paris, Bibliothèque nationale, cod. Nouv. Acq. Lat. 3102. The verso of this page contains musical notation and a hymn to the Virgin; the leaf was originally positioned between folios 9 and 10 in the psalter amid a short suite of scenes of the Life of Christ, following the liturgical calendar and preceding the text of the Psalms; see Guy Du Boisrouvray and Jean Porcher, *Manuscrits à peintures offerts à la Bibliothèque nationale* (Bibliothèque nationale, 1961), p. 28. Other single leaves are now housed in Berlin (Stiftung Preussischer Kulturbesitz) and Washington, D.C. (National Gallery of Art, Rosenwald Collection B-13, 521). For the former, see Johann Christian Klamt, "Zum Arenberg-Psalter," in Tilmann Buddensieg and Matthias Winner, eds., *Munuscula Disciplorum: Kunsthistorische Studien, Hans Kauffmann zum 70. Geburtstag, 1966* (Berlin: B. Hessling, 1968), pp. 147–59. For the latter, consult Gary Vikan, ed., *Medieval and Renaissance Miniatures from the National Gallery of Art*, exh. cat. (National Gallery of Art, 1975), cat. 33; and *Joel Spitz Collection*, sale cat. (Sotheby's, London, Nov. 29, 1990), lot 98.

2. See New York, Jacques Seligmann and Company, *Illuminated Manuscripts (11th through the 16th Century) from the Bibliothèque of Their Highnesses*

4. For more on this plaque, see John Lowden, *Early Christian and Byzantine Art* (Phaidon, 1997), pp. 217, 219–20.

**6. *Pilgrimage Jug with Christian Symbols*, pp. 23–24.**

1. For this jug and similar mold-blown glass, see Kurt T. Luckner, "Ancient Glass," *Art Institute of Chicago Museum Studies* 20, 1 (1994), pp. 88, 91; E. Marianne Stern, *Roman Mold-Blown Glass: The First through Sixth Centuries* ("L'erma" di Bretschneider/Toledo Museum of Art, 1995); Dan P. Barag, "Glass Pilgrim Vessels from Jerusalem, Pts. I–III," *Journal of Glass Studies* 12 (1970), pp. 35–63, and *Journal of Glass Studies* 13 (1971), pp. 45–63.
2. For more on late-Antique pilgrimage to Jerusalem, see *Egeria's Travels to the Holy Land*, trans. John Wilkinson (Jerusalem: Ariel, 1981), pp. 3–88.

**7. *Fragment with Nasrid Coat of Arms*, pp. 24–25.**

1. For more on this fragment, see Otto von Falke, *Kunstgeschichte der Seidenweberei* (Berlin: E. Wasmuth, 1913), pl. 370; Christa C. Mayer, *Masterpieces of Western Textiles from The Art Institute of Chicago* (Art Institute of Chicago, 1969), p. 48; and Christa C. Mayer Thurman, *Textiles in The Art Institute of Chicago* (Art Institute of Chicago, 1992), pp. 14, 143.
2. For more on these works, see Monique and David King, *European Textiles in the Kerr Collection, 400 B.C. to 1800 A.D.* (Faber and Faber, 1990), p. 37.

**8. *Fragment of Doña Leonora's Mantle*, pp. 25–26.**

1. For more on this fragment, see Florence Lewis May, "Hispano-Moresque Brocades from Villasirga," *Notes Hispanic* (New York: Hispanic Society of America, 1943), pp. 118–34; idem, *Silk Textiles of Spain, Eighth to Fifteenth Century* (New York: Hispanic Society of America, 1957), pp. 90–91; and Christa C. Mayer Thurman, *Textiles in The Art Institute of Chicago* (Art Institute of Chicago, 1992), p. 15.

**9. *Hispano-Moresque Lusterware Plate*, p. 26.**

1. Ahmed ibn-Yahya, writing in Damascus and Cairo, and Ibn Battuta, who traveled as far as China, both spoke of lusterware around 1350; see Alan Caiger-Smith, *Lustre Pottery: Technique, Tradition, and Innovation in Islam and the Western World* (Faber and Faber, 1985), pp. 85–86.
2. See ibid., pp. 100–126.

**10. *Sketches of the Emperor John VIII Palaeologus*, p. 27.**

1. Carmen C. Bambach in Helen C. Evans, ed., *Byzantium: Faith and Power (1261–1557)*, exh. cat (Metropolitan Museum of Art/Yale University Press, 2004), p. 529. This drawing appears in ibid., cat. 318A. Pisanello used studies on a related sheet (Musée du Louvre, Paris) in what may have been his first medal, a portrait of the emperor on horseback, see ibid., cat. 318B.
2. For more on this figure and its meaning, see ibid., pp. 531–32.
3. Ibid., p. 531. For an illustration of the verso, see Suzanne Folds McCullagh and Laura M. Giles, *Italian Drawings before 1600 in The Art Institute of Chicago* (Art Institute of Chicago/Princeton University Press, 1997), cat. 250v, pl. 19.

**The Twelfth Century, pp. 28–29.**

1. Bernard of Clairvaux, "Saint Bernard to William of St. Thierry," trans. Caecilia Davis-Weyer in *Early Medieval Art, 300–1150: Sources and Documents* (Prentice-Hall, 1971), pp. 168–69. For Abbot Suger and Theophilus, see Abbot Suger, *On the Abbey Church of St.-Denis and Its Art Treasures*, ed. Erwin Panofsky, 2nd ed. (Princeton University Press, 1979); and Theophilus, *De diversis artibus*, trans. C. R. Dodwell (London: T. Nelson, 1961).

**11. *Reliquary Casket of Saints Adrian and Natalia*, pp. 30–31.**

1. This reliquary is published in Marian C. Donnelly and Cyril S. Smith, "Notes on a Romanesque Reliquary," *Gazette des Beaux-Arts* 58, 1101–02 (July/Aug. 1961), pp. 109–19; Jesús Hernández Perera, "Las artes industriales españolas de la época románica," *Goya* 43 (July 1961), pp. 98–112; and John W. Williams in Metropolitan Museum of Art, *The Art of Medieval Spain, A.D. 500–1200*, exh. cat. (Metropolitan Museum of Art, New York, 1993), cat. 122.
2. See, for example, Jacobus de Voragine's *The Golden Legend: Readings on the Saints*, trans. William Granger Ryan, vol. 2 (Princeton University Press, 1993), pp. 160–64.
3. See Carmen García Rodríguez, *El culto de los santos en la España romana y visigoda* (Madrid: C.S.I.C., 1966), pp. 199–201.
4. See Metropolitan Museum of Art (note 1), p. 257.
5. On the medieval cult of saints, see Patrick J. Geary, *Furta Sacra: Thefts of Relics in the Central Middle Ages* (Princeton University Press, 1978). On relics and works of art, see Köhler *Gesta* 37, 1 (1997); and Anton Legner, *Heilige und Heiligtümer: Ein Jahrtausend europäischer Reliquienkultur* (Cologne: Greven Verlag, 2003).

**12. *Plaque with Bishop*, p. 31.**

1. For more on this plaque, see Meyric R. Rogers and Oswald Goetz, *Handbook to the Lucy Maud Buckingham Medieval Collection* (Art Institute of Chicago, 1945), cat. 29, pl. 33; Hanns Swarzenski, *Monuments of Romanesque Art: The Art of Church Treasures in Northwestern Europe* (University of Chicago Press, 1954), p. 82, fig. 521; Dietrich Kötzsche, "Zum Stand der Forschung der Goldschmiedekunst des 12. Jahrhunderts im Rhein-Maas-Gebiet," in *Rhein und Maas: Kunst und Kultur 800–1400*, Cologne, Schnütgen Museum, 1972, exh. cat., vol. 2 (Schnütgen Museum, 1972), p. 224, fig. 52; and Anton Legner, *Ornamenta Ecclesiae: Kunst und Künstler der Romanik*, exh. cat., vol. 1 (Schnütgen Museum, 1985), no. B12.
2. See Swarzenski (note 1), figs. 513–16, 520–21.

**13–14. *Plaques with Saints James and John*, p. 32.**

1. See Schnütgen Museum, Cologne, *Rhein und Maas: Kunst und Kultur, 800–1400*, exh. cat. (Schnütgen Museum, 1972).
2. Theophilus, *De diversis artibus*, trans. C. R. Dodwell (London: T. Nelson, 1961), p. 62. Theophilus is widely believed to have been Roger of Helmarshausen, a monk and documented goldsmith who apprenticed at Stavelot and was later active in Cologne and Helmarshausen.
3. For more on this theme, see James Gordon, "The Articles of the Creed and the Apostles," *Speculum* 40, 4 (Oct. 1965), pp. 634–40; Nigel Morgan, "The Iconography of Twelfth-Century Mosan Enamels," in Schnütgen Museum (note 1), vol. 2, pp. 263–67, esp. p. 268, fig. 8; and Neil Stratford, "A Propos des trois émaux du British Museum: Le Thème des apôtres au Credo au XIIe siècle," in Pierre Lacroix et al., *Pensée, image & communication en Europe médiévale: À propos des stalles de Saint-Claude* (Besançon, France: ASPRODIC, 1993), pp. 111–12.
4. This legend dates back to the sixth century; see Pseudo-Augustine in J. P. Migne, *Patrologia Latina* (Rome: Typis Vaticanis, 1906–08), xxxix, 2189; and Priminus in ibid., LXXXIX, 1034. For the biblical account of Pentecost, see 2 Acts.
5. For an illustration of the Boston enamel, see Hanns Swarzenski and Nancy Netzer, *Enamels and Glass: Catalogue of Medieval Objects* (Museum of Fine Arts/Northeastern University Press, 1986), pp. 46–47, cat. 6.

**15. *Mass of Saint Gregory*, p. 33.**

1. This leaf is published in Hanns Swarzenski, *The Berthold Missal: The Pierpont Morgan Library MS 710 and the Scriptorium of Weingarten Abbey* (Pierpont Morgan Library, 1943), p. 15, figs. 10–11; and Michael Heinlen, "An Early Image of a Mass of St. Gregory and Devotion to the Holy Blood at Weingarten Abbey," *Gesta* 31, 1 (1998) pp. 55–61.
2. For the early Gregorian "Legend of the Doubting Matron," see Gerhard Ladner, "The Life of the Mind in the Christian West around the Year 1200," in *The Year 1200: A Symposium* (Metropolitan Museum of Art, 1975), p. 19.
3. See Caecilia Davis-Weyer, *Early Medieval Art, 300–1150: Sources and Documents* (Prentice-Hall, 1971), pp. 47–49; and Celia Chazelle, "Pictures, Books, and the Illiterate: Pope Gregory I's Letters to Serenus of Marseilles," *Word and Image* 6, 2 (Apr./June 1990), pp. 138–53.

**16. *Capital with the Adoration of the Magi*, p. 34.**

1. This capital was previously believed to have come from southern France; see Meyric R. Rogers and Oswald Goetz, *Handbook to the Lucy Maud Buckingham Medieval Collection* (Art Institute of Chicago, 1945), cat. 2. The most recent study is in Walter Cahn et al., *Romanesque Sculpture in American Collections*, vol. 2, *New York and New Jersey*, Publications of the International Center of Medieval Art 3 (Turnhout, Belgium: Brepols, 1999), p. 199.

**17. *Corpus of Christ*, p. 35.**

1. For an illustration of the baptismal font in Liège, see Schnütgen Museum, Cologne, *Rhein und Maas: Kunst und Kultur, 800–1400*, exh. cat., vol. 2 (Schnütgen Museum, 1972), pp. 151–53. For more on the Cologne crucifix and others related to it, see Peter Bloch, "Bronzekruzifixe in der Nachfolge des

218–22. Laura Bruck of Northwestern University proved enthusiastic and invaluable in researching the history of this collection.

21. *Bulletin of The Art Institute of Chicago* 10, 1 (Jan. 1916), p. 144. For more on the history of manuscript collecting in Chicago, see Sandra Hindman and Nina Rowe, eds., *Manuscript Illumination in the Modern Age: Recovery and Reconstruction*, exh. cat. (Mary and Leigh Block Museum of Art, Northwestern University, 2001), esp. pp. 262–72.

22. Seymour de Ricci and W. J. Wilson, *Census of Medieval and Renaissance Manuscripts in the United States and Canada*, vol. 1 (New York: H. W. Wilson, 1935), pp. 513–18.

23. Mrs. C. Philip Miller interviewed by Evelyn Rivers Willbanks and Mary Janzen, Mar. 4, 1985), oral history transcript. For more on Kate Buckingham, see Margaret W. Norton, "Kate Sturgis Buckingham," in Schulze and Hast (note 7), pp. 125–28.

24. In 1927 Buckingham donated $750,000 for the Buckingham Fountain to be erected in Grant Park; she later gave the city $1,000,000 for a gilt statue of Alexander Hamilton in Lincoln Park.

25. *Bulletin of The Art Institute of Chicago* 15, 2 (Feb. 1921), p. 122.

26. Germain Seligman credited Blumenthal as a guiding force behind Kate Buckingham's endeavor; see Seligman (note 5), p. 89.

27. Louis Cornillon to Robert Harshe, Feb. 13, 1924.

28. *Bulletin of The Art Institute of Chicago* 13, 5 (May 1924), p. 54.

29. Kate S. Buckingham to C. J. Demotte, Apr. 1933.

30. Kate S. Buckingham to Mr. Kaltenbach, Oct. 1933.

31. Among these were the 1925 loan exhibitions of furniture from Jacques Seligman, New York, and tapestries from Demotte and Company, Paris (see note 19).

32. For more on the Guelph Treasure and publications related to its contents and history, see cats. 30–31.

33. The dealers assembled a small exhibition catalogue, *The Guelph Treasure Exhibition: November 30th to December 20th, 1930, 730 Fifth Avenue, New York* (New York: Goldschmidt-Reinhardt Galleries, 1930). The same text was used in Chicago with a revised title. For more on the show's text, see Heather McCune Bruhn, "The Guelph Treasure: The Traveling Exhibition and Purchases by Major American Museums," in Bradford Smith (note 2), pp. 199–202.

34. These objects are catalogued in *Der Welfenschatz: Einführung und beschreibendes Verzeichnis* (Staatliche Museen zu Berlin, 1935).

35. The Art Institute now houses eight items from the Guelph Treasure. Marion Deering McCormick donated a circular monstrance (1962.90); a reliquary with a Fatimid rock-crystal flask (cat. 31; 1962.91), the Veltheim Cross (cat. 30; 1962.92), and a pyx (1962.93); the Antiquarians gave a silver processional cross (1931.265); and Kate Buckingham Endowment purchased a church-shaped reliquary (1938.1956), a circular monstrance (1938.1957), and a silver reliquary (1938.1958). All are published in Patrick M. de Winter, "The Sacral Treasure of the Guelphs," *Bulletin of the Cleveland Museum of Art* 72, 1 (Mar. 1985), pp. 139–42.

36. Annual Report of the President of the Antiquarian Society, Nov. 14, 1939. Starting in the 1940s, however, the group's focus shifted to American art. See Hilliard (note 12), pp. 20–21.

37. For more on Rich, see John W. Smith, "The Nervous Profession: Daniel Caton Rich and The Art Institute of Chicago, 1927–1938," *Art Institute of Chicago Museum Studies* 19, 1 (1993), pp. 58–79, esp. 64, 66–69.

38. According to Rich's plan, an endowment would allow for further additions to the Clarence Buckingham collection of prints; the Lucy Maud Buckingham collection of Chinese bronzes would be reinstalled, and another fund would allow for the purchase of Chinese paintings. See "Buckingham Report," dated May 15, 1940.

39. Goetz and Swarzenski apparently maintained close ties after arriving in the United States. On Swarzenski, see Kathryn McClinock, "'Arts of the Ages' and the Swarzenskis," in Bradford Smith (note 2), pp. 203–208; and Jan Fontein, "A Medievalist and Renaissance Man," in Hanns Swarzenski and Nancy Netzer, *Enamels and Glass: Catalogue of Medieval Objects* (Museum of Fine Arts/Northeastern University Press, 1986), pp. ix–x. Many thanks to Brandon Ruud in the Department of European Decorative Arts and Sculpture, and Ancient Art for his help in piecing together the provenance of the Art Institute's works and establishing the connection between Harry Fuld and "Mayer-Fuld," presumably his descendant.

40. See curatorial files, Department of European Decorative Arts and Sculpture, and Ancient Art; and Department of Prints and Drawings.

41. For more on the provenance of this piece, see Oswald Goetz and Myric R. Rogers, "A Medieval Masterpiece Rediscovered," *Bulletin of The Art Institute of Chicago* 38, 4 (Apr./May 1944), pp. 54–58.

42. See Myric R. Rogers and Oswald Goetz, *Handbook to the Lucy Maud Buckingham Medieval Collection* (Art Institute of Chicago, 1945). For details on Goetz and Rogers's reinstallation, see *Bulletin of The Art Institute of Chicago* 34, 1 (Jan. 1940), pp. 4–6.

43. The exhibition started in New York and traveled to Cleveland, Chicago, San Francisco, San Marino, Kansas City, Houston, and Boston; see Pierpont Morgan Library, New York, *Treasures from the Pierpont Morgan Library: A Fiftieth Anniversary Celebration* (Pierpont Morgan Library, 1957).

44. For more on the Worcester collection, see Smith (note 37), p. 68.

45. For more on Harding, see Harris (note 1) and Walter J. Karcheski, *Arms and Armor in The Art Institute of Chicago* (Art Institute of Chicago, 1995), pp. 8–15; Harding's alabasters are published in "Medieval English Alabasters in American Museums," *Speculum* 31, 1 (Jan. 1955), pp. 64–71.

46. For more on the Alsdorf collection, see *Art Institute of Chicago Museum Studies* 25, 2 (2000). During this period, exhibits of medieval objects at the Art Institute included *French and Flemish Illuminated Manuscripts from Chicago Collections* (1969) and *Medieval Decorative Arts from Chicago Collections* (1986); for more on the former, see Herbert Kessler, *French and Flemish Illuminated Manuscripts from Chicago Collections* (Division of the Humanities of the University of Chicago, 1969). In 1991 the Art Institute and the Metropolitan Museum of Art, New York, collaborated on *Decorative and Applied Art from Late Antiquity to the Late Gothic Style*, a loan exhibition displayed at the Pushkin Museum, Moscow, and the Hermitage, Leningrad.

### 1. *Virgin and Child, Christ on the Cross*, pp. 20–21.

1. For more on this diptych, see Christopher Lloyd, *Italian Paintings before 1600 in The Art Institute of Chicago: A Catalogue of the Collection* (Art Institute of Chicago/Princeton University Press, 1993), pp. 131–35; and Helen C. Evans, ed., *Byzantium: Faith and Power (1261–1557)*, exh. cat. (Metropolitan Museum of Art/Yale University Press, 2004), cat. 288. For more on these works, see Evans (note 1), cats. 272, 276.

3. For more on these icons, see Lloyd (note 1), p. 134; and Evans (note 1), p. 479.

4. Evans (note 1), p. 479.

5. Ibid., and Lloyd (note 1), p. 134.

### 2. *Siculo-Arabic Casket*, pp. 21–22.

1. A similar casket in the church of San Sernin, Toulouse, France, bears the same (but more clearly legible) inscriptions; see José Ferrandis Torres, *Marfiles árabes de occidente*, vol. 2 (Madrid: E. Maestre, 1940), pp. 169–70, pl. 39.

2. For more on these caskets, see Perry Blythe Cott, *Siculo-Arabic Ivories* (Department of Art and Archaeology, Princeton University, 1939), esp. p. 33, and pl. 7; Ralph H. Pinder-Wilson and C. N. L. Brooke, "The Reliquary of Saint Petroc and the Ivories of Norman Sicily, *Archaeologia* 54 (1973), pp. 261–305; and Avinoam Shalem, *Islam Christianized: Islamic Portable Objects in the Medieval Church Treasures of the Latin West*, Ars faciendi'? (Frankfurt: Peter Lang, 1996), pp. 110–13. See also Stefano Carboni in Helen C. Evans and William D. Wixom, eds., *The Glory of Byzantium: Art and Culture of the Middle Byzantine Era, A.D. 843–1261*, exh. cat. (Metropolitan Museum of Art/Harry N. Abrams, 1997), cat. 343.

### 3–5. *Solidus of Heraclius*, pp. 22–23.

1. For more on Heraclius, see Walter E. Kaegi, *Heraclius: Emperor of Byzantium* (Cambridge University Press, 2003). For publications on this type of coins, see Philip Grierson, *Byzantine Coins* (Methuen/University of California Press, 1982), pp. 93–94, 356, esp. pl. 16, no. 277; and Cécile Morrison, *Catalogue des monnaies Byzantines de la Bibliothèque nationale*, vol. 1 (Paris: Bibliothèque nationale, 1970), pp. 264–66, pl. 42.

2. For more on this type of coin, see Grierson (note 1), pp. 165, 364, esp. pl. 35, no. 648; and Morrison (note 1), vol. 2, pp. 506–509, pl. 71.

3. For more, see Grierson (note 1), pp. 195–200, 370, esp. pl. 51, no. 907; and Morrison (note 1), vol. 2, pp. 626–28, pl. 84. The solidus (meaning whole, complete, or pure) was the standard gold coin of the late Roman Empire; it was replaced around the tenth century by the Greek nomisma, or "gold coin." The increasing hellenization of Byzantine coins was also marked by the gradual shift from Latin to Greek, which resulted in some coins bearing inscriptions in both languages.

# NOTES

*Nielsen*, "To Step into Another World," pp. 6–17.

1. For more on Kate S. Buckingham and Martin A. Ryerson in particular, see Neil Harris, "Midwestern Medievalism: Three Chicago Collectors," *Cultural Leadership in America: Art Matronage and Patronage*, Fenway Court 27 (Isabella Stewart Gardner Museum, 1997), pp. 104–23.

2. For more on the rise of American collectors, see Paul Williamson, "The Collecting of Medieval Works of Art," in *The Thyssen Bornemisza Collection: Medieval Sculpture and Works of Art* (Sotheby's Publications, 1987), pp. 80–120; Walter Cahn and Linda Seidel, *Romanesque Sculpture in American Collections*, vol. 1, *New England Museums*, Publications of the International Center of Medieval Art 1 (New York: B. Franklin, 1979), pp. 1–16; and Elizabeth Bradford Smith, *Medieval Art in America: Patterns of Collecting, 1800–1940*, exh. cat. (Palmer Museum of Art, Pennsylvania State University, 1996).

3. For more on Gardner, see Anne Higgonet, "Private Museums, Public Leadership: Isabella Stewart Gardner and the Art of Cultural Authority," Fenway Court 27 (note 1), pp. 79–92. For Morgan, see K. Aaron Rottner, "J. P. Morgan and the Middle Ages," in Bradford Smith (note 2), pp. 115–26; and Jean Strauss, "J. Pierpont Morgan, Financier and Collector," *Metropolitan Museum of Art Bulletin* 57, 3 (Winter 2000). On Walters, see William R. Johnston, *William and Henry Walters, the Reticent Collectors* (Walters Art Gallery/Johns Hopkins University Press, 1999), pp. 179–81; and Marshall Price, "Henry Walters: Elusive Collector," in Bradford Smith (note 2), pp. 127–32.

4. For more on Barnard, see Elizabeth Bradford Smith, "George Gray Barnard: Artist/Collector/Dealer/Curator," in Bradford Smith (note 2), pp. 133–42; and J. L. Schrader, "George Gray Barnard: The Cloisters and the Abbaye," *Metropolitan Museum of Art Bulletin* 37, 1 (Summer 1979).

5. Germain Seligman, *Merchants of Art, 1880–1960: Eighty Years of Professional Collecting* (New York: Appleton-Century-Crofts, 1961), pp. 13–14.

6. See, for example, Jean F. Block: *The Uses of Gothic: Planning and Building the Campus of the University of Chicago*, exh. cat. (University of Chicago Library, 1983).

7. See a newspaper clipping from the 1910s in the Art Institute Scrapbook, Ryerson Library. For more on Bertha Palmer, see Margo Hobbs Thompson, "Bertha Honore Palmer," in Rima Lunin Schultz and Adele Hast, eds., *Women Building Chicago, 1790–1990: A Biographical Dictionary* (University of Indiana Press, 2001), pp. 661–64. For more on von Bode, see his autobiography, *Mein Leben* (Berlin: H. Reckendorf, 1930).

8. Ryerson attended Harvard while the art historian and Dante scholar Charles Eliot Norton was teaching there, an experience that may have sparked his interest in late-medieval art; see Helen Lefkowitz Horowitz, *Culture and the City: Cultural Philanthropy in Chicago from the 1880s to 1917* (University Press of Kentucky, 1976), p. 73. For more on Ryerson and his collections, see Martha Wolff, "Introduction," in Christopher Lloyd, *Italian Paintings before 1600 in The Art Institute of Chicago: A Catalogue of the Collection* (Art Institute of Chicago/Princeton University Press, 1993), pp. xi–xvi; and *Bulletin of The Art Institute of Chicago* 27, 1 (Jan. 1933).

9. Martin A. Ryerson to Robert Harshe, Apr. 12, 1914, Archives of the Art Institute of Chicago. Unless otherwise specified, all references to Art Institute correspondence, minutes, oral histories, sales receipts, and other manuscripts and ephemera are to documents residing in these archives. The present location of this statue is unknown.

10. For the catalogue of the Spitzer sale, see Frédéric Spitzer, *La Collection Spitzer: Antiquité, moyen âge, renaissance*, sale cat. (Paris: Maison Quantin, 1890–93).

11. These appear in a memo, dated Nov. 26, 1941, that lists items "Formerly in the Spitzer Collection and later acquired by the Art Institute through the Ryerson Collection." The items obtained from the Spitzer sale were kept at the Ryerson home until Mrs. Ryerson's death in 1937, when they entered the Art Institute.

12. For the history of the Antiquarian Society, see Celia Hilliard, "'Higher Things': Remembering the Early Antiquarians," in *Art Institute of Chicago Museum Studies* 28, 2 (2002) pp. 6–21.

13. Bessie Bennett, appointed curator of decorative arts in 1914, did not begin to exercise control over the Antiquarians' purchases and exhibitions until well into the 1920s. For more on Bennett, see Bart H. Ryckbosch, "Bessie Bennett," in Schultz and Hast (note 7), pp. 77–81.

14. For more on this, see Bruce Boucher, "'Another Country': Display and the Decorative Arts at the Art Institute, 1900–2000," in *Antiques Chicago: Antiquity to the Avant-Garde* (Antiques Chicago, 2004), pp. 21–27.

15. See Hilliard (note 12), pp. 11–12.

16. Minutes of the Antiquarian Society annual meeting, Nov. 9, 1909; the society paid $300 for the Spanish altarpiece and $310 for the Virgin and Child, which may remain in the museum's collection as 1909.21 and 1910.1, respectively. Minutes of the Antiquarian Society board meeting, Apr. 12, 1910; *Bulletin of The Art Institute of Chicago* 6, 3 (Jan. 1913), p. 38; minutes of the Antiquarian Society board meeting, Dec. 13, 1910.

17. For more on Blair, see Hilliard (note 12), pp. 12–14; for a record of the exhibition, see *Catalogue of the Mary Blair Collection of Mediaeval and Renaissance Art* (Art Institute of Chicago, 1914).

18. Harriet Monroe in *Chicago Daily Tribune*, Jan. 18, 1914; Maude I. G. Oliver in *Chicago Record Herald*, Jan. 20, 1914; *Chicago Record Herald*, Feb. 15, 1915. To the Antiquarians' chagrin, Blair's collection was eventually sold at auction during the Depression; see Hilliard (note 12), p. 19.

19. Examples of these were a 1924 exhibition of medieval art by the New York dealer Joseph Brummer and a 1925 display of medieval tapestries from Demotte and Company, Paris.

20. See "The Voynich Collection," *Bulletin of The Art Institute of Chicago* 9, 7 (Nov. 1915), pp. 97–100. For more on Voynich, see Hans Peter Kraus, *A Rare Book Saga: The Autobiography of H. P. Kraus* (Putnam, 1978), pp.

Opposite: Cat. 15 (detail).